Harding's Lessons on Drawing

A Classic Approach

J. D. HARDING

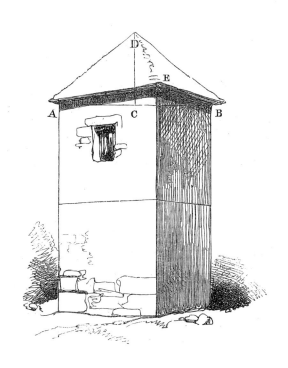

DOVER PUBLICATIONS, INC.
Mineola, New York

Bibliographical Note

This Dover edition, first published in 2007, is an unabridged republication of the second edition of the work, originally published by Day and Son, London, ca. 1860 under the title *Lessons on Art*.

Library of Congress Cataloging-in-Publication Data

Harding, James Duffield, 1798–1863.
 [Lessons on art]
 Harding's lessons on drawing : a classic approach / J. D. Harding. —Dover ed.
 p. cm.
 Originally published: Lessons on art. 2nd ed. London : Day and Son, ca. 1860.
 ISBN 0-486-45691-9 (pbk.)
 1. Drawing—Technique. I. Title. II. Title: Lessons on drawing.
NC730.H32 2007
741.2—dc22
 2006048861

Manufactured in the United States of America
Dover Publications, Inc., 31 East 2nd Street, Mineola, N.Y. 11501

PREFACE TO THE FIRST EDITION.

THE power either to draw, or to appreciate Art and Nature, is, and must be, the result of education. This truth, although now more generally acknowledged than formerly, is by no means so universally acknowledged as it should be, in order that the human mind may progress in Art, as it does in every other pursuit.

This power is still falsely considered to be an inborn faculty, which, if not possessed in some remarkable degree, is not present in any valuable degree. Were this true of the power to draw, it would be true of every other faculty. Orators, poets, and writers would monopolise language; science, mental and material, would belong only to philosophers; and music would be the exclusive inheritance of Handels, Haydns, and Mozarts. To argue that those who have shone as orators, poets, philosophers, or musicians, have faculties denied to all the rest of mankind, would be absurd; nor would it be less at variance with truth to insist that painters of genius only can have the necessary power to draw.

The faculties of the mind called into action by the practice of Art, belong to all men in some degree—they are the same as those employed when the mind essays any other mental acquisition; but as each pursuit exercises and improves one faculty, or set of faculties, more than another, so the study of Art, besides demanding the exercise of such as are necessary to other pursuits, employs those which are more peculiarly necessary to its own particular attainment. It should, therefore, be esteemed as an important coadjutor with other pursuits, for it co-operates in the development of every mental faculty and feeling, and especially helps to bring into life and activity such as, without its aid, would lie dormant or unknown. If this be admitted (and I think it can scarcely be denied), then it may be fairly asserted that no mind can be fully developed but by its assistance.

If any additional evidence be required in proof of this, we have only to turn to Nature, which has obviously been fashioned for our enjoyment, else why the pleasure derived from its contemplation? why the gratification in seeing that Art has fixed its transient beauties? In Nature are to be found the sources of all the pleasure we derive from the colour, form, character, and combination of objects. Individuals who are not made acquainted with the beauties of Nature through the medium of Art, acknowledge, indeed, their existence as an undeniable fact, but those only who have

studied Art, are conscious how they abound on all sides, or can be fully alive to their influence. It is one thing to acknowledge the existence of beauty; it is another to feel its power. Those who have not studied Art, see as through a glass darkly the beauties which the Creator has spread around in exhaustless abundance, and are but faintly conscious of their ameliorating effects on the mind and feelings. A portion only of the charms of Nature can be realised; the rest, for those who are ignorant of Art, have been all but created in vain. Need more be said to induce the adoption of the study of Art as an essential requisite? It is surely a conclusive argument in its favour, that, by its study, the feelings become refined, and the mind awakened to a new sense and new powers, by which it can estimate what has been done by a beneficent Creator for its gratification, and can find occasion to be grateful for the bounty which has supplied such stores of refined and elevating enjoyment.

A strong argument in favour of the study of Art may be deduced, not only from its growing diffusion and general employment, apart from what is shown in the higher walks of painting and sculpture, but in its application to manufactures of every kind, and as an adjunct in conveying just and correct ideas on many important branches of knowledge.

There never was a time when Art was so much in request for the embellishment of what ministers to our physical wants. We breathe an atmosphere of Art: objects, whether of small or great utility, now teem with every beauty the imagination can contribute. If we acknowledge its advantage in these respects, we cannot doubt its high importance, nor overrate its value in conveying ideas, and in thus quickening the march of mind. Scarcely a publication is now issued and not illustrated. Does not Art, whilst gratifying the feelings, penetrate the intelligence, and fix its own truths on the mind with a power beyond the reach of words? The press daily affords its millions of proofs of these facts; spreading in all directions communications of vast commercial importance in no other way communicable, and thus creating and extending sources of wealth among the nations. Those geographically remote are made proximate by a language which leaps the barriers of differing tongues, and speaks what can be universally comprehended.

It would be useless to multiply arguments in favour of the study of Art; what more than the foregoing considerations could enhance its value,—what less could do it justice?

J. D. HARDING.

3, ABERCORN PLACE, ST. JOHN'S WOOD.

PREFACE TO THE SECOND EDITION.

THE demand for another Edition of " The Lessons on Art," has tempted me, by the opportunity thus afforded, to change the form of the work to one which I hope will be found more portable, and, therefore, more convenient. I have also been desirous of supplying it at as small a cost as possible, consistent with its practical utility, so as to bring it within the reach of a larger number of persons.

This new Edition is accompanied by an entirely new set of Drawings, and whilst I have preserved the original plan of the book intact, I have made such additions and changes as will, I hope, be found to increase its usefulness as a practical work. That I may still more effect this, which has been my especial object in laying it before the public, I propose soon to follow it by another, and a smaller part, which shall serve the purpose of a Guide or Companion, so that together, the two may present to the Pupil and the Teacher something like a comprehensible digest of the initiatory steps to Art.

My desire is not more to aid those who learn than those who teach Art. The very great favour with which the former Edition has been received by both, and the large extent to which its principles have been acknowledged and adopted, have encouraged me to take every pains to increase its utility, and to render it worthy of becoming confirmed in public estimation.

INTRODUCTION.

As the " Lessons on Art " differ so widely from any other work of the kind yet offered to the public, some explanation may be required of the objects sought to be attained by them, in order that teachers may judge of what is here intended to aid them in their attempts to impart instruction, and to enable parents and the public to comprehend what benefit may be derived from Art if properly studied.

But, before entering on this explanation, it will be desirable to say a few words on what has been generally wanting in works of this kind, and also on what has hitherto impeded the proper study of Art, so that it may be understood why the great advantages it offers, and the new powers its proper study would confer, have so rarely been realised.

Lessons, such as have been ordinarily offered for the pupils' use through the medium of lithography (my own among the number), have been but seldom accompanied by verbal instruction ; and, although consisting of single objects, and therefore appearing to the eye to present but little or no difficulty, are by no means found so easy as they appear. Nor is this to be wondered at. Before the hand can transcribe forms easily and truthfully, especially such as are circular, the mind must possess some simple machinery, to aid the hand to execute, and the eye to judge accurately. There must be some simple elements into which all forms, however complicated, may be resolved, as a primary condition, on which hangs the power to draw well; or even to draw at all. If the mind must be trained before it can direct the hand in drawing any single and familiar object accurately, how much more preparation is requisite to draw various objects in varied combinations ? Without such preparation, drawing is a hopeless effort—with it, an improving exercise of the best faculties of the mind ; and if difficulties attendant on drawing objects singly, be multiplied in proportion as the objects are numerous, what reasonable expectation can there be that, ere these are mastered, and the mind has become familiarised to them, an attempt to colour can be successful ? None—absolutely none.

One great impediment to a more extensive acquisition of Art is the mistaken belief that peculiar faculties are required. But the giant barrier to be overcome is

the extraordinary demand that those who take up Art shall in a short time be made capable of producing complete works of Art in *colour*, such as can only be effected, and ought only in reason to be expected, from accomplished painters. Every solid and future advantage is sacrificed at the shrine of present gratification. This mischief is attended by a train of evils; it nullifies the efforts of the teacher, who could and would be useful to his pupil; his own time, and that of his pupil, are wasted in their united attempts at impossibilities—the one suddenly to impart a power which the other has not been allowed time to acquire, and never will, but through the ordinary steps of elementary knowledge. This is a costly error in every sense, and involves an irreparable loss of *time* and money. The fallacy of these expectations, to say nothing of all their other attendant mischiefs, which I refrain from enumerating, might be readily made apparent.

Drawing is an art immeasurably more difficult than penmanship, although the latter is but drawing forms with a pen instead of a pencil; yet, to attain even a legible handwriting, much more an elegant one, years of tuition are submitted to, and it is deemed satisfactory if a progressive improvement be periodically manifested. So also with the living and dead languages; in fact, with every other branch of education except drawing. A power, the sole acquisition of those who have devoted to it years of study, is demanded of youth, before the intervening steps have been seen, studied, or even thought of.

If I can succeed in convincing parents of these truths, I shall have effected one-half my object in this work. The mischief I complain of is wide-spread, of which all teachers and many parents can bear witness. All the solid advantages and enjoyments which Art is calculated to afford, are lost sight of or overlooked. A proper study of it exercises and assists to mature the reasoning, the perceptive, and the reflective faculties of youth, developing and preparing these, the best powers of the mind, for more efficient exercise on any other subject; and, should the pencil in after life be no longer required, which is barely possible, there will be not only no wasted hours to regret, but occasion of thankfulness for the valuable service it has rendered, the enjoyments it has supplied, and the many collateral advantages it has furnished.

In approaching the study of Art by the initiatory steps contained in these Lessons, I set aside altogether the question whether those who would use them possess either taste or genius. If all other branches of education depended on the decision of this question, and on their affording amusement to youth, Latin and Greek would indeed be dead languages; arithmetic and mathematics in danger of becoming unknown; Art and science extinct. We boast of many scholars, who began by wishing the classics any fate but a pleasant one, and to whom a general conflagration of classic authors would have proved intense enjoyment. I banish therefore the question of innate love; as in all other cases, it is unnecessary (certainly if it show itself it is

always an advantage), because Art can be acquired to as useful a degree as language, by all possessing average intelligence. My object in this work is not to amuse, but to instruct, to train the mind with the hand; not to show how time and talents may be lost or wasted in pretty pastime, but how their value may be increased by another means for rightly employing them. Truths of Nature are placed before the mind of the pupil, and their imitation before his eyes, by methods of ready attainment, and such as are adapted to the comprehension of youthful minds and powers. The exercise of the reason is invited, so that the youths may be convinced that what is presented is true, and being thus prepared, they may finally become their own teachers; for this is, or ought to be, the end of all education. Few will have studied Art, and not have occasion to test its value. It is hardly possible to imagine any position into which the chances and changes of life may throw a youth, where his pencil will not be of equal importance to him as his pen; so often, indeed, as to be beyond the belief of those who have not been taught by experience its worth and its universal applicability.

Added to the desire to effect the objects already explained, I here offer to the teachers of drawing aid analogous to that which a teacher of language derives from a grammar, thinking that my experience of many years of tuition might assist in diminishing their labours, and at the same time in making them more effective. Written instructions accompany the graphic examples, to which the pupil can refer in the absence of the master, and be better prepared for his recurring visits; and the interrogatories of the master will enable him immediately to ascertain whether the Lesson has been wholly or partially understood; not whether it has been drawn, but whether it has been comprehended.

These Lessons may, perhaps, also be useful to private governesses, whose pupils, residing at a distance from a town, are not within reach of public teachers.

The objects I have had in view in this work need no apology, and should the theory and practice presented, be found in other hands as efficient as they have in my own, I shall continue to add other Sections on other subjects of progressive difficulty, and adapted for those pupils who, having accomplished the Lessons herein contained, will be worthy of working in a wider field, and finally will have acquired the enviable power of drawing from Nature herself.

To this end, which has always been borne in mind, reference to Nature is continually made throughout these Lessons; and a knowledge of the initial principles of perspective imparted by a simple method, which obviates the harassing and cumbrous complexities and terminology of that science, hitherto so repulsive and bewildering to youth.

LESSONS ON ART.

PREPARATORY OBSERVATIONS.

THE examples contained in this Number consist of certain elementary forms, which, though but rarely seen in naturally organized bodies, are yet very generally found in all the works of man, and constitute a standard by which you may estimate the obliquity, curvature, or irregularity of lines. As these forms will be frequently referred to in the future Numbers, and where their practical application will be more fully developed, it is necessary, therefore, that you should not only learn to draw them correctly, but also with facility, and from memory.

However simple these Lessons may appear to you, they are, notwithstanding, the bases on which your future knowledge must rest; they should, therefore, be most carefully studied and completely acquired, otherwise the future development of their principles cannot possibly be clearly comprehended. The order of instruction is regularly progressive: your first Lesson is preparatory to the second, the second to the third, and so on. Each, in the order given, should be thoroughly mastered before you attempt the next, that you may be able to call to mind and draw the example directly that it is referred to, and form a clear mental perception of it.

No attempt could here be made to point out to you the various errors into which you are liable to fall, any more than the author of a grammar could anticipate your various misapplications of its rules. Here, as in the grammar, it is stated to you what is to be done, and how. Your tutor, if you have one, will judge of your performances, and will point out any errors which may have escaped your less practised observation. He will also see that you comprehend the Lesson, and are able to draw the whole from memory, without either referring to the example or the written instructions connected with it. If what is thus done should be wrong, he will examine whether you are able to discover the errors, and can yourself make the necessary corrections, not from the eye, but from a positive knowledge of the subject. No Lesson can be said to be really learned, unless this can be done.

The instructions annexed to every Lesson should be carefully read over, before any attempt be made to put them in practice; and every Lesson should be well

learned before you attempt the one following, as the instructions contained in the previous Lessons will not be repeated, it being always supposed that you have acquired them perfectly, and in the order in which they are presented.

It is a good plan for some one to read aloud to you the written instructions, whilst you examine the drawing to which they refer; and, doing this alternately for another, both you and a fellow-pupil, will learn at the same time, more rapidly and with less fatigue.

You should be furnished with a straight and a triangular ruler, and a pair of compasses, to be used only when you have first tried each Lesson by the eye, and as here recommended. The object is, first to exercise your eye, and then to set before it rigid accuracy, from the production and contemplation of which your hand and eye will become accurate, without the aid of mathematical instruments.

ON CUTTING THE PENCIL.

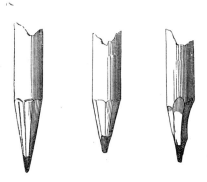

BEFORE you enter on the study and practice of the Lessons, I must teach you how to cut your pencils. In proportion as your pencil is soft or hard, so does it require more or less the support of the wood. To obtain that support, you must cut your pencil, with a *sharp* knife, evenly all round, as you see in Figs. 1 and 2; the hard like Fig. 1, the soft like Fig. 2. If you attempt to cut with a blunt knife, you will find that you break the lead continually; and if, after many fractures, it is at length cut like Fig. 3, which is the usual form given by young hands, it breaks again and again, wherever the wood is too weak to support the lead; it cannot, therefore, be used firmly, or with the required pressure for the deeper tones of colour.

It must be observed, that no pencil appears to be the same at all times; this arises from the nature of the paper, whether hard or soft, smooth or rough, or the condition of the atmosphere, which affects it materially. The same pencil on smooth or rough, moist or dry paper, will mark as if four different pencils had been used; the softer and darker degrees of lead are weaker, and, from their very nature, yield more readily than the harder varieties.

Chalk is in some important respects preferable to the lead pencil. Among its chief merits are its greater depth of colour, and the possibility of seeing whatever is done with it in any light, because it does not shine like the lead pencil. As, however, its operations cannot easily be effaced, and are more frequently altogether ineffaceable, it is not adapted for beginners. I therefore recommend you to delay its use until you have acquired some considerable command over your pencil.

For general use, the best chalk is the glazed conté, as it works very freely, and every varied tone of colour may be produced with it, although much depends on the paper. The best white paper for the purpose is certainly glazed blotting-paper, of a moderate thickness, rather thin than thick. Place the piece you draw on, on other paper; for, if you have wood underneath, you may as well have hard paper. The object sought is a smooth and slightly yielding surface, one on which you can produce tender or forcible tones of colour without the risk of breaking your chalk by the too great resistance of the paper, or of tearing up the surface of the paper by its too little resistance.

A great objection to the use of chalk is often, and with reason, the dirty condition into which the hands are brought by cutting it, and not only the fingers and hands, but through them the paper; both that and the drawing are in consequence often spoiled. The most convenient mode I know of for obviating these discomforts is to 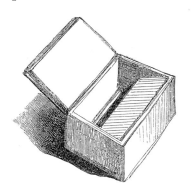 use a small box, like the annexed cut, which contains a file so placed as to incline inwards. On this you rub your chalk from one end to the other, at the same time turning it in your fingers so as to obtain a perfectly conical point. During the operation, all the chalk absorbed by the file falls to the bottom of the box, and is prevented from escaping by the closing of the lid. Thus the hands, the paper, the table, and whatever may be around,—all are kept clean. In proportion as you place your chalk in the direction of the file, will you have a long and fine point; in proportion as you hold your chalk more upright, will the point be more stumpy. After renewing your point you will find on it some portion of the dust occasioned by the filing, which is easily removed by the application of soft paper, a piece of cotton, soft leather, etc. etc.

ON HOLDING THE PENCIL.

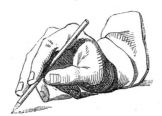

Fig. 1.

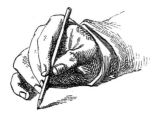

Fig. 2.

Fig. 3.

BEFORE you attempt to put your pencil to the paper, I must teach you how to hold it properly, so that you may be able, eventually, to use it dexterously and effectively.

Fig. 1, here given, shows how the pen is held; a position of the hand to which you are accustomed, and in this position you may be apt to hold your pencil; but however well suited to the pen, it is fatal to the use of the pencil, because you can, when thus holding either instrument, only make lines in one direction. Now in drawing, you require to make lines in every possible direction; hence then, you must hold the pencil in the way here shown by Fig. 2—that is, between the first and middle fingers and the thumb, bringing the latter down so low as to be nearly as low as the tips of the fingers. Allow the third and little fingers to come forward, and not to be turned back towards the palm of the hand, as they are when writing. When thus holding the pencil, you may soon learn to draw lines with facility in any direction; the motion being made with the fingers only, or with the whole hand from the wrist.

I add also another mode (Fig. 3), adapted to the use of a short pencil. When thus holding it, you are able to draw more readily long horizontal or curved lines; and now, you not only obtain the motion of the fingers, but of the whole arm from the shoulder. This affords great freedom in the use of the pencil, and forms of every variety are comprehensively grasped.

LESSON 1.

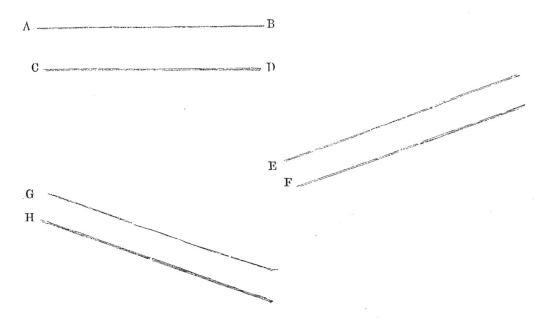

Your first step in Art is, to acquire the power to draw straight lines, such as are given in all the Lessons of this Number. These consist mostly of three kinds : horizontal, as **A B, C D** ; oblique, as **E F, G H** ; and perpendicular, as **L M**, in Lesson 2. The horizontal and oblique lines of this Lesson must be drawn with your elbow close to your side ; but before you essay to draw them, place dots for each extremity, first putting down the one on the left.

Place a dot on the left hand at **A**, and another on the right at **B**. In doing this, you are obliged to reflect on two things : first, on the distance of **B** from **A**, so that the line may be of the required length ; and secondly, that **B** may be level with **A**, so that the line required may be horizontal. Thus you obtain a *mental* perception of the line required ; and, in proportion as you obey these conditions, and thus obtain a true *mental* perception, so will your hand obey its dictates, and draw the line accordingly, truly or falsely. Clear mental perception of what is to be done, previous to any operation of the hand, is the characteristic and important principle on which this work is framed, and to this I must claim your especial attention, as your success depends on its being in all cases implicitly followed.

If, when you have drawn the line **A B**, you find that, instead of being horizontal, it slopes in some way, your mental observations must be repeated, and another dot for **B** must be placed above or below the one first placed, according as you find the line you have made slopes either upwards or downwards. When drawing the second line, you study it *mentally*, and *mentally* compare it with the first ; this is the great

object. Having placed dots for **C** and **D**, and having assured yourself, as well as you are able, that you have formed a right judgment, draw the second line **C D**, and if you deem it to be correct, draw it firmly, and then rub out the first, but not before. Each pair of lines must be made as they are here represented, parallel to each other—that is, they must be equally distant from each other at every part. Take care always to draw the upper line first, and whilst drawing the lower, allow the eye to regard that first drawn, so as to keep their separation equal everywhere. In this manner all future Lessons must be practised.

It is also most essential that you observe to draw the lines in the order in which I have instructed you. For example, if you find yourself anywhere directed to draw a line indicated by **A B** or **C D**, it is to be drawn from **A** to **B**, or from **C** to **D**, as the most convenient mode of doing it, the most likely to insure its correctness, and to make your hand skilful. In this respect, you must follow the instructions rigidly.

LESSON 2.

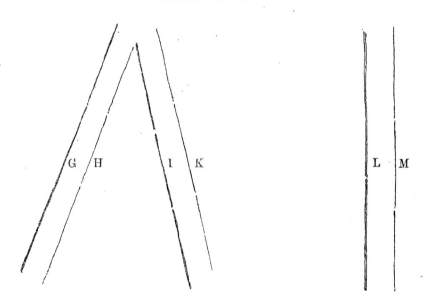

In drawing the oblique lines **G H I K**, and the perpendicular lines **L M**, of this Lesson, your elbow must be placed away from your side, for **G H** but little, but for **I K** and **L M** as far apart from the side as possible. The dark and left-hand lines should be first drawn. It would be very difficult, if not impossible, for you to draw such lines as long as are given in this Lesson without a break; they should, therefore, be divided into such lengths as are here seen, taking care, after each break, to continue the line in exactly the same direction, whether oblique or perpendicular.

In this, as in your preceding Lesson, dots must be first placed for each extremity of each line; and when the first for the upper extremity is placed, the dot for the lower one should be placed with reference to it, so that when both are united by the line afterwards drawn, it may be found to have the required direction.

When you can draw the lines composing these two Lessons firmly, with the pencil held so as to have its point a moderate distance from the ends of the fingers, as shown in Fig. 2, on page 4, you should then project it twice as far, and attempt to draw every line without a break, allowing then not only free motion to your hand, but to the whole arm.

These Lessons are learned when you can draw the lines firmly and unhesitatingly, either quite perpendicular or of any required slope.

THE RIGHT ANGLE.

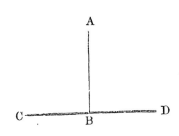

Of the straight, or right lines in the preceding Lessons, three kinds of angles are formed, by combining any two of them; and these are respectively called a right angle; an acute angle; and an obtuse angle.

The right angle, as in this Lesson, is formed by a vertical line, **B A**, and a horizontal line, **B D**. The lines forming a right angle are mutually perpendicular to each other, though, when the one line is horizontal, the vertical one is usually called the perpendicular. The property of a right angle is, that on producing or extending either of the sides, as from **B** to **C**, the angle **A B C** thus formed is equal to the adjacent one, **A B D**. If **A B** be extended below **C D** in the same manner, it will be perceived that the divergence of the lines from the point **B** forms four right angles. It is hence obvious, that not more than four right angles can be formed about any point on a plane surface.

THE ACUTE ANGLE.

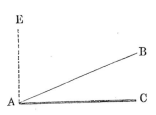

An acute angle is less than a right angle; that is, the lines which form it are not so far apart as those forming a right angle: thus, any angle which is less than a right angle is acute. The acute angle is formed by an oblique line, **B A**, and a horizontal line, **A C**. The dotted perpendicular line, **E A**, which forms a right angle with **A C**, shows how much the acute angle **B A C** is less than the right one **E A C**.

THE OBTUSE ANGLE.

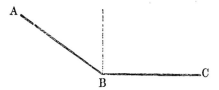

AN obtuse angle is greater than a right angle; that is, the lines which form it are farther apart than those forming a right angle : thus, any angle which is larger than a right angle is obtuse. It is formed by an oblique line, **A B**, and a horizontal one, **B C.** The dotted perpendicular line above **B**, which is at right angles with **B C**, shows how much larger the obtuse angle is, than a right angle.

The difficulty you have to overcome in these Lessons is, to draw one line perpendicular to another which is horizontal, so as to form a right angle ; and also, having drawn a right angle, so to make any other angle, acute or obtuse, in any required degree, such as is here given, or such as may be given. All the observations made in Lessons 1 and 2, with regard to the position of the arm and hand, and the mode of drawing the lines also, must be constantly attended to. You should sit upright, and merely incline the head so that the eye, being distant from the paper, may enable you always to grasp the whole subject of the Lesson. It is a very great error to stoop so as to bring your eye near the paper ; it is, besides, ungraceful and unhealthful.

LESSON 3.

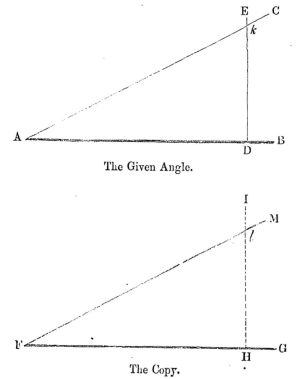

The Given Angle.

The Copy.

BESIDES knowing the names of the different kinds of angles, I would have you able to draw a right angle accurately, as by means of this you estimate the relative magnitude of all angles; that is, you can, without the aid of any mathematical instrument, make an angle equal to a given angle, or, in other words, draw from a point two lines which shall have the same degree of divergence, or separation from each other, as two other lines. Let **B A C** be the given angle: at any distance which may be judged most convenient from the angle **A**, take a point **D** (anywhere will do) on the line **A B**; and from this point draw the perpendicular **D E** till it touches or crosses **A C** at **E**. This much being done as regards the given angle, now draw for your copy of it a line **F G** indefinitely, and on it fix the point **F**; then mark as near as you can judge the length **F H** equal to **A D**, and from **H** draw a perpendicular for **H I**. Consider now the distance **D** *k* in the given angle, and mark off **H** *l* in the copy equal to it; then draw through it from the point **F** the line **F M**, and the angle this makes with the line **F G**, viz. **M F G**, will be equal to the given angle **C A B**.

LESSON 4.

AN obtuse angle, like **C A B**, must be measured differently. Fix on the points **A** and **B**, and draw the line **A B**. Extend it to the left as far as **D**, and from **D** draw the perpendicular **D C**. Having fixed the point **C** at its required height from **D**, draw the line **C A**, and the obtuse angle you have thus obtained will be like the one here given, that is, if the distances from **A** to **D**, and from **D** to **C** have been accurately measured. Your eye only must be made the judge; mechanical measures, such as strips of paper or compasses, should not be used, except to prove how far your eye has been accurate.

Or an obtuse angle may be measured by the method shown in the following Lesson.

LESSON 5.

DRAW the line **G F E**. Fix on the point **F**, and set up from it a perpendicular equal to **F H**, then fix on a point for **I**, which must be level with **H**, and of the required distance from it, draw **I F** and the obtuse angle required, **I F G**, is obtained. This mode equally obtains the acute angle **I F E**.

In examining what you have done, you will see that when lines have to be copied, which form acute or obtuse angles, they can only be copied accurately by comparison with a right angle, and that, to judge correctly of the obliquity of any lines, you must compare them with perpendicular or horizontal lines—these being the standards of comparison.

As all rectilinear objects* perpetually present to the eye angles of every variety, acute or obtuse, it is of great importance that you should be ready with some mechanical means of ascertaining, and of accurately imitating, the obliquity of lines; this power when completely acquired will render the following Lessons comparatively easy to you; indeed, without some such preparations, they would be with great difficulty practicable at all. Hence these are most important Lessons, and such as you will have constant occasion to practise and apply. To enable you to become adroit in measuring such angles, it is of great consequence that you always draw the lines in the order and in the manner directed. I cannot too much urge your attention to this. Any attempt to do them otherwise, or to copy the examples, regardless of the instructions accompanying them, is only wasting your time. In so doing you will make no more progress in Art than if you were sleeping,—in fact, merely copying the examples by the eye, without reference to the written instructions, is putting your mind to sleep; whereas my object is to keep it awake and active.

I have, in the next two following Lessons, supplied other examples for measuring angles.

* Objects composed of straight lines.

LESSON 6.

A B C is the angle given ; A B and B C are lines which slope differently, and are of different lengths. The object is to imitate their length and their obliquity. In order to do this accurately, the horizontal line D E must be drawn through B, and then perpendicular lines from A and C till they touch the horizontal line in the points D and B : thus the required right angles A D B and C E B are obtained.

To copy this Lesson, you first draw the line D E of any length, then fix on a point for B; then judge how far D is to the left, and E to the right of this. Having fixed these poins, find the height of A perpendicularly above D, and draw A B; then the height of C above E, and, having decided on this, draw C B. If you have judged accurately of the distances of these points from each other, the required lines A B and B C and the angle A B C will be accurate.

In the next Lesson you have a still more complicated figure, with more lines and angles. To obtain these, with the slope and length of the lines in their relation to each other, would be very difficult, unless by employment of the means I have already described. It is only necessary for you to apply these, in order to obtain the required angles accurately, when you will find it as easy to draw these lines as any others.

LESSON 7.

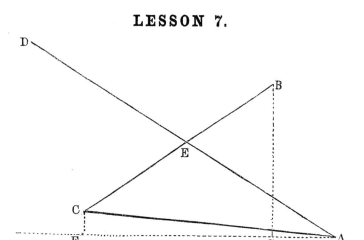

DRAW the horizontal line **F A** indefinitely, fix on the point **A**, and, at their required distances from it to the left, place the points **G** and **F**; from these raise perpendiculars, and ascertain the points **C** and **B**, and then draw the lines **C A** and **C B**. Having done these, you obtain the line **D A**, by observing that the point **E** is midway between **C** and **B**, and that **D** is as far from **E** as **E** is from **A**. You have therefore merely to extend the line from **D** through **E** to **A**; you may draw it, whether with a ruler or by hand, by beginning at **D** and proceeding through **E** to **A**.

LESSON 8.

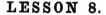

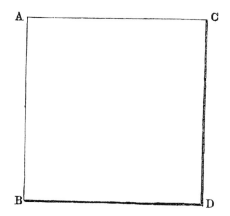

THE figure to which your attention is now called is a square; that is, it consists of four equal sides, and all its angles are right angles. In drawing this figure, you should be particularly attentive to make the first angle, **A B D**, exactly a right angle; for unless this be done, you will find it impossible, by the adaptation of the other lines, to make a perfect square.

The first line drawn should be **A B**, placing first a dot for **A**, and another for **B**, wherever you may think they should come, judging first of the perpendicularity of the line to be drawn, and then of its height. After having drawn this, you must fix on the point **C**. To do this, take care first that it be horizontally level with **A**, and secondly, that it be as distant from **A** as **B** is. You then draw the line **A C**. This mental process is the all-important pre-requisite on which your progress is based. It is the training of your mind to reflect before you act. You thus mentally see each line before you attempt to draw it. You then, in like manner, place a point for **D** under **C**, and level with **B**. Then draw **C D** and **B D**. When the four lines are drawn, you must carefully examine and compare them with each other, to see that the two lines, **A B** and **C D**, are both horizontal, of the same length, and parallel ; and also that **A B** and **C D** are both perpendicular, of the same height, and parallel ; and that all four angles are right angles.

LESSON 9.

THE figure which forms the subject of this Lesson, is of an oblong, **A B C D** composed of two equal squares, and a like square, **F G D H**, to the right of it. This, with the square **E B F D**, makes another oblong, **E G B H**, equal to **A B C D**. These figures are called rectangular parallelograms.* Like the square, they have four right angles, and differ from it only in not having all their sides of equal length. The essential character

* The leaf of this Drawing Book is a parallelogram, and is rectangular—that is, all its angles are right angles.

of this figure consists in all its angles being right angles, and in the proportion between its adjacent sides and the base. Its properties are the same, whether it be comparatively narrow or so wide as to approximate to a square.

To draw an oblong whose longest side shall be in proportion to the shortest, as two to one :—First draw the square **A E F C**, then extend the lines **A E** to **B**, and **C F** to **D**, till **E B** is as long as **A E**, and **F D** as long as **C F** ; then draw the line **B D**. Now draw **F G** equal to **E F**, and **D H** equal to **B D**, and the figure is complete. But it may be executed in another way. Fix on the point **A**, and on the point **B**, perpendicularly under it; having drawn the line **A B**, draw **A C** half the length of **A B**, and at right angles with it; then perpendicularly under **C**, and level with **B**, as accurately as the eye can judge, place a point for **D**, then draw the lines **C D** and **B D**, taking care that they be severally parallel to **A B** and **A C** ; then draw the square **F D G H**, as already described, and if all the lines be parallel, and all the angles right angles, the figure is right. This figure must be executed in both ways, as here described.

It matters not in drawing this figure whether you make a copy the exact size of the original or not ; the point of consequence is, that your copy should be a strictly rectangular (right-angled) figure, of the same proportions as the original ; and the ready way by which you will ascertain those proportions is, to divide the long side actually, or to imagine it to be divided, by the width, or base. When you can do this with facility, you may draw oblongs, or parallelograms of different proportions, by making the long sides **A B** and **C D** twice, three times, or four times longer than their bases **A C** and **B D**.

Whatever be the length of the sides, it is of consequence that your hand should be exercised in drawing them with as few breaks as possible. The great object in this Lesson is, that you should learn to draw parallelograms of any required proportions.

LESSON 10.

DRAW the parallelogram **A B C D** according to the instruction you have gained from the preceding Lesson, and draw the line **F E**, which, if the parallelogram be correct, will divide it into two equal squares; extend **B D** on the left to **I**, taking care to make **I B** as long as **B D**; next fix on the point **G** below **F**, about one-fourth the length of the line **F B**, then perpendicularly over **I**, and horizontally, level with **G**, place a point at **H**, and having decided on this, draw the lines **H G** and **H I**; the point **K** must now be ascertained, which should be nearly half-way between **A** and **F**. Having found this point, draw the line **H K**: thus the angle **K H G** will have been measured according to Lesson 3.

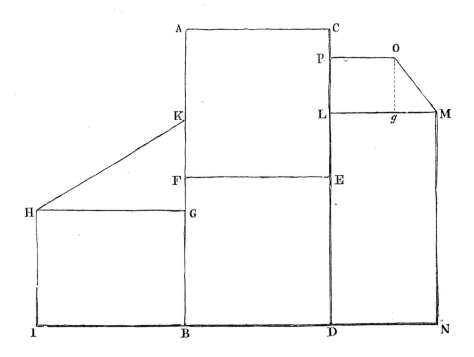

You should here observe that **G H I B** is a parallelogram ; because, although its opposite sides are equal, as **H I** to **G B** and **H G** to **I B**, yet its adjacent sides are unequal, as **H G** and **H I**.

Annexed to what is so far done you have another figure, also a parallelogram, but of different proportions.

To draw this correctly, the point **L** must be fixed on in relation to the point **K** and to the line **C E**, which it divides nearly in half. The point **N** must be found in relation to the line **B D**,—namely, that it is shorter ; having decided on this, find the point **M**, and observe that it be level with **L**, and perpendicularly over **N** ; then draw the lines **L M** and **M N**. Fix the position of **P**, and from it draw a horizontal line indefinitely, and parallel to **L M**. Now determine on the place of *g* either in relation to **L** or **M**, and from this draw a perpendicular line till it touches the horizontal line you drew from **P**. This will determine the place of **O**, and consequently the slope of the line **O M**, which will complete the Lesson. Having drawn this Lesson from the example, now repeat it from memory, observing to draw the lines in the prescribed order. This exercise of the memory is very essential.

LESSON 11.

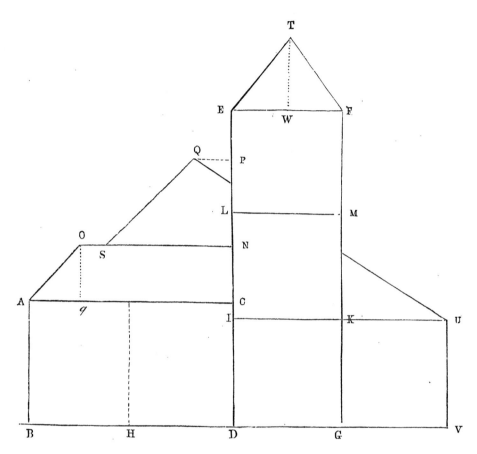

Draw the parallelogram **A B C D**, divide it equally by the dotted line above **H**, then take the line **D G** equal to **H D**, and on this form the parallelogram **D E F G**, which is three times the height of its base. To ascertain its precise height, divide it into squares by the lines **I K** and **L M**. Find the position of **N**, which is rather more below **L** than **C** is above **I**, then decide on the place of q on the line **A C**. Having done this, raise a perpendicular and auxiliary line to find the place of **O** perpendicularly above q, and level with **N**; then draw the lines **O N** and **O A**. The acute angle **O A C** has thus been ascertained by the method shown in Lesson 3.

Having so far executed this Lesson, find the form of **G K U V** in relation to **D I K G**; then find the point **P** midway between **E L**, draw from it an auxiliary horizontal line to find the place of **Q**; find also the place of **S** on the line **O N**, and draw **Q S**, which will be right if it slopes like **A O**. You now draw a line from **Q** to **U** uninterruptedly, and afterwards take out that portion of it which has crossed the middle portion of the Lesson and the line **L M**. Find now the point **W**, halfway

between **E** and **F**; from this raise a perpendicular auxiliary line to obtain **T**, and draw **E T** and **T F**. Your Lesson is now complete, and by it you have learned the dependence of one line on another, and how forms and lines are to be judged of by comparison with, and in relation to, each other. You should be able perfectly to apply this mode of estimating the proportionate length of the sides of an oblong by comparing them with a square, as you will find it of general use in the practice of Art, more especially in the delineation of buildings.

The object in these Lessons is, therefore, to habituate you to regard each line in reference to another or others, and to observe their relative proportions. If the instructions given above have been properly understood, at once proceed to the next Lesson. If, however, you should still be in any difficulty, apply to your master, whose efforts these Lessons are intended to aid, not to supersede.

In going through these and some of the following Lessons of this Number, it is more than probable you may find them wearisome, if not complicated. This feeling, however, you only experience on the first effort; they will, or should be, easy enough the second time. Do not forget that I am now proposing to teach, not to amuse you. The acquisition of knowledge should, of itself, always be your sufficient entertainment, and the adequate recompense for any amount of labour. To this you should now yield yourself willingly, as the *condition* on which you purchase solid gratification for the rest of your life. It is surely better than to waste your time in momentary pleasure now, only to experience in future the miseries of ignorance. However tedious these instructions may appear to you, I have not failed, when preparing them, to remember the value of your precious time, and that the season of your youth can never be repeated. It is under a full sense of its inestimable value, and the precious benefits which accrue to you from its right employment, that they have been composed; and therefore it is that I earnestly invite your complete attention to acquire them perfectly; be assured you will have your reward eventually.

LESSON 12.

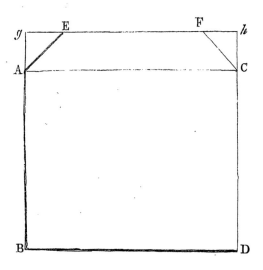

Hitherto your Lessons have consisted entirely of objects having shape without thickness,—that is, they were considered merely as superficies.* In the present Lesson the subject is a cube, or solid prism, having six equal sides, and all of them squares, like a dice. Your study, therefore, is more advanced. Many of the following Lessons would be more advantageously studied, if you had a cube before you, in order that, by examining it in connexion with your instructions, you may the more readily and the more accurately comprehend them. You must first understand, when looking at this, or at any other solid object in nature, you never can see it as it really is. For instance, you see, in the cut on the right, a solid object with six equal square sides, and there is no position in which it can be placed, so that you can see more of them at one view than three. Try this if you have a cube. It may happen, that neither of these sides, although square, can be so represented; nevertheless it is truly represented,—that is, although each right angle of the figure in nature is represented, as here, by an acute or an obtuse angle, yet you perfectly understand it to be a solid object with square sides, and all the angles right angles. It may also be in a position such as shown above in the present Lesson, so that one side will be seen a perfect square; but if the top be 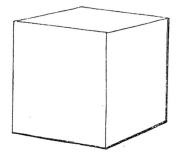 also seen, although in nature equally a square, yet it is not seen a square, neither can it be so represented, because it is not so seen. These are observations which it is very important for you to bear in mind; because the purpose of Art is to represent objects in a picture or drawing as we see them in nature, and not as they actually are.

* Superfice, a plain flat surface, like the walls, floor, and ceiling of a room.

This being the case, we must evidently learn first to understand what we see, that is, how we see an object; or in other words, the eye must be educated through the medium of the intelligence. I am desirous also for you to know, that the tendency of every Lesson set before you, is by degrees to make you so well acquainted with what you will find in nature, and how it may be represented by art, that finally you may possess the power ably to depict her for yourself. This is to be your ultimate possession.

This Lesson shows you the appearance which a cube presents when viewed directly in front, and with your eye a little above the level of its upper side. This mode of representing a cube when viewed in such a position, is not, as many persons suppose, one of the mere conventionalities of art: the real body actually appears to the eye as it is here represented. The lines of the upper surface, on the right and left, **F C** and **A E**, instead of being parallel here, as they actually are in nature, appear to the eye to converge* as they recede, while the line **E F** appears nearer to **A C** than it really is— now in nature they are as far apart from each other as **A C** and **B D**: these lines, however, do not converge—they are parallel. Thus a surface, **A E F C**, which in nature is truly a square, appears to the eye no longer a square; and we only recognize it to be such from mental conviction, obtained by previous comparison with the other sides,— by actual lineal admeasurement—or by touch. The angles in nature are all right angles; but here, they are represented by two obtuse angles at **E** and **F**, and by two acute angles at **A** and **C**. This square is said to be seen obliquely.

Having drawn the square **A B C D** of any size, according to the instructions given in Lesson 8, the distance of the farther side, **E F**, from the side **A C**, must then be determined. In nature, this depends on the height of your eye above the upper surface of the cube, as will afterwards be explained. The instructions now given apply entirely to the Lesson on the paper, which you are to copy. On comparing the distance between **E F** and **A C**, with the distance between **A C** and **B D**, you will find that the former is about one-fourth of the latter. At this distance, draw the line **E F**, any length longer than **A C** but parallel to it; then continue the lines **A B** and **C D** upwards from each angle **A** and **C**, until they touch the line **E F** at g and h; then, having ascertained how far **E** is from g, and **F** from h, place dots at **E** and **F**; then draw the lines **E A** and **F C**, and the whole figure described by the lines uniting at the angles where the letters are placed, will be that of a cube, when viewed in the manner before explained. The auxiliary lines g **E** and **A** g, **F** h and h **C**, should now be rubbed out, as should the auxiliary lines in all future Lessons. In this Lesson you will again recognize and remember the instructions contained in Lessons 3, 4, and 5, and will here see their application.

* Converge, to tend to one point from different places.

LESSON 13.

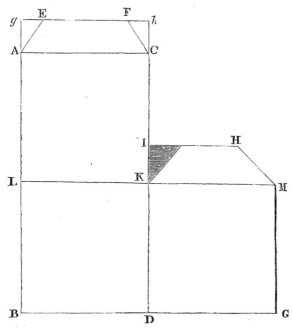

In this Lesson you have a solid parallelogram* at **A B C D**, with the top seen, like the cube in the last Lesson, and with that figure placed on the right of it. The instructions contained in the three previous Lessons should be sufficient to enable you to execute this; but it may be important to show you that it can be obtained by another method.

Draw the base line **B G**, divide it equally at the point **D**, set up the perpendicular **L B** equal to **B D**, erect two more perpendiculars **K D** and **M G** of the same height, then draw the line **L K M**; and you will have a figure of the same proportions as **B E G H** in Lesson 9. Next draw **A L**, equal to **L B**, and **C K** equal to **A L**; then draw **A C**, and the whole of the front of the figure will be obtained: Proceed to draw the top **A E F C** according to the instructions given to you in the last Lesson, and the top of the square **K I H M** by what you have learned from Lesson 11, in the production there of the figure **A O N C**. In this way you are called upon to apply your instructions variously, until they become as familiar and as easy to you as the mere act of holding the pencil.

And now observe, that the top of the parallelogram **A E F C** and **K I H M** are in nature equal squares; but the latter, because of its being more below the eye than the other, appears wider: Horizontal lines, which are always parallel to each other in nature, often appear to converge, or to get nearer as they recede. You here enter upon a very important portion of your study, and you should therefore commit to memory, and thoroughly understand, the following sentence.

If two objects, of equal size, be placed so that one be nearer to the spectator than the other, that which is farthest must appear to be the least, and *vice versa*. So, also, if the object be divided into equal parts, like a door by panels; if to any person viewing it, one panel be farther off than another, it will appear less; and that appearance of the diminished size of an object is always in proportion to its distance from the spectator.

* Or, more correctly speaking, a parallelopiped; but I avoid this word for the sake of using what the pupil may find more simple.

LESSON 14.

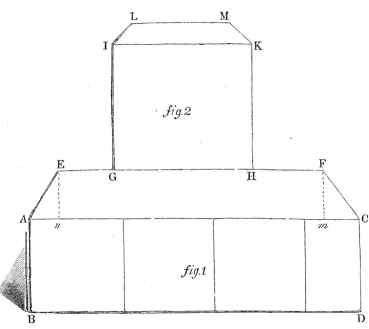

In this Lesson are combined two oblong solid figures, one lying on its long side, and the other behind it, standing on end. The figure in front is just as a book would appear to your eye if placed on a table with its back towards you, supposing the ribs of the binding to be represented by the upright lines between A B and C D, and to prove to you that, however dry these and other elementary Lessons may appear, the application of this Lesson is here shown, and a book is here drawn, which has the exact form of the figure you have studied. Thus you see, in the Lessons put before you, are contained the essential means which you may eventually apply in numberless instances for yourself.

Draw the parallelogram A B C D, and measure its proportions by squares, here shown by the perpendiculars equal and parallel to A B and C D, which proves that the figure is three and a half times as long as it is broad.

A E F C shows you a figure like the top of the cube in the preceding Lesson, and this may be drawn equally accurate by another mode.

Fix the place of n, on the line A C, at its proper distance from A, and m also, on the same line, at the required distance from C; you will observe that these distances, A n and m C, are not equal. From n and m draw equal upright lines, whose height may be judged of by comparison with A B—they are about half its height; this done draw A E, E F, and F C, and the figure will be complete.

The figure behind is nearly a repetition of Lesson 12, which you must proceed with according to the instructions there given, and after you have decided on the place of the perpendiculars, I G and K H; this you must do by first finding the distance of G from E, and H from F; you must notice, also, that they are not equal.

LESSON 15.

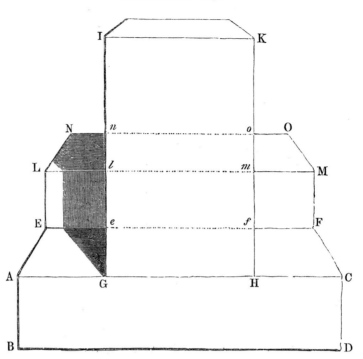

THIS Lesson is composed of two parallelograms, like Fig. 1 of the preceding Lesson; but of different proportions, and placed one above the other, like steps when viewed in front. Fig. 2 in the last Lesson is also brought forward, and placed on the front step. Draw the step **A B C D E F** according to the instructions for Fig 1 in your last Lesson. You will see that no upright lines are now given to aid you in judging how much longer **A C** is than **A B**: this you must do for yourself.

No perpendiculars are given, by which you may decide on the distance of **E F** from **A C**, or the exact slope of the lines **A E** and **F C**. These you should be able to supply from the knowledge you have already acquired.

Be sure that this lower step, when done, is correct. Whilst drawing it and the one above, pay no attention to the upright object on the steps, but draw all the horizontal lines of the steps through, as you see they are drawn in the example.

Next draw the uprights **L E** and **M F**, comparing them with **A B** and **C D**. Proceed with this upper step as with the lower. When done, the top of this, **L N O M**, must be compared with the top of the lower one, **A E F G**, to see that it is narrower. Observe also that the lines **N O, L M, E F, A C**, and **B D**, be perfectly parallel; that **L N** and **A E** slope alike or nearly, and also **O M** and **F C**; and that the parallelogram **L E M F** be of the same proportion as **A B C D**, but smaller, on account of its distance. If after thus examining the lines and proportions of the various parts, by comparing them with each other, you are satisfied that the two steps are right, proceed to draw the upright and oblong figure **I G H K** according to the instructions given for **A B C D** in Lesson 13, the place of **G** and **H** being first found as in the last Lesson. This done, rub out the lines *n o, l m,* and *e f.*

LESSON 16.

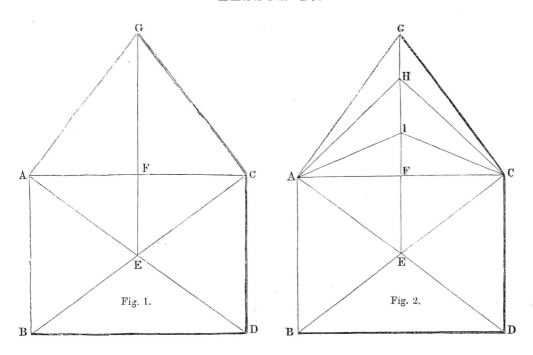

Fig. 1. Fig. 2.

THE form given in this Lesson is the gable of a house, composed of two sloping lines, meeting in a point at **G**—such forms, flatter or steeper, are common to Greek temples, to Gothic buildings, and to humble dwellings.

Draw the figure **A B C D**, then the diagonals* **A D** and **B C**. Where they cross at **E**, set up the perpendicular **G F E**, taking care that the distance from **F G** be equal to **A B**; having thus found the point **G**, draw the oblique lines **G A** and **G C**. You must remember that the object in drawing the diagonals **A D** and **B C** has been to ascertain the point exactly in the middle of the figure **A B C D**, and to show you how to find the point from whence a perpendicular would divide the whole figure exactly in half, and from which, when extended upwards, lines, whether drawn from the point **G**, or from any other points, such as **H** and **I** in Fig. 2, would make the sides of the gable equal.

You should practise this Lesson by drawing **A B C D** of different proportions to those here given. To these add other gables, like **H** and **I**, of different proportions, and flatter than the first, taking care to observe the proportions which **H F** and **I F** may bear to **A B**. In the example which I have here given, you will see all these gables are erected on the same base, thus forming one figure; but you must separate them, and draw three figures. Do the same with the next following five Lessons, in which you will learn how right lines and angles are used as a means for ascertaining the *exact* curvature of curved lines. They are the *only* standard for judging of degrees of curvature, especially when the degree of curvature is small.

* Diagonal, a line drawn from opposite angles.

LESSON 17. LESSON 18.

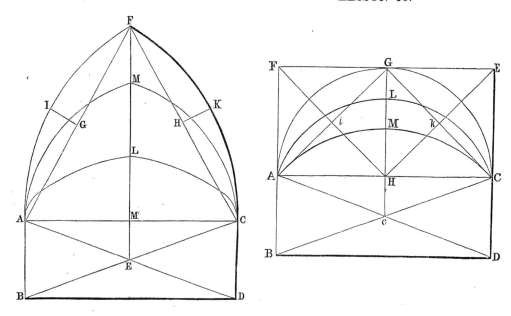

LESSON 17.

To draw a Gothic arch as seen in front:—Draw **A B C D** of the proportions given. Where the Diagonals cross at **E**, set up the perpendicular **E F** equal to **A C**, and having fixed the point **F**, draw the oblique lines **A F** and **F C**—thus far you have a gable like as in your last Lesson, but of different proportions. Divide **A F** at **G**, and **F C** at **H**, equally, by two short lines at right angles with them; the framework is thus prepared for drawing the curves, first drawing **F I A**, and then **F K C**. When these are done they must be carefully examined, to see that you have made the two curves to correspond exactly with each other. This Lesson you should practise on a larger and on a smaller scale, and draw the three kinds of arches here represented by **A M C** and **A L C** separately.

LESSON 18.

To draw a circular arch as seen when standing immediately in front of it :—Proceed with **A B C D**, the diagonals, and the upright line from **E** as in the preceding Lessons. Extend the perpendiculars **A B** and **C D** to **F** and **E**, and let these two uprights be equal to **A H**; then draw **F E** and **G H**, and the diagonals **A G**, **F H**, **H E**, and **G C**; then draw the curves from **G** to **A** and from **G** to **C**, which must cross the diagonals **F H**, and **H E**, so as to be nearly in the middle between **F** *i* and *k* **E**.

When drawing the curves **A L C** and **A M C**, each to the same base, and to a framework prepared as described for the first arch **A G C**; you will find the diagonals **F H, A G, H E**, and **G C**, and the perpendicular, **G H**, will aid you; as, by observing where these arches cross the diagonals, you will be able easily to draw them, and if not with great, yet with sufficient accuracy.

Practise this Lesson also on a larger and smaller scale.

LESSON 19.

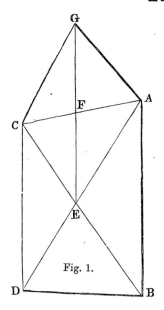

Fig. 1.

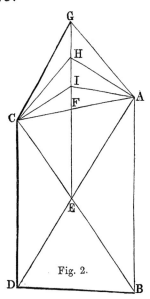

Fig. 2.

To draw a parallelogram as **A B C D** when seen obliquely.

Before we proceed to this Lesson, I must here repeat to you what has been said in Lesson 13, that when lines, which in nature are actually horizontal, as **C A** and **B D** are, if they be so placed that we view them with one end nearer to us than another, as **C A** and **B D** are here viewed, then, instead of appearing horizontal, as they really are, they generally appear oblique, as here represented, and never so long as they really are.

This Lesson you should draw to a larger scale than is here given.

Draw **A B**, then **B D**, indefinitely, first placing a horizontal line—as in Lesson 6, although it is not here given—which shall touch **B**, so that the exact slope of the line **D B**, may be obtained, unless your eye be now accurate enough to judge without it.

When fixing the point **D** for the length of **D B**, remember that, from being seen obliquely, with the end **B** nearer than **D**, it appears foreshortened, or shorter than **A B**, although it is really, in nature, of the same length.

Fix on the point **C**. Before you can do this accurately, there are two things which you must bear in mind—first, it must be perpendicularly over **D** ; next, it must be lower down than **A**, so that **C D** shall be shorter than **A B**, because of its distance, and so that **C A** shall be an oblique line, because it is seen obliquely. All this you must foresee, and judge of beforehand. When this is done, draw the lines **C D** and **C A**.

Proceed with the diagonals, as in the three Lessons immediately preceding this ; draw **G F** equal to **F E**, and then the lines **G C** and **G A**, which will complete the gable. Draw the gables, **H** and **I**, of their different proportions, as shown in Fig. 2, separately, and on a larger scale.

To make this Lesson the more intelligible to you, I have here given a drawing of a house of the same form as **A B C D** of your Lesson, but reversed, of which the parapet and the base are, as you would know, perfectly horizontal and parallel; so also are the tops and bases of the windows and door, yet none of them are so represented in the drawing, and thus you have an illustration and an application of what you have been taught in this and the foregoing Lessons.

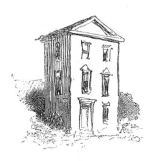

LESSON 20.

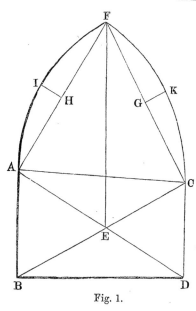

Fig. 1.

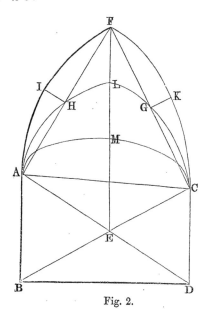

Fig. 2.

It is most important for you to remember well the observations already made in the previous Lessons; your future success depends on it. Otherwise do not attempt any subsequent Lesson,—it will not advance you a step. Assuming, however, that you have thoroughly understood and remember them, I need not repeat them here. Draw **A B C D**. From **E** set up a perpendicular of any height to **F**, draw **F A** and **F C**, divide them equally at **H** and **G**, and then draw the small lines proceeding from those letters at right angles with **F A** and **F C**; these regulate the curvature of **F I A** and **F K C**; but while doing so it should be remembered that as **G K** is farther off than **I H**, it must, therefore, be shorter; this attended to, the curved lines of the arch **F I A** and **F K C** may be drawn, and they will be true.

This Lesson you should practise by sloping the line **A C** more than here, and by placing **F** higher and lower, as at **L** and **M** in Fig. 2. Gothic arches differ according to the date of the buildings in which they are found, and have their points at various heights above their springings, which the points **A C** are called.

Proceed to draw, by the same means, arches of different proportions and separately, as shown in Fig. 2, by **A L C** and **A M C**.

LESSON 21.

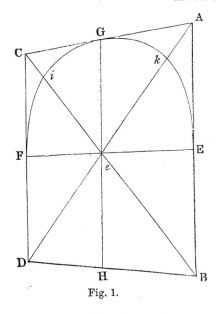

Fig. 1.

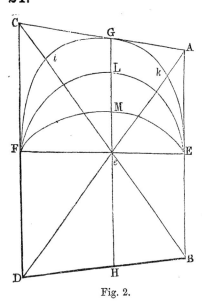

Fig. 2.

To draw a semicircular arch, when seen obliquely :—

Draw **A B C D** according to the instructions which have already been given. The line **G H** is drawn through the point *e*, and represents a line in nature which would be found exactly in the middle of the figure **A B C D**, thus dividing it in halves, which you will see here are not equal; because as one-half, **D C G H**, is farther off than **H G A B**, it is therefore drawn smaller because it is seen smaller, and the exact place of the line **G H** being found by the diagonals, you show the distant half of the figure to be less than the nearer half, in exact proportion to its distance. The circular line of the arch may now be drawn, first from **G** to **F**, and then from **G** to **E**, observing while doing so that the point *i* is less distant from **C** than *k* is from **A**, because the space **C** *i* is more distant than *k* **A**.

What you have to accomplish in this and the last Lesson is, to make the sides of the semicircular arch, and also of the Gothic one, appear as if they had equal and like curvature and length, such as they would have in nature, although here in the drawing they differ in all these respects, especially the more distant side of the arch. This difference becomes more marked in proportion as the lines **A C** and **F E**, on which the arches are formed, slope more, or are shorter. You will see what is here intended by reference to Fig 2.

Draw now, by the same means, the semicircular arch as it is represented in Fig. 2, where you see it is turned in an opposite direction to Fig. 1, and draw separately the arches **F L E** and **F M E**, which are not semicircular, but smaller portions of a circle, and whilst drawing these curves, observe where they cross the diagonals **C** *e* and *e* **A**.

LESSON 22.

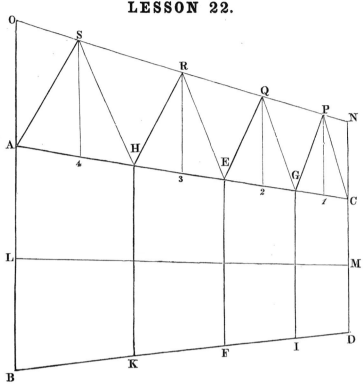

You will find this and the following Lesson are the three preceding Lessons amplified, and teach you how to divide any given rectangular figure, when it is seen obliquely, as **A B C D**, into several parts, each smaller than the other, and in proportion to their increased distance from you, so that they shall appear as if representing parts in nature which are of equal magnitude. These two Lessons may appear to you to be intricate, and therefore formidable; but you will find them far less so in practice, if you *have well learned* the previous Lessons contained in this Number, and follow strictly the instructions here given.

Draw **A B C D**, divide the lines **A B** and **C D** equally, and mark the division by points, from which draw **L M**. Let **A O** equal **A L**, and **N C** equal **C M**, then draw **O N**. The figure **A B C D** must now be divided. First fix on the line **E F**, taking care that it is nearer to **A B** than to **C D**, so that the farthest half of the entire subject may be the least. When this is done, divide each half by **H K** and **G I** with the like considerations, so that each division may be gradually less and less, according to its distance : it is so far right.

Divide now the four spaces 4 3 2 1, as marked on the line **A C**, so that 4 shall be nearer to **H** than to **A**, because that half is farther from you ; and so on with 3 2 1. This done, set up the perpendicular lines from them until they touch **O N** severally at **S R Q P**, and then draw lines from each of these points to **A H E G** and **C**, and you will obtain the four gables.

You will find this a simple method, and you should practise it until you can do it with tolerable accuracy. But before you can do it strictly correct, you must go through the next figure, where you will learn means for executing it with mathematical precision. You need not be alarmed at its apparent complexity ; it is far more simple than you anticipate.

LESSON 23.

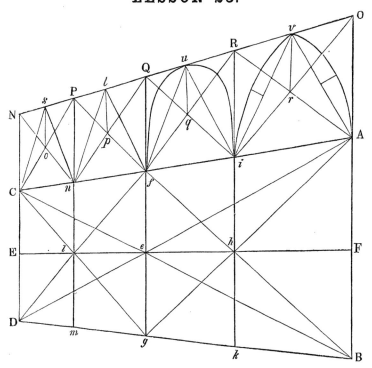

To execute this Lesson neatly, you must use a flat ruler, in order to draw all the straight lines perfectly, and have a pair of compasses to measure accurately. Draw, as usual, the figure **A B C D**, and the diagonals **C B**, and **A D**, through where they cross at *e ;* draw the perpendicular *g f.* Next draw the diagonals **A** *g*, and *f* **B**, where they cross at *h ;* draw another perpendicular *i k*, then the diagonals **C** *g*, and **D** *f*, where these cross at *l*, draw the perpendicular *m n ;* and lastly the line **E F**, through the points *l e h.*

By these means you will divide the figure **A B C D**, by the perpendiculars, into four portions, so that each portion will be less in *exact* proportion to its distance.

Rub out now all the diagonals, taking great care to preserve the perpendiculars. Measure off **O A**, equal to **A F**, and **N C**, equal to **C E**; draw **N O**, and extend the other three perpendiculars until they touch **N O** at **P Q R**. Next draw diagonals from **N P Q R** and **O**, to **C** *n f i*, and **A**.

To draw a Gothic arch in the first and right hand division, it is only necessary to set up a line from *r* to *v*, and proceed as directed in Lesson 20 ; and to draw a semicircular arch in the next division to the left, draw the line from *q* to *u*, and proceed as directed in Lesson 21.

What you have now done with rigid accuracy, you should compare with your attempt to draw Lesson 22, which you did by the eye alone, and the necessity for your knowing how to produce it by these more accurate means will be manifest. This figure requires to be very neatly drawn, and when you have drawn it as here directed, you should try it first without the ruler and compasses, and lastly from memory. In any case, it will be better to draw this Lesson to a larger scale.

CONCLUDING OBSERVATIONS.

IN this, the first Number of the LESSONS ON ART, I have set before you the means for accomplishing every Lesson in the succeeding Numbers. With these you should be perfectly familiar, and able to execute them with neatness and certainty, before you enter on those contained in the second and following Numbers; which, but for this preparation, would be hardly, if at all, intelligible, and certainly not practicable; nay more, if these, the first steps in Art, be not accomplished, you had better lay aside the pencil altogether, rather than waste your precious time on vain efforts. If, on the contrary, you will listen to the voice of experience, adhere to these instructions, and place them so well on the memory, that you can execute one and all readily and neatly, the future Lessons will be more than half learned; and however those may appear to you to be more difficult and complicated, you will find that, possessed of the information derived from the study of this Number, both the difficulties and complexities will be easily mastered; for you must understand, that the attainments presented in this and the future Numbers, have not the narrow intention of entertaining you for the present moment, but are intended as necessary steps to the pleasures and wants of your future years.

It is the more necessary to enforce these observations, and to impress them on your mind, from the general tendency of youth to be caught by what is attractive to the eye, and to escape the intervening steps to a coveted conclusion. If the later Numbers of the Lessons should be found to possess those charms so constantly and so eagerly sought, and you be tempted to disregard the progression which it may be fairly said would assure the acquisition of the power to imitate them, and to draw the like from nature, for yourself, you may rest assured that you yearn for what you never will attain but by such discipline. Of this truth, if you be not now persuaded, conviction will be brought home to you by the certain success of others, who have been content to climb the ladder of knowledge by the successive rounds from its base. Conviction will then, as in all similar cases, come too late.

I am quite aware that these are not likely to be palatable truths, such is the constant demand to attain power in Art by what is fancied to be a pleasanter if not a shorter road,—in fact, to arrive at colour. All this is the more to be regretted, because the attempt is, in rare instances, productive of anything beyond the most pitiable daubing, and the most profound ignorance; so entirely is it forgotten, or rather so little is it known, that a proper education in Art is to instruct the eye; to cultivate the powers of sight through the medium of observation and reflexion. Activity and exercise must be given to the reasoning powers; the force of truth sought, and the means to anticipated ends, which the mind can approve. The all-important mental training, whose value cannot be over-estimated, is sacrificed at the shrine of glitter, or vanity, in a fruitless attempt to acquire what is rarely productive of any one valuable result. Art thus erroneously commenced on false hopes, ends in—nothing.

To prove the truth of these observations, I would particularly recommend, nay I would urge, you immediately to attempt a copy of any Lesson in No. IV., because it contains such as are often given for *early* Lessons. This, however, you must do without reading one word of the text relating to it. Let this copy be preserved, in order that it may be compared with the same Lesson when you copy it a second time, after you have passed through the previous instructions. This will have more effect in convincing you of their necessity and importance, than anything I could say.

I have appended a series of questions, which you should be able to answer satisfactorily; you will then prove yourself to be in possession of the information I have desired to convey. A glance at their number and variety will show the amount of what you should have learned. You have done as yet nothing pretty to look at. You must judge of the progress your mind has made by the number of ideas gained; this is the true test of advancement,—aught else is visionary.

QUESTIONS FOR EXAMINATION.

These you must be able to answer without reference to your examples.

1. Explain the method of holding the pencil, and wherein it differs from the pen, and why.

2. For what reasons do you place a dot for the commencement and termination of a line before you attempt to draw it?

3. How do you proceed to correct any line which you may discover to be wrong?

4. What is parallelism?

5. Which of two lines should be first drawn? and why?

6. How should the arm be placed for drawing horizontal, oblique, or perpendicular lines?

7. How many kinds of angles are there?

8. What is a right angle? Draw it, and explain its properties?

9. What is an acute angle? and in what does it differ from a right angle?

10. What is an obtuse angle? Draw it, and explain in what respect it differs from the others?

11. By what means do you draw an acute angle equal to a given acute angle? or in other words, how do you copy it accurately?

12. How do you measure an obtuse angle? Prove more than one method.

13. What is a square? Draw it, and prove that what you have done is correct.

14. What is a parallelogram? and how do you ascertain its proportions?

15. What is a superfice?

16. What is a cube?

17. How is it the purpose of Art to represent objects? as they are, or as we see them?

18. When are lines said to converge?

19. What effect has distance on an object? and on the parts of an object?

20. When is a square said to be seen obliquely? and what form does it then assume?

21. How do right angles appear when seen obliquely?

22. Explain how parallelograms of different proportions are measured.

23. Show that you can divide any given parallelogram, however obliquely seen, into four parts, or if necessary into eight parts, exhibiting their gradual diminution as they recede from you. Do this first by the eye, and then by the rules for so doing, which you have learned. On each division construct gables or arches.

SECTION II.

PREPARATORY OBSERVATIONS.

THE Lessons in the first Section, with but few exceptions, treated of the superficies of objects, and these were always executed in outline. The Lessons in this Number will represent objects as solids, with their light and shade. The most correct outline always requires shade to convey to the mind a complete idea of the solidity of the object it represents; but the first great essential is always to obtain a correct outline, and to this your attention will be particularly called throughout " The Lessons."

In this Number, also, you will find the practical value of your earliest Lessons by witnessing their application.

I cannot too much urge your attention to drawing from memory almost every Lesson. This practice is attended by many advantages, too important to be overlooked. It at once shows you what you have actually gained from the study of each Lesson; and shows your master whether you have really learned each Lesson, or merely copied it mechanically. His examination, in addition, enables him to judge whether you should repeat the Lesson, or may be permitted to proceed.

Drawing from memory educates your mind to a correct preconception of the change in the forms, and in the combination of objects, according to the point of view from which you see them; and beyond all other kinds of practice it best cultivates in you the power to draw from nature.

It is a great object, also, that you should execute these Lessons neatly, making all the perpendicular and horizontal lines perfectly perpendicular and horizontal, and exactly parallel.

To accomplish this, you should at first use a straight and a triangular ruler, and afterwards, when you perfectly understand the mode and order of executing each Lesson, you should draw it by hand only, and lastly from memory.

In this Number, also, is given to you a more complete application of the last paragraph of Lesson 13, which will be an additional proof of its great importance.

As the shadow in all cases contributes powerfully to satisfy the eye, it is more than probable you may hurry over the outline in order to put in the shade, which you find so pleasing and effective. If so, you will indeed " give up the substance for the shadow." You must, however, remember that no shade can be effective on an incorrect outline, except to exhibit its defects more glaringly.

Drawing, and not shading, is the difficult acquirement. It is the form of a shadow, not the depth of its colour, which is of importance.

LESSON 24.

THE general remarks which you have at present to bear in mind regarding shade are,—

That it is produced by a repetition of lines either perpendicular, horizontal, or oblique; as shown in the Examples 1, 2, 3. These lines incline according to the inclination of the object whose shaded side is to be represented, subject to such modifications as varying circumstances may demand.

In all cases, shade, as seen in nature, whatever its depth, is of an *even* colour throughout; if it be found darker in one part than another, the increase in its depth is *gradual* from the lighter part—never sudden.

To produce this requisite evenness, the lines must be all of the same strength, and equally separate from each other, and the pencil must be held firmly in the hand. The distance of its point from the end of the fingers must be regulated by the depth of shade required, and should be greater or less, according as a lighter or darker shade is wanted, and should be produced from pencils having a broad point, and such as are made expressly with thick and broad lead.

Example 1 is done by perpendicular lines, which are plainly seen on the upper part, but they are not allowed to touch each other at their extremities.

Lean as equally as possible on each line, and separate them equally from each other; the whole mass of shade being thus done, though with great care, will not be perfectly even, the white and lighter spaces between the lines must afterwards be filled up by other perpendicular lines, and with a harder pencil. The shade may thus be made as even as you see it in the lower part of the example.

Example 2 is produced by a mass of sloping lines, as shown on the upper part, the light spaces being afterwards filled up, also by oblique lines, with a pencil having a finer point, until the whole of the shade becomes, like the lower part of this example, perfectly even. It is this perfect evenness which is the essential requisite.

Example 3 is produced by horizontal lines, the ends of which should not touch, or barely; but here they have been allowed to overlap, in order to show you that if by chance you should make such a mistake, the excess of colour thus produced you may nearly or quite remove by just touching the parts which are too dark with the point of a small piece of bread which has been rolled between the fingers into this form . By thus removing any parts too dark, and by filling in such as are too light, the shade may be made even.

Example 2.

Example 1.

Example 3.

Example 4.

Example 5.

Lesson 24.

P1. 1

As a general rule, such methods of shading as are here represented in Examples 1, 2, and 3, are employed on near objects, because, at the same time that the shade is made even, the lines assist to indicate the surface and the proximity of the object. But shade, such as may with more propriety be applied to distant objects, or in cases when it is desirable not to show any character, must then be done in the following manner, as seen in Example 4.

Take a soft pencil, and rub it on a piece of coarse paper, and charge a leather stump with the lead so obtained, with which produce the shade as here shown, by passing the stump backwards and forwards perpendicularly; then with a fine point to a harder pencil, fill up the light spaces as before. The stump must of course be charged with the lead in quantity according to the depth of shade required. When the shade is completed by filling up the light parts, it is always darker. It must, therefore, in the first instance, be laid in paler than is required, so as to allow for the additional depth obtained in making it even. The last—

Example 5, is done by the stump only when lightly charged with lead, and may be so managed as to procure evenness at once.

In attempting the various shades, besides attending to the instructions here given, you must bear in mind what is said in the first Lesson relative to the position of your arm.

LESSON 25.

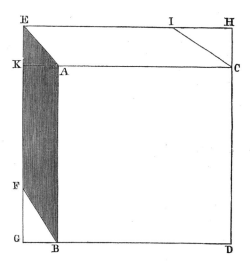

HITHERTO your study has been confined to the drawing of superfices, that is, of forms which have no breadth or thickness, and therefore have no shade.

You are now entering on the study of solids, and, consequently, will require the addition of shade to express solidity. Having passed through the various examples contained in your last Lesson, you should therefore be prepared to add the shade, properly, to all your future Lessons, whatever may be the direction of the lines by which they are produced. Remember they are always regulated by the nature of the surface under shade, whether it be perpendicular, horizontal, oblique, or curved.

Several of the following Lessons you will find illustrated by wood-cuts. In these, the shades are represented by narrower and more obvious lines, than could be easily produced from the chalk or pencil; but it is not necessary that you should imitate them. All you are required to do is to take notice of the depth of the shade, and the direction of the lines; and, above all, to make the shade even, which is the only characteristic of nature you can give to it, and this is indispensable on every occasion, and to every subject.

IN this Lesson you have the cube, with three of its surfaces, or sides, seen at one time; the side **A B C D** being represented by a perfect square, such as in Lesson 8. Here you will remark that only the side **A B C D** is seen a perfect square, with every angle

a right angle; the top and sides are each composed of two acute and two obtuse angles. Take a cube from the box of models, and set it before you till you see it of this form. The top and side, as here drawn, represent two figures, which in nature are actually square.

When you thus see them you are said to view them obliquely, that is, with one portion more distant than another. This figure may be very easily drawn thus:— Draw **A B C D**, extending **D B** to the left, and **D C** upwards, both indefinitely. Fix on the point **G**, at its required distance from **B**; then on the point **H**, at its required height above **C**; and lastly on **E**, observing that it must be horizontally level with **H**, and perpendicularly over **G**; then draw the lines **E H** and **E G** parallel with **A C** and **A B**. Fix on the point **I** and draw **I C**; then on **F**, and draw **F B**, and **E A**, and the figure will be complete.

You have just read, that when you view surfaces so that you do not see their true form, you view them obliquely. They are also said to be foreshortened; but this term is more generally applied to lines such as **I C**, **E A**, and **F B**; or to objects so seen that one end of them, as **C**, **A**, and **B**, is nearer to you than any other part; when so seen, they are never seen of their true length.

At the bottom of the page you have this object reversed, for the sake of applying your instructions to another view of it.

This, and the following two Lessons, you should first accomplish by the use of the *rulers*, that you may do them *exactly*, and afterwards by your eye, without the auxiliary lines, and of different proportions. This Lesson you may do by making a square on any line longer or shorter than **B D**, all other lines and spaces being in proportion.

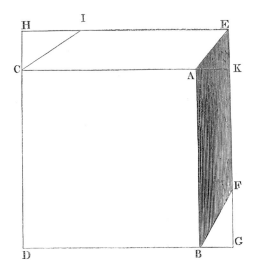

LESSON 26

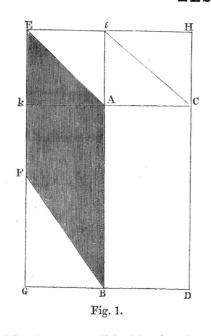

Fig. 1.

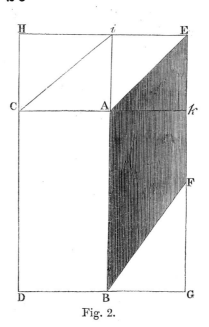

Fig. 2.

MAY be accomplished by drawing the figure **E G H D,** looking well to its proportions; then *i* **B** and *k* **C.** Having found the exact places of these in relation to the other lines which have already formed **A B C D,** draw the slanting lines **E A, F B,** and *i* **C,** and the figure will be complete. Draw it both ways, as here given, and at the same time place the model before you.

LESSON 27

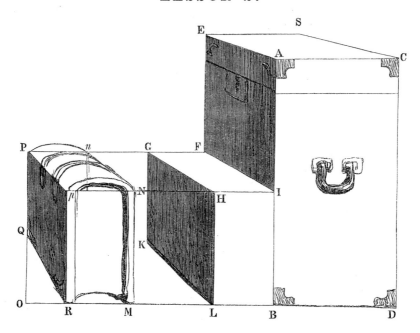

Is a combination of the last Lesson, with a solid oblong, viewed like the cube in Lesson 25.

Draw **A B C D**. Extend **D B** on the left to **O**. Find the places of **R, M,** and **L,** then find the place of **I** on **A B**, and the place of p perpendicularly over **R**, and draw the line p **I** parallel to the base line. Draw now the top of the box **A E S C,** by the method shown in Lesson 25, and make **E F** shorter than **A I**, because of its being more distant, and draw **F I**. Now draw the perpendiculars p **R, N M,** and **H L**. Find now the point **P** over **O**, and level with **F**, and draw the lines **P F,** and **P O,** and **P** p. Find now the places of n and **G**, and place n from **P** at a less distance than **N** from p, because that end of the book is more distant, and for the same reason **G** must be less distant from **F** than **H** is from **I**. Having made these comparisons, draw n **N** and **G H**. Find now the point **Q**, on **O P**, and, parallel to it, the point **K** under **G**, so that **G K** and **P Q** may be equal; draw **G H, Q R,** and **K L,** when the whole subject will be complete.

You must now examine what you have done, in order, first, to ascertain whether the figures **R** p **N M,** and **H L I B,** are like each other, and of the proper proportions, and if the points n and **G** and **E S** are in their right places; so that **P** p, n **N, G H, F I, E A,** and **S C,** have their true inclination in relation to each other, that is, that each line to the right of **P** p, as n **N, G H,** and **F I,** slope gradually more and more as they are more distant from it—that **Q R** is longer and slopes more than **P** p, because it is more below the eye, and that **K L** slopes more than **G H,** for the same reason. Compare the lines **E A** and **S C** with each other, and see that they slope less than any, because they are higher up and more nearly level with the eye. When you have performed these Lessons without the aid of auxiliary lines, then you should set up the models, or if you do not possess them, set up a book or a box in like positions, and try to draw them; you will be thus drawing from nature.

It is in this way, by going to nature, that you test your acquirements. Each step you take, you prove; and thus discover whether you have really learned your Lesson, or merely gone through it mechanically. Your ability to draw from nature such objects as you have studied in your Lessons, is a proof that you have gained real and the requisite knowledge.

LESSON 28.

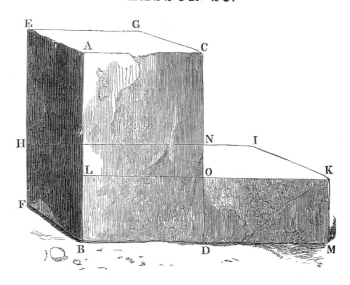

In this Lesson you have, in the upright stone, a figure similar in form to the chest in your last Lesson. This must be first drawn. To ascertain the slope of the lines **F B**, **H L, E A, G C**, and **I K**, you must apply the means you have been taught in previous Lessons, which you ought now to be perfectly familiar with, and capable of applying readily, so as to obtain the exact obliquity of these, or of any other lines, with unerring certainty.

Having drawn the first stone correctly, you proceed to draw the other lying by its side, observing that **D M** is as long as **B D**, and that **O D** is one-third the height of **C D**, and that **N O** is half the height of **O D**. You must judge the length of **N I** by that of **O K**. These instructions should be sufficient for you.

I would have you, however, examine the example given you, when you will see either that it may be interpreted as consisting of two stones, one upright and another lying by its side on the right; or as composed of one long flat stone, and another, a cube, placed upon it to the left. You should now endeavour to accomplish it, by first drawing the long flat stone, and then placing the other upon it, taking care that whilst drawing the lines **E H, A L**, and **C A**, you observe their proportion to **H F, L B**, and **O D.**

In executing this Lesson, by either method described, you will observe that you are required to notice the proportions of one object with another, hence it matters not what size you adopt, and you should draw the example by the two different methods, that you may show yourself capable of arriving at the same results by either; like working an arithmetical question by two different methods. For this, and the two following Lessons, you should set up your models.

LESSON 29.

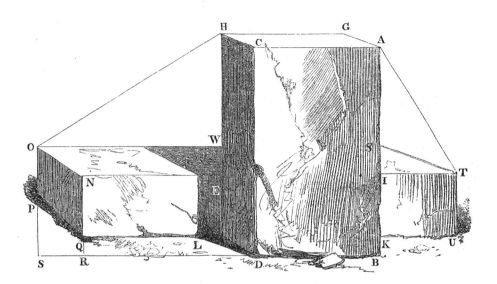

In this Lesson you see in front a stone, **A B C D,** represented like the chest in Lesson 28, and another lying behind it. Draw this front stone, and when this is correctly done, draw the base line **B D** on to **R,** then **Q L** parallel to it. A perpendicular from **R** will decide the place of **Q.** Then fix on **S,** and take a perpendicular from this to **P,** observing the difference of the length of the line **P S** as compared with **Q R;** next draw **P Q,** and **N Q,** which is longer than **Q R;** then **O P,** which must be shorter than **N Q** because of its distance; then draw **O N.** If this last line slope more than **P Q,** so as to leave **O P** longer than **N Q,** it is wrong; draw a line from **N** parallel to **L Q,** and then **O W** parallel to that. On the right of the upright stone is seen a portion of the stone behind, of which you have already drawn the greater part. Observe that you make **I T** level with **N E,** and **K U** with **Q L;** then fix on **S,** which should not be quite as high as **W,** and draw the line **S T,** when the whole will be complete. The lines **A T** and **O H** are auxiliary lines, by the inclination of which the length of the stone behind may be determined, as well as by comparison with the one in front,—in fact by the operation of the principles of Lessons 6, 7, 8, 9. It remains now to be completed by the shading.

In doing this, you must observe that all the perpendicular edges are made irregular, and also that the lines on the perpendicular surfaces have various inclinations, in order to characterize the irregularity of those surfaces. The unevenness of the ground also must be noticed, which adds to the irregularity of the base lines of both the stones lying on it. These observations equally apply to the following Lesson.

LESSON 30.

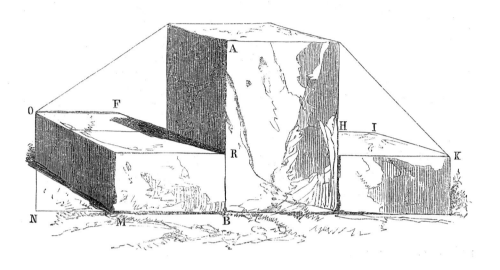

WHICH is composed of three stones of different forms and sizes. The one to the left should be first drawn. When this is accurately done, by the aid of the auxiliary lines and the right angles **F O N,** and **O M N,** the height of **A R** may be obtained by comparison with **R B,** and from this the whole of this stone may be completed, if you employ the instruction you have derived from previous Lessons. You will see that the third and right-hand stone is, in front, as high as the left, and that its base line is of the same length. The place of the top, and distant line, **H I,** may be obtained by comparison with **O F;** its length, and that of **I K,** may be obtained by the means with which you are, or ought to be, already well acquainted. It is in order to test your acquirement of the preceding Lessons that this has been given to you.

LESSON 31.

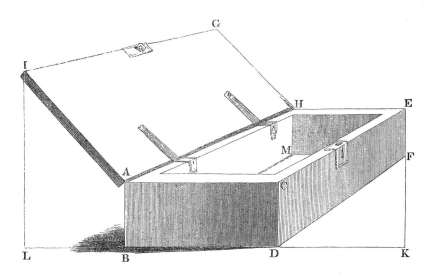

THIS figure, which is said to be seen foreshortened, is more complicated than the preceding, and will serve to show you the importance of the previous instructions. Draw the base line **L K**, fix **B** at its required distance from **L**. Fix on the point **D** at its required distance from **K**, and draw **A B C D**, then set up the perpendiculars from **L** to **I**, and from **K** to **F**, and then draw **D F** and **I A**; decide on the height of **E F**, which, because it is more distant, must be shorter than **C D**; draw **E C**; find the length of **H E**, which must be shorter than **A C**, again, because of its distance; draw **H A**, then **H M** equal to **E F**; draw the inner line all round for the thickness of the box, and thin lines from **M** to **B** and **M F**, until they touch the inner line. The lid must now be drawn. If **I** has been rightly fixed on, the slanting line **I A** should be as long as **A C**; this being correctly done, the point **G** must be fixed, so that a line from it to **H**, shall be nearly parallel to **I A**, as long as **H E**, and so that **I G** may be shorter than **A H**; this done, draw **I G** and **H E**, and the box will be complete. It must now be shaded.

Put a box before you in a similar and also in a reversed position, that is, so that the lid may open to the right, and draw from it. You should also take one of different proportions. The instructions you have received apply to all; and it is the application of your instructions, not the mere recollection of them, which is the great end you should have in view.

LESSON 32

Is very like Figs. **D C A B** of Lesson 19, with this difference, that it is made to appear hollow, like the framework of a doorway with a step.

Draw **A B C D**; reference to the lines from *m* will indicate to you that the lines **C E, E F**, and **D F**, are to be obtained by means already amply shown; then draw the inner lines parallel to **C D E F**, to show the thickness of the door-frame, and then the upright line *n o*; from *n* draw a line towards the corner **E**, and quite horizontal; then from *o* another small line for the bottom of the opening parallel to it. Extend **B D** to **I**, and complete the step by the instructions contained in the preceding Lessons, supplying auxiliary lines if you should require them.

LESSON 33.

This Lesson exhibits to you a doorway as it is seen when you approach it with the intention of entering, and you must observe, before attempting to draw it, that more is seen of the ceiling than of the floor, and more of the right than of the left side. Draw **A B C D**; find the position of the points *i* and *k*, and draw *i k* parallel to **A C**; find the positions of *l* and *m*, draw *l m* also horizontal; now find the points **E** and **F** on *i k*, and immediately under them **G** and **H** on *l m*, then draw **E G**, and **F H**, which must be perpendicular. The step in front must be done according to Fig. **1**, in Lesson 14, taking care to observe that **B N** and **D O**, are extensions of **G B** and **H D**, and must slope like them. You must now notice that **E G F H**, which is the further end of the doorway, is smaller than **A B C D**, because of its distance, but that it is a figure of exactly the same proportions. It now remains for you to draw the arch in the centre, and to place the stones round **A B C D**.

Over doorways it is common to put one single stone, as **A C**, in order to support the weight of the building above it, and down each side there are at the angles irregular stones, narrow or wide, long or short, and this must be carefully noticed, as well as the varied emphasis given to the lines which mark them. Repeat this Lesson from memory, smaller and larger.

LESSON 34.

This, as you will see, is a representation of the interior of an apartment, having on the right-hand side the opening of a doorway like **C D E F** in Lesson 32, and another doorway in the furthest wall. The instructions given in the two previous Lessons and

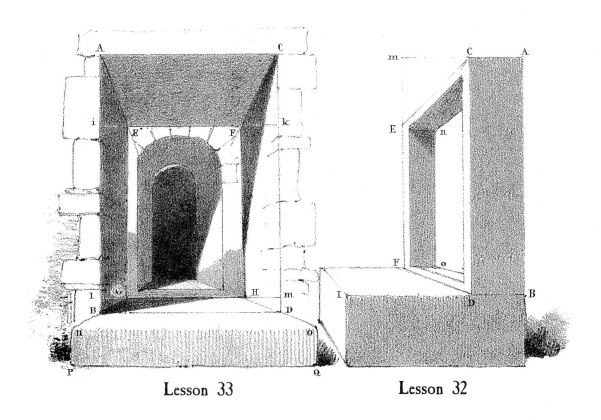

Lesson 33 Lesson 32

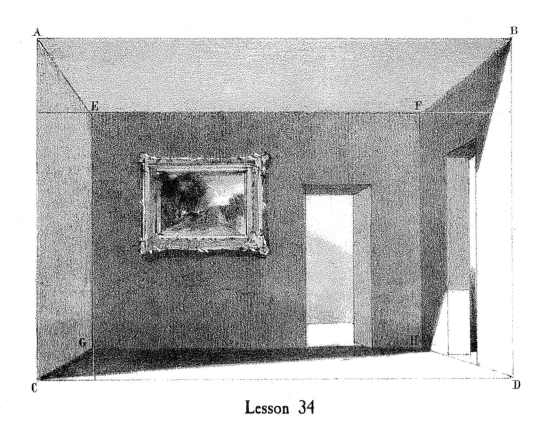

Lesson 34

Pl. 2

the observations made on them, apply equally to this. The last Lesson showed you a parallelogram based on its end; but this is on its side, and if you are able to draw this Lesson correctly, it will prove that you have completely learned and understood the preceding one. In shading the Lessons 33 and 34, take care to observe the direction of the lines, and the relative strength of the shades, and that you do them in accordance with the instructions given to you in Lesson 24, and also that their edges be well defined.

You will recollect what has been observed in Lesson 13, and also the frequent remarks which have been made to you about objects being drawn smaller on account of their distance. In this Lesson, **E F G H** is smaller than **A B C D**; and this shows the width of the apartment, for, were the further end less than it is here drawn, the room would appear longer, because the further end, by being less, would necessarily appear more distant.

LESSON 35.

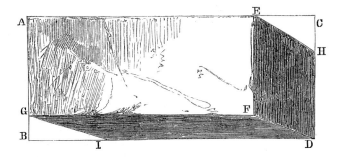

THIS Lesson is intended to show you how to draw a right-angled solid when it is *above* your eye, and you see the under surface. The lines of the retreating sides, and of the underneath parts, now slope downwards, while those of the tops of the Lessons from 25 to 31, and their retreating sides, appear to incline upwards, because they are *below* the eye.

You may either draw first **A G E F**, and then **G B, B D, E C**, and **C D**, and afterwards the other lines composing this object; or **A B C D** may be drawn first, and the points **E H G I** may be decided afterwards, from which the figure will be completed.

LESSON 36.

THIS consists of two solids nearly square, placed side by side, and connected by means of the roofs which form them into a building.

You should now be able to draw the solid objects without reference to the previous Lessons, observing always to follow the prescribed order for drawing the lines, beginning always with the nearest angle. When these solids are done, set up the gable, observing that **D E**, and **E I**, project over the angles of the building; next find the point **F**, and make **F C** shorter than **D E**, because of its distance, and **F D** nearly but not quite parallel to **C E**; the point **I** must project over the line **K L**. Find now the points **G** and **H**, and draw the line regardless of the chimney, and then take care that **A G** slopes rather more than **C E**. When this is done, draw the chimney, taking care to obtain the precise slope of the top by the line **F C**, and of the retreating side of it by comparison with **E I** and **D B**, and then shade.

LESSON 37.

THIS is a combination of Lesson 35, with modifications of preceding Lessons. Draw **A B**, **C D**, and **E F**. Divide **A C** equally, and set up the gable, taking care to observe the projection of the roof beyond the walls at **A C** and **E**.

Extend **A B** downwards to **G**, **C D** as low as **L**, and **E F** to **P**. Make **B H** and **K D** equal, and draw the perpendiculars **H I**, and **K M**. Draw now the arch from **H** to **K**. On the line **B H K D** you will find the upper line of the timber which crosses the opening or doorway, and by this you will ascertain the perpendicular line within, which describes the thickness of the wall. The outline is now complete. You must observe, that on the retreating or shaded sides, as the line **C E** is higher up, and more above the eye, than **D F**, its inclination downwards is therefore greater. This Lesson must now be shaded, and the broken character given to the outline everywhere, always taking especial care to bring the shading close to the outline in all cases. You will have remarked that whilst the shades generally are even, the darkest shades are of various degrees of depth, increasing in intensity gradually, as you see them in the innermost parts of the opening in this Lesson.

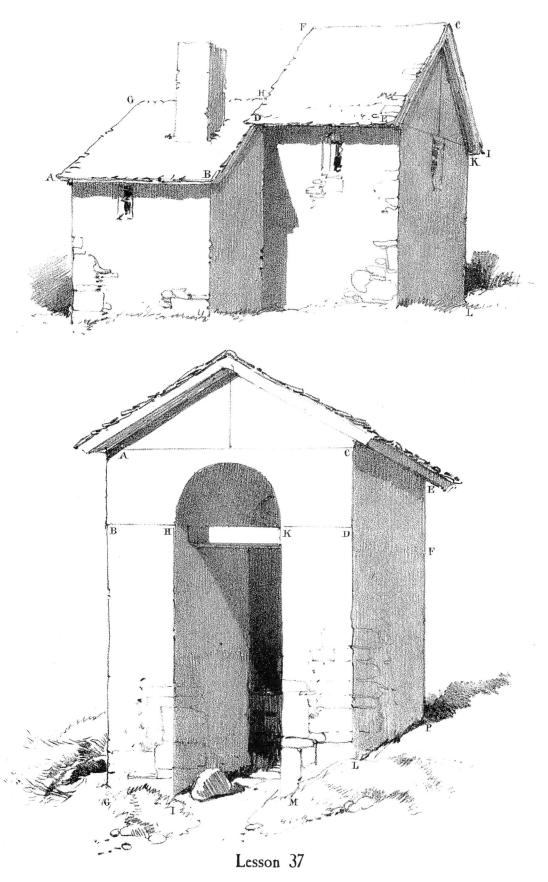

Pl. 3

Lesson 38

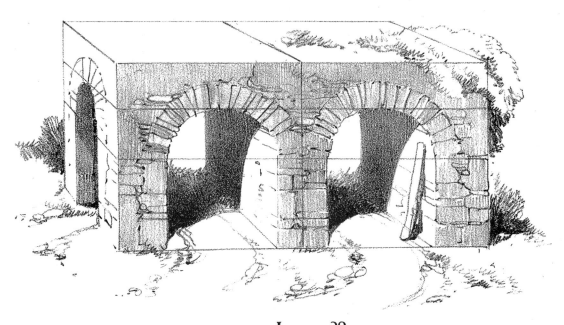

Lesson 39

Pl. 4

LESSON 38.

A GLANCE at the woodcut will show you that this Lesson is composed of two blocks, like the upright stone in Lesson 29, placed side by side, and that what was there a stone has, by the addition of a roof and other features, assumed the character of a building.

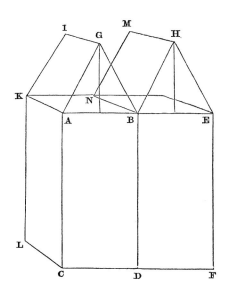

Draw **A B C D**, and complete the figure as in Lesson 32; then extend **A B** to **E**, making **B E** as long as **A B**; extend **C D** to **F**, and make **D F** as long as **C D**, and draw the perpendicular **E F**. Draw the gables **G** and **H** according to the instructions contained in Lesson 16, taking care to observe their proportions, and that they are of equal height. You must now fix on the point **I**, so that the line **I K** may slope like **G A**, but be shorter on account of its distance, and also, so that **I G** shall be shorter than **K A**. Having, with these considerations, fixed on the point **I**, draw the lines **I G** and **I K**.

In fixing on the point **M**, so as to draw **M N**, and **M H**, and thus complete the figure, you must remember that **M** must be placed exactly level with **I**, the line **M H** must also be longer than **I G**, as, in consequence of being more to the right, and therefore not so nearly opposite to the eye, it would not be seen so foreshortened as **I G**; and also, that **M N** must be parallel to **H B**. Having fixed on the place of **M**, draw **M H** and **M N**. If, when you have drawn these lines, you find the figure incorrect, you must pass in review the considerations I have enumerated, when you will find your error to have arisen from your neglect of some one or other of them.

When, by the aid of the wood-cut, you have perfectly understood how to draw the figure accurately, you must look to the lithographic drawing as your example, by following which, you may learn how to give to it the characteristics of a building.

You must observe that the lines are not, as in the wood-cut, uniform throughout their whole lengths. They must have expression and emphasis given to them in various breaks, and in differences of depth of colour according as the lines are on the light or shaded side of the object. Be careful to preserve the evenness, intensity, and variety of the shades, which on the object are done by perpendicular lines; the small pieces on either side of the building by slightly inclined lines.

This Lesson should be drawn from memory.

LESSON 39.

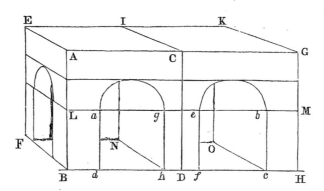

THIS Lesson is composed of two cubes, such as you have already drawn in Lesson 25. I presume, therefore, that you are in possession of the knowledge necessary for drawing the right-hand cube in this figure, and shall not repeat the instructions, because, if you still need them, you must return to that Lesson, and study it afresh.

Having drawn the left-hand cube accurately, draw the square **C D G H,** equal to **A B C D**; draw **I K** equal to **E I**, and then draw **K G.** Your figure will be right so far, if **I C** is longer than **E A,** and **K G** is longer than **I C.**

Place the point **L** exactly mid-way between **A** and **B,** and the point **M** in the like relation to **G H,** and draw the line **L M.** Draw now the small perpendiculars *a d, g h, e f,* and *b c*; taking care that **L** *a* **B** *d, h g e f,* and *b* **M** *c* **H,** are forms of equal magnitude and proportion. From the points *a g* and *e b,* set up semicircular arches, according to Lesson 21.

Draw now perpendiculars from the points **I** and **K** downwards, till the points **N** and **O** are exactly level with **F**; then draw the lines **N** *h* and **O** *c,* and the figure will be complete.

In preparing this, as well as the last figure, from the wood-cuts, all the lines should be, as in them, perfectly straight and formal, and when the figures are in this manner complete, the lines, if too dark, may be subdued with crumbs of bread before you add to them the character given in the lithographic example.

Be especially careful in this Lesson to observe the direction of the lines representing the stones which form the arches—the direction of the shadows—where they are darkest—their form; and the varied lines which characterize the ground.

LESSON 40.

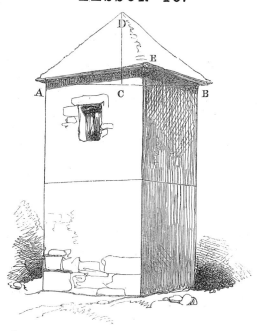

You will more easily and thoroughly understand this Lesson by setting up two cubes, one on the other, as they are here represented, so that the line where they separate shall be exactly level with your eye, and whilst you are reading your instructions refer to the model as well as to the Lesson.

In all the preceding Lessons of this Number, and in some of the early Lessons, one face of the object has always been shown as if it were opposite to you, and therefore it has been necessarily represented by perfectly horizontal and perpendicular lines.

In this and the two following Lessons, neither the upper nor the under surfaces of the cubes are exhibited, but the sides only, and both of these are represented as retiring.

All the figures in the preceding Lessons being right-angled, the sides opposite to you were represented by right angles; but the object represented on this page although composed in nature of right angles, yet, both the sides being turned away from you, every right angle appears to you either acute or obtuse, and therefore you see the upper and lower lines of both sides obliquely.

The object of importance is for you to ascertain the precise obliquity of the upper and lower lines, the length of the perpendiculars in proportion to their distance, and consequently the exact forms of the sides.

When any side of an object is seen to retire, that side is said to be seen in perspective; and when, as in this and the two following Lessons, both sides retire, then the whole object is said to be seen in perspective; and so of every object when its apparent form differs from its real.

The difficulty in art is to imitate the apparent form so accurately, that the mind may be conscious of what the real form is, and satisfied that it is truly portrayed.

A roof of the description here given should be drawn by taking a horizontal across from **A** to **B**, dividing it equally at **C**. From this set up a perpendicular, and having found the point **D**, draw from it lines to **A**, **E**, and **B**.

LESSON 41.

THE intention of this Lesson is to show a cottage, as you see it in perspective, and divided into three equal parts, so that these divisions shall be at unequal distances from you; and so to represent them as to account for their several distances, by drawing one less than another, at the same time leaving an impression on your own mind, and on the mind of other persons, that they are in nature of equal magnitude. Put three cubes together, and roofs on them till you have obtained the form of the cottage in this Lesson, when you will better understand it.

Draw the whole of the figure composed of the lines uniting the points **A B C D E** and **F**, observing the order pointed out in preceding Lessons. Then place **I**, so that **I A** shall be shorter than **I K**, and **I K** than **A B**; then divide **D C I K**, so that **G H** may be nearer to **C D** than to **I K**; these being done, draw the roof, beginning with the gable. Here will be seen the application of Lesson 19. Then find the point **M** by the directions for finding **C** in Lesson 38, and draw **M C** and **M L**. These two lines will be right, if **M L** be shorter than **C A**, and more sloping because it is higher up, and if **M C** slope more than **A L**.

When you have to complete any Lesson, like this, by broken lines, characteristic of the materials which compose the object of it, take care in the first instance, to draw the form of it in light lines, entirely without any character and with a rather hard pencil, never using this pencil for the shading. You ought by this time to be able to draw such lines as **C A** and **D B**, without a break; and **A E** and **F B** without auxiliary lines such as were shown to you in your early Lessons. What you then did actually, you should now do mentally.

LESSON 42.

IT is intended by this Lesson to show you the mode by which a stone or brick wall is constructed, and how to draw the courses of the stones or bricks, and also the inevitable inclination of these lines, showing these courses, when above or below the eye. The example is therefore given to you on a large scale.

Draw all the exterior lines straight and continuous, as you have hitherto done, without regarding the breaks, and begin with the line **A B**. Divide this by the compasses, or by the eye, into four equal parts, which will be most easily done by first dividing it into halves at h, and then again each half equally at g and i. Divide **E F** and **C D** also into four equal parts, in every case placing points where the small letters are placed in the drawing here given; join these points by lines. When this

Lesson 41

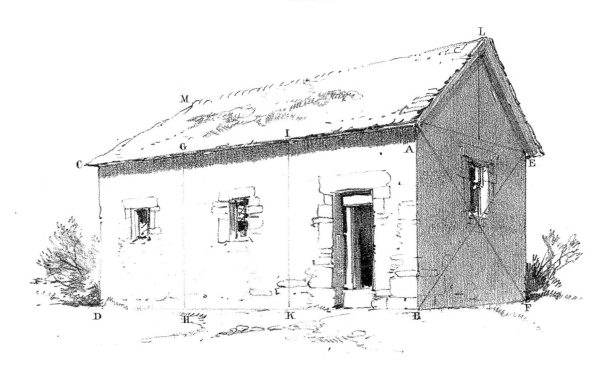

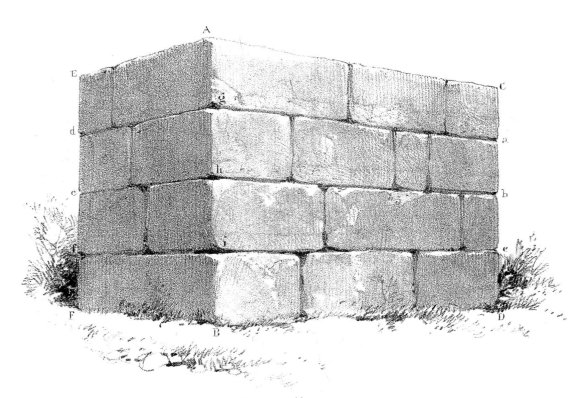

Lesson 42

Pl. 5

is done, you must stop to observe, that not only are the lines **C D** and **E F** shorter than **A B**, because they are more distant, but the divisions of them also ; and that the lines which unite them, and show the courses of the stones, appear nearer to each other as they become more distant, and, consequently, that the stones also appear less. All these lines likewise slope differently, one only on each side appears horizontal, *f i* and *i c ;* and this shows, that this particular division has been exactly level with the eye of the spectator, below which the lines representing the divisions, or courses of the stones, incline upwards, and above it, downwards.

In placing the upright divisions of the stones, take care not to place the division of one course immediately over the division of another. These divisions vary in their breadth and depth of colour : they thus represent the condition of the wall, when the humidity of the atmosphere has moistened the cement which originally bound the stones together, and when, in course of time, it has fallen away from the joints, and the corners of the stones have become more or less rounded. This may be seen on the outer angles **C D** and **E F**, but especially on the inner angle **A B**. All the varieties of colour, and the emphasis they give, you must especially mark, as well as the little breaks of light on the upper corner of the stones at *g h* and *i*.

You now see, that all these varieties of form and shade are not the results of caprice, but come from the knowledge of nature, and the effort to follow her ; and it is only by thus knowing her that you can ever be skilful yourself, or judge of another's skill. My object is, that you shall have a reason for every line you draw, and also to show you, that whatever you do without reason is worthless.

If, now, you look back to the Lessons you have already passed, and forward to those you have yet to study, you will find that the lines, however small, expressive of the stones or bricks on the surfaces, or the edges of the objects, have all been put on under guidance of the knowledge here conveyed ; thus every touch is accounted for.

You must take great care also with the delicate shading on the light side **B A C D**, observing the difference of its form on each stone. This is required to give the appearance of irregularity to the surface.

This is one of the most important Lessons you have as yet received, and should be well learned, as the stepping-stone to many which follow, and because reference will be frequently made to what you have here been taught.

ON THE STUDY OF CIRCULAR OBJECTS.

LESSON 43.

We come now to the study of circular objects. If you look down into a cup, or a wine glass, you then see the outer rim of either to be a perfect circle; but if you raise the glass, and hold it up perpendicularly before you, the rim no longer appears circular, but oval, and in appearance more and more narrow, according as you raise the glass higher and higher, until the rim is exactly level with your eye, when it appears a straight line. You should take a glass and prove this.

When your eye is immediately over the glass—that is, when the ray from your eye is perpendicular to the plane of the circle—you see the figure of its true form. When a tumbler stands on a table, its rim **A B** and its base **C D** are said to be circles on a horizontal plane,* and when your eye is immediately over their centre, it is said to be perpendicular to their planes, or at right angles with them, and thus you see their true circles.

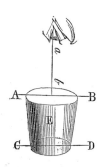

E is the glass on the table; **A B** and **C D** show the planes of the rim and base to be horizontal. The eye placed as here shown has its principal visual ray † *a b* at right angles with their planes : they would, therefore, when viewed from this position, appear perfect circles so also if the glass and the eye were thus placed in relation to each other as in Fig. 2 ; here also the ray *a b* is at right angles with **A B** and **C D** ; but when your eye is in *any other way* placed in reference to the circle, or in reference to the plane of any other object, it is then said to be inclined towards that plane.

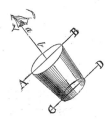

Fig. 2.

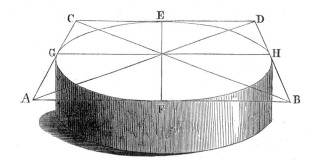

The figure here given for your Lesson is a grindstone, to which the above remarks apply. To draw this, first represent the square **A B C D** as seen in perspective. Draw

* Plane: a surface which lies evenly between its bounding straight lines.

† Visual ray: a straight line supposed to pass directly from the eye to the object it regards.

the line **A B,** decide on the position of the points **C** and **D,** so that the line **C D** may be horizontal as **A B,** and of its required distance from it, and also that **C A** and **D B** should have their required inclinations. Then draw the diagonals; and through where they cross, draw the horizontal line **G H,** and the perpendicular **E F;** thus you will find that the halves to the right and left of **E F** are equal, because they are equally distant; but the halves above and below **G H** are unequal, because one is further off than the other. This framework being done, you may draw the top of the stone, taking care to make the curved line touch the points **G E H F.** Perpendicular lines of equal length should now be drawn down from **G** and **H** for the thickness of the stone, and when drawing the line for the bottom of the stone, take care that the upper and lower lines of it are widest apart at **F,** because this part of the stone is the nearest to you. On examining this Lesson, you will see that the curved line **G F H** does not curve so much as the lower line for the bottom of the stone, because it is higher and therefore nearer to your eye, and that the upper or further half of the stone **G E H** does not curve so much as the lower and nearer half at **G F H,** nor does it appear so large, because it is more distant.

This subject should now be shaded. Take care to make the shades gradually darker from the lightest parts. The shadow on the ground should have a well-defined edge, and be made gradually darker from the lighter to the intensely dark part.

LESSON 44

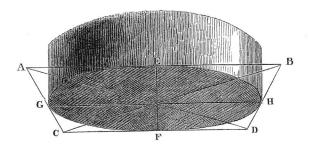

EXHIBITS the grindstone as you see it when it is above your eye. The instructions and observations given in the last Lesson, apply equally to this, and having understood those, you should be able to draw this easily.

First construct the framework, beginning with the line **A B,** and drawing the others in the order described in the last Lesson.

SHADE AND SHADOW.

I HAVE already told you of the positive necessity for drawing every object accurately, without which light and shade can be of no avail. I must now tell you what is the purpose of light and shade, or rather shade and shadow, when added to your outline. They are to make the object look solid—to show those parts which advance and those which retire, and thus explain the irregularity of surfaces, and, in fact, to exhibit the space an object occupies.

And as you are now about to add to your drawings shades and shadows, in order to produce those results, it is important for you, before you proceed further, to study well the laws relating to them.

The subject of Fig. 1 in the annexed wood-cut is a cylinder, and your last two Lessons are simply slices of it, as at **E F** and **G H**; therefore, the laws of light and shade relating to this belong to them.

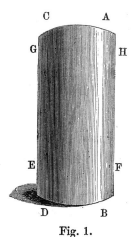

Fig. 1.

Fig. 2.

The brightest light on a cylinder is at some little distance from the outline on the illuminated side, as at **A B** *; and the shade is darkest at some little distance from the outline on the shaded side, as at* **C D**.

In cylindrical figures and in rotund forms, such as those of the human figure, the shades separate from the light GRADUALLY. *When objects are angular, the lights and shades separate abruptly, as in all your preceding Lessons.*

In light and shade, distinction should be made between *natural shade* and *accidental shadow*. NATURAL SHADE *is that which is inseparably connected with every object receiving the light.* ACCIDENTAL SHADOW *is that which one object, or part of an object, casts on another object or part of another,* by interposing between it and the light.

For instance, if you look at Fig. 2 on the last page, you will see the accidental shadow of the hoop on the jar. This accidental shadow would, of course, be moved on removing the hoop. This shows that the shadow does not belong to the jar, but is accidental.

There are some other laws belonging to accidental shadows with which you must be made acquainted before you can proceed; because I wish you to understand, that any example set before you is not intended as an exercise for your eyesight and patience in making a copy of it, but that, whilst so doing, you shall be able to show that you have understood the laws of nature therein exhibited, and when comparing your copy with the original, be able to convince yourself that you have carried them out with the same power. This is the use intended by the examples given, and the use you should make of them.

An accidental shadow may be lighter or darker than the object casting the shadow.

If the object casting the shadow be of the same colour as the object on which it falls, then the shadow is *darker* than the shaded side of the object casting it: it is still darker if it falls on a darker object. Look at Fig. 2; you will there see that the shadow on the jar is darker than the shaded side of the hoop, and if the jar were of a darker material, the shadow of the hoop would be in like degree increased.

When an object casts its shadow on another of lighter colour, then the shadow is lighter than the shaded side of the object casting the shadow: for instance, when a brick house throws its shadow on one of plaster or light-coloured stone, or a book, in black or dark-blue binding, on another in white binding. This, however, is not an invariable rule, as the depth of the shadow greatly depends on the proximity of the objects casting and receiving. Place your finger down on the paper, you will see that the shadow of it on the paper is darker than the shaded side of your finger, although the shadow falls on an object lighter in colour than your finger which throws the shadow.

In cast-shadows, then, having noticed the circumstances with reference to their depth, we observe: *That cast-shadows do not mark the forms of the object casting*

them, but the surface of that which receives them. For proof of this, see the wood-cut below, where the shadow of a stick is thrown across the base of a column. Now the shadow of the stick has no resemblance to the form of the stick, but it describes perfectly the varied surface on which it falls; but where it is thrown on a flat surface, as at the upper part of the base of the column—*there* you see the form of the stick.

It is often difficult, if not impossible, without the assistance of a cast-shadow, to explain or comprehend a surface, as you will see by reference to Fig. 3, where you have the recess of a blank window, plainly shown by the cast-shadow in it; but you can form no idea of the surface of the architrave round the window; you know

Fig. 3.

Fig. 4.

nothing of the irregularity of its surface: you see only a few straight lines; but if you look at Fig. 4, you will instantly see that the cast-shadow from the moulding above the window, has, by its form, perfectly depicted, not only the recess of the window, but the precise surface of the architrave around it.

Another feature of cast-shadows is, that *they always have sharp and well-defined edges*, whether the object casting them have a sharp edge like the knife in Fig. 5, or whether it be round like the stick in the subject on the last page.

Fig. 5.

All cast-shadows are darkest when immediately next to the object casting them, and are lightest when most distant from it. See where the stick touches the column and the ground—there the shadow is the darkest: look also at Figs. 2, 4, and 5, for further evidence.

Lastly, *the* LIGHTS *on objects receiving cast-shadows are always* BRIGHTEST *where they are in immediate contact with the* DARKEST *of these shadows.* For instance, the brightest lights on the base of the column would be immediately next to those parts of the shadow where the stick and the stone touch each other, and where you have the shadow of the upper member falling on the one below, as at *a a.*

Now, all these are universal laws, and therefore you must be careful to understand them thoroughly; indeed, they should be committed to memory, and you should take every opportunity of observing their truth: you best see them on white objects in strong light. These laws equally operate on dark as on light objects; but as they are not so easily detected, it is the more important that they should be known, so that the mind may teach the eye to observe them, and both direct the hand to portray them.

Without such knowledge, drawing from nature would indeed be a blind and blank occupation; it would be an attempt to follow an object you could not see, and an unmeaning record of what you did not understand.

You are now prepared to enter on the shading of this and every subject constituting the future Lessons of your life. You will look beyond their mere exact imitation; you will cease to follow the lines of your example: you will look forward to the end sought by their employment. Whilst you add the shades and shadows to each Lesson, inquire of yourself, not how much they resemble the example, but whether they possess all the properties of nature; look only to your copy in order to judge whether you have always as truly and as emphatically observed them: not whether your drawing possesses the same lines, and lights and shades, but the same truth, as forcibly and as faithfully expressed.

LESSON 45

Is little more than a repetition of Lesson 43, and shows you the application of different and more simple means for drawing familiar objects which are circular, like this, or the tub in the Lesson following. These, however, you cannot apply unless you have perfectly understood the two previous Lessons.

Draw the line **A B**, then the curved line **A G B**, without caring for the break at **G** for the handle, then draw the curve below **A B**, remembering that this half of the object is the nearest. The great difficulty in drawing this oval figure is to curve it properly at **A** and **B**. The distance across from one handle to another may be judged of by a perpendicular line made or supposed In drawing the rim, take care that that also appears thickest at the nearest part; draw the lines $a\,c$ and $b\,d$ of equal length, and then the line $c\,\mathbf{E}\,d$, reflecting on what has been said in Lesson 45. The bottom of the vessel may now be drawn as it is here seen in the interior. In doing this, it should be regarded in connexion with the exterior line $c\,\mathbf{E}\,d$, and drawn as if it could be seen entire, as it is here shown. It should be observed, also, that from **G** to the bottom of the vessel inside, it is seen to be shallower than at the outside in front, that being the most distant part.

On the outside of the subject, you see the shades are made gradually darker from their lightest parts, leaving no visible edge, as in the cylinder; but the shadow cast from the rim between **A** and **B** on the inside, and from the rim at **B** on to the handle at **H**, and also the shadow of the whole on the ground, have all sharp and well-defined edges. The direction of the lines of the shades must be carefully noticed, their relative intensity, and where they are darkest; and let the outline of the object everywhere be firmly drawn.

LESSON 46.

THIS Lesson is a further exercise for you in drawing curved lines. You must proceed with the tub exactly as you proceeded with the last Lesson. It has been chosen in order to afford you practice in drawing the curves of the hoops greater and greater as they are more and more below the eye.

The tub is supposed to be placed on the ground, and therefore you would see its upper rim a very broad oval; this figure is consequently more difficult to draw than the vessel in the last Lesson.

Lesson 46

Pl. 6

Take great care to draw all the lines showing the staves of the tub. From **G**, where they are perfectly perpendicular, they gradually incline each way, till they slope like **A C** and **B D**.

In placing the handles of the tub, their relation with **A B** and with each other must be observed, so that a line across from each may appear to divide the tub equally. This would be ascertained by dividing the line **A B** at **H**, and then by taking a point for the farther handle; from this draw a straight line through **H** till it touches the nearer part of the rim: this will show you the place of the nearer handle. Too much care and attention cannot be given to shade this subject, bearing in mind what has been said in Lesson 25, and on cast-shadows. Above all things, let the outlines be pure and cleanly drawn, and always a little darker everywhere than the shades.

All the features of cast-shadows are, in this subject, especially manifest. If you look at the shadow of the stick to the left on the front of the tube, you will see by its form how clearly you distinguish the projection of the hoops from the tub, and that they are flat hoops. Look also at the shadows thrown from these, how they mark the smooth roundness of the tub; and notice the shadow of the stick thrown on the inside, and how entirely it is in form different from that on the outside.

See also how dark the shadows are close to the object casting them, and how sharp and defined are their edges.

When drawing curved lines for objects of some size like these Lessons, it is not easy to draw them with the hand resting on the table: you should merely support the hand by the tip of the little finger, and allow the whole arm motion from the shoulder, when you will be able to draw curved lines, not only with more accuracy, but with more freedom, especially if the pencil be held as shown in Fig. 3 on page 4.

LESSON 47.

THE intention of this and the following Lesson is to show you the courses of stones, or any other division of a circular object, and the form of its top and base, which, according as they are above or below the eye, curve differently, and to show you other means for producing these curves truly; their curvature being, as I have told you, greater in proportion as they are more above or below the eye.

First draw the figure as shown in the outline Fig. 1, by the exterior and perpendicular lines. Unite these by the upper and lower lines **C A, D B, A E,** and **B F,** and you will have a figure like Lesson 40. Then divide each perpendicular line at the angles of the building into four equal parts, and draw straight lines to unite them, as in Lesson 42; then begin at **C** to draw a line gradually curving upwards, till it touches **A,** and then descend gradually on the right to **E.** Having done the top, proceed with the base **D B F.** Draw now the three intervening divisions, and regard the straight lines uniting on the near angle **A B,** as the means by which to obtain the exact curvature of the other curved lines. These must now be examined, when it will be found that each, as it is higher up, curves more, and *vice versa*.

When you are shading this subject, refer to the drawing, and remember what has been said in the two previous Lessons; and remark, in addition, that the shadow which is thrown by the roof on to the tower curves, and thus essentially assists to show the rotundity of the tower: notice also that it is darkest just above the window, where the tower itself is brightest. Examine again the shadows of the hoops on the tub in the Lesson immediately preceding this, and you will see that the lines for the shadows on the tower curve in like manner and in conformity with that division to which they are proximate, and that they are allowed to be seen but faintly where they mingle with the shade on the left: this assists to give the roundness of the tower with additional effect.

Take care to obey the laws I have pointed out to you on cylindrical objects, in Fig. 1 on page 54, and observe, that, except in having a roof, this Lesson differs in no degree in its form from that figure.

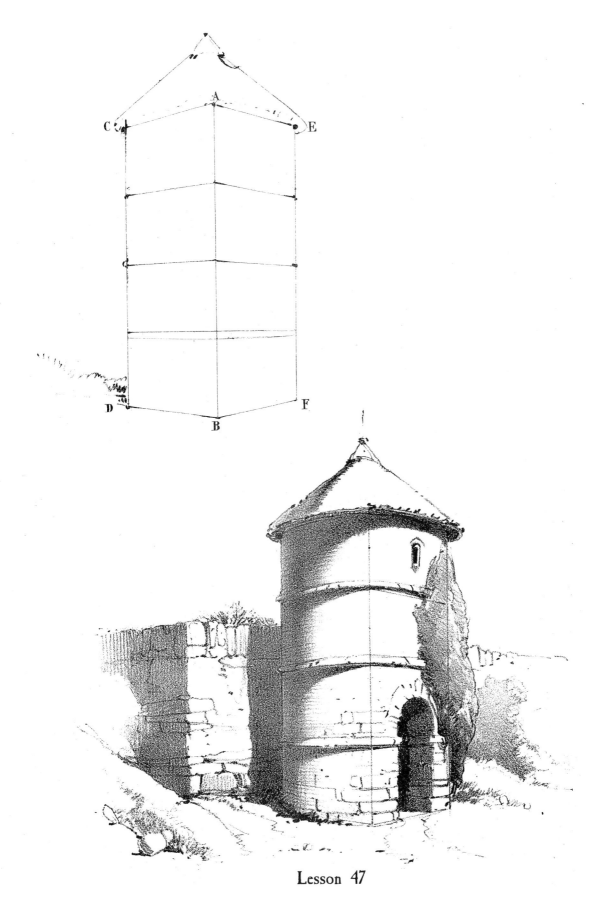

Lesson 47

Pl. 7

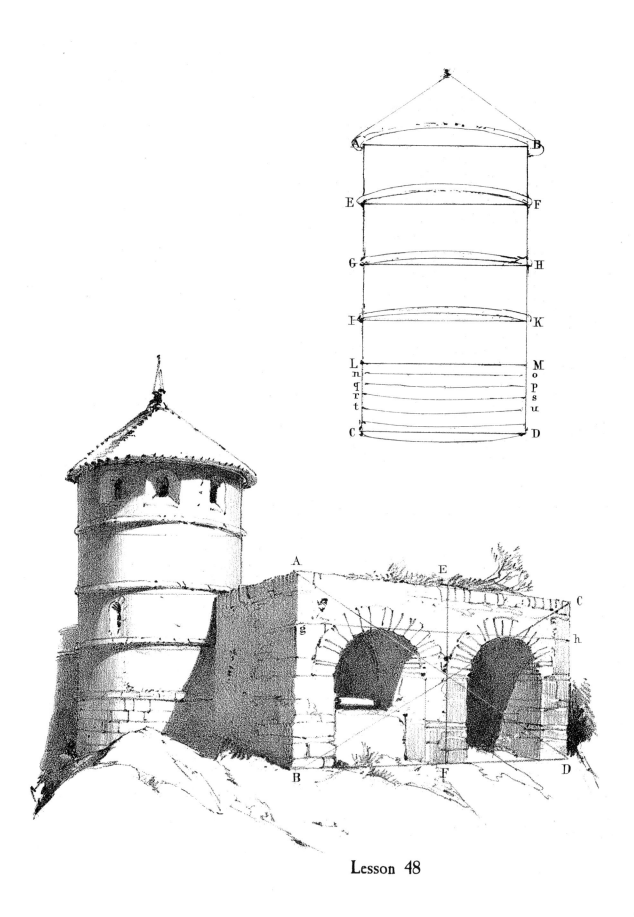

Lesson 48

Pl. 8

LESSON 48.

The tower may also be drawn in the following manner :—Draw the outside lines **A C** and **B D**, and divide them equally into five parts, and draw the horizontal lines uniting **A B, E F, G H, I K, L M,** and **C D**; then draw the curves, bearing in mind the remarks made in the first paragraph of the last Lesson, and also the curved lines *n o, p q, r s, t u,* and the ground-line at **C D**. The line **L M**, being horizontal, shows the height of the eye of the spectator when viewing the tower.

The portion added to the tower in this Lesson has been given to exercise you in the application of Lesson 23. Having drawn the exterior straight lines, and by the diagonals divided **A B C D** at **E F**, divide the upper half equally at *g h*, where this line and the diagonals cross will be found the height of each arch. Before drawing these, mark the perpendiculars on which they rest, taking care to observe the spaces which separate them from the angles of the wall, and from each other.

There is more depth of shade and more of the character of stone given in this than in any of the preceding Lessons. This you must carefully attend to, and bear in mind what has been described to you in Lesson 42. Take care that each line, round each arch, which represents the divisions of the stones forming it, gradually leans right and left, according as it is on the right or the left of the centre, and that it is always directed to a point midway between the springings of the arch.

CONCLUDING OBSERVATIONS.

THE Lessons contained in this Section, have taught you certain general laws regarding shades and shadows; and, as was stated in the preparatory observations, you will be more thoroughly convinced of the truth of what was said to you in the last paragraph of Lesson 13.

You will here have entered on the study and application of outlines, characteristic of objects of different kinds; and, when you can execute the Lessons of this Section with neatness and precision, you should seek an illustration of the truth of the observations which I have made to you; not only by studying the Lessons themselves, but by endeavouring to draw familiar objects which surround you, such as cups and saucers, jars, mugs, jugs, and wine-glasses, which, if you have mastered the examples accompanying your Lessons, you will be able to accomplish with facility and truth.

Such familiar objects furnish you with excellent opportunities for trying your ability to draw circular forms; but you should at the same time look to your models, which, by reason of the all but infinite novelty of combination of which they are susceptible, afford abundant examples, either actually like such as you have here found in your " Lessons," or others so analogous as to enable you immediately to trace the direct applicability of your instructions.

You may be able to copy accurately the examples which illustrate your Lessons, but to your models you should return after each, in order to prove by drawing from them that you are really in possession of, and can apply, the instruction each Lesson is intended to convey. Such exercise will test whether in going through your Lessons you have employed your intelligence or your eyesight.

You must not forget that the constant aim of every Lesson is to teach you principles; to set before you whatever will enable you first to see truly every object which your eye may regard; by making you understand that you do not ever see the real form of any solid object, and to show you the causes for the difference between the form seen and the real form. Your vision will thus be made accurate by accurate judgment, and the first step will be made towards gaining the power by which you may be able to imitate all the varying forms which every object assumes, either from varied position of its own, or when viewed by you from different points. My intention also is, in the examples to place before you means by which you may be capable, with any materials, of characterizing the different properties of objects satisfactorily, and of following nature's undeviating laws of light and shade, so that you may place a truthful image before the eye and the mind, and impress them with the powers of Art.

QUESTIONS FOR EXAMINATION.

1. When shading with the chalk or pencil is produced by lines, what regulates their inclination?

2. What is the great characteristic of shade?

3. Explain how you procure this characteristic.

4. What is a superfice?

5. How are you said to view an object when its apparent form differs from its real form?

6. How do right angles appear when seen obliquely?

7. When is a line, or an object, said to be foreshortened?

8. What should be your chief object in the study of your Lessons?

9. How do the horizontal lines of the retreating sides of a right-angled solid appear to slope when they are *above* the eye? and how when they are *below* it?

10. How should a right-angled form be represented when immediately opposite to you?

11. How is the retiring side of an object said to be seen?

12. What is the great difficulty to overcome in the drawing of forms of any kind?

13. When sketching an object, do you regard the lines characteristic of its nature? or do you draw it in straight and continuous lines?

14. Show that you understand how to draw a wall when its sides retire; that you can give the exact inclination of the courses of the stones or bricks composing it; and explain its construction, and whether you would represent the division of the stones by lines of regular or irregular breadth and depth; and why.

15. Under what circumstances do you see a circle of its true form?

16. When does its apparent form differ from the real?

17. What form does it then assume?

18. When does it appear only as a straight line?

19. Show that you understand what is meant by a circle on a horizontal plane.

20. What is a horizontal plane?

21. What view are you said to have of a plane when the principal visual ray is not at right angles with it?

22. Show that you understand what form circles appear to have when above or below the eye. Explain the difference between shade and shadow.

23. When only can they be of any avail?

24. For what purpose are they applied to forms?

25. Where do you find the brightest lights and shades on objects of a cylindrical form?

26. How do the lights and shades on such objects separate?

27. How do they separate on angular objects?

28. May an accidental shadow be lighter or darker than the object casting it?

29. If darker—under what circumstances?

30. If lighter—why?

31. When shades and shadows increase in depth, is that increase gradual or sudden?

32. On what does the depth of a cast-shadow also depend?

33. What form does a cast-shadow portray?

34. Under what circumstances does the shadow sometimes exhibit the form of the object casting it?

35. Where are cast-shadows darkest? and where are they lightest?

36. What other features do you remark in reference to cast-shadows?

37. Where is the light the brightest on objects which receive cast-shadows?

38. On what objects are the laws in reference to cast-shadows exhibited? and by what light?

39. Are they universal or partial?

40. Do you endeavour to carry out all the laws relating to shades and shadows with reference to the facts of nature, as you see them exhibited in your examples, and with the same force and truth? or do you deem it sufficient to make as near an imitation of your example as your patience and your eyesight will help you to effect?

SECTION III.

PREPARATORY OBSERVATIONS.

It is more than probable, that as the next eight Lessons present to your eye nothing which is attractive, you will be disposed to pass over them to those which are more winning. If you fall into this error, you will effectually arrest your progress, for unless these Lessons be well understood, you will find all beyond utterly impracticable, however they may be more pleasing; but if you learn these well, you will have mastered the most perplexing difficulties of all the future Lessons, and therefore they will cease to be difficulties to you; your undivided attention can then be given to the mastery of such as belong to each individual subject. Not only will you, by the exercise of these Lessons, have acquired power to imitate the various examples contained in this and the following Sections, but the power to draw the like from nature with proportionate ability. This is the end to be aimed at continually; not as an amusing but as a valuable power; not as a pastime but as a necessity, which the circumstances of your future years may demand.

You should attentively regard the six sides of the cube in Lesson 49, remembering that each is in reality a square, and remark how, in representation, they each differ from that reality. This representation accords exactly with the form each side appears to the eye to assume, according to its different position.

Whenever any reference is made in the future Lessons to those which have preceded them, it is most desirable for you to turn to them, and read them again. Thus you not only fix them more securely on your memory, but witness their general utility, and become more willing, because more able, to practise them.

LESSON 49

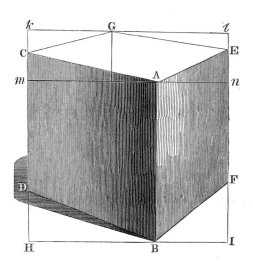

Shows you the cube when the top and two of its sides are all seen in perspective, and here the auxiliary lines must not be at first used to aid you in drawing the object correctly; but afterwards, when it has been drawn without their aid, to assist you in proving whether you have drawn it correctly or not.

Draw a line **A B** of any length, and assume that this line represents the angle **A B** truly, draw **C A** and **A E**, of the required inclinations, but of any length; place the point **C** so that **C A** shall be shorter than **A B**, because it is seen obliquely or fore-shortened; having determined the length of **C D**, (for reasons you are already made acquainted with, in Lesson 13, last paragraph) draw **D B**. Fix on **E**, so that **A E** may be shorter than **C A**, because, as it is the top line of the side which is most turned away from you, it is therefore seen more foreshortened than **C A**; draw **E F**, and recollect that it is the most distant perpendicular, and should, therefore, be shorter than **C D**; then draw **B F**. Fix now on the point **G**, so that **G E** shall be shorter than **C A**, and draw **G E** and **C G**.

If the cube has been drawn according to these instructions, and the lines are shorter in proportion to their different distances and the degree in which they are seen foreshortened, and all the lines as they descend from **G C** and **G E** gradually slope more and more, *it must be true.* Should the eye not be sufficiently correct to see this, it will be aided by comparing them with the auxiliary lines *k l m n* and **H I.** All this is but the measurement of angles, shown in Lesson 6.

You must absolutely repeat this Lesson again and again, larger and smaller, and follow your instructions closely, until you are perfectly familiar with them, and can draw this object easily and accurately, from having reasoned on it truly. On this depends your comprehension of all the future Lessons, and consequently your further progress.

LESSON 50

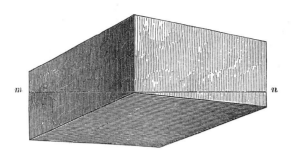

SHOWS a right-angled solid, with the sides and underneath parts seen in perspective. Here again you must draw each line exactly in the order described in the last Lesson, comparing them with each other, and reasoning on them in the same way, but without the aid of auxiliary lines, except the line *m n*, and that only to show that you have drawn the object correctly by the eye. But if you cannot draw the figure without the aid of auxiliary lines, it is evident that you have not properly acquired the preceding Lessons, and you must repeat them till you know them thoroughly, and can give the proper reason for every line you draw.

LESSON 51

SHOWS precisely the same view of the cube as Lesson 49, but here it is represented as if transparent, so that all its sides are seen. It must be drawn according to the instructions contained in Lesson 49; when this is done, draw G H less than any of the perpendiculars, because it is the most distant of all, then draw H F and D H. No auxiliary lines are here to be used. A B, being the nearest perpendicular line, must be the longest, and may be made of any length you please, it matters not—the others, each in proportion, shorter; and if, in fixing their different lengths, attention has been paid to the foregoing instructions, they cannot be wrong; and when to these are joined the lines of the upper surface C G and G E, whose length has been determined by the degree in which they are seen foreshortened, the whole figure *must be right*. In shading this Lesson, take care to make the cast-shadow G H F darker at the points G and F, and also sharp on the edge. This shadow is thrown by the lines G E and E F on the surfaces C D G H, and D H F B, and throughout must be made darker than the shaded surface G H E F.

LESSON 52

Is a repetition of Lesson 12, except that, like the preceding Lesson, it is transparent. Having first drawn it as in Lesson 12, draw **E G** and **F** both shorter than **A B** and **C D**, but of equal lengths, because they are equally distant; then draw **G H**, **G B**, and **H D**, and the outline of the cube will be complete. The remarks on the cast-shadow and shaded side of the preceding Lesson apply equally to this.

LESSON 53,

Which you find on the next page, represents to you, in the first and nearest portion of it, a cube like Lesson 51, with another, and more remote one, of exactly the same dimensions, but close to it, on the right-hand side; the object is so to draw this second cube, after having drawn the first, that it shall truly represent a cube of the same real magnitude as the first, but drawn smaller in exact proportion to its distance.

First draw the near cube, then extend the lines **A C** towards **L**, and **B D** towards **K**, both indefinitely. Having done this, divide **C D** equally at **I**; then draw the diagonal from **A** through **I**, till it touches the extended line **B D** at **K**; on this set up a perpendicular till it touches the line **A C** at **L**; thus you have found the exact place

of **L K**, and beyond contradiction true. Extend **E G** towards **M**, indefinitely; then draw the diagonal **E L**, and through where this crosses **G C** at **N**, draw a line from **A**, till it touches the extended line **E G** at **M**, then draw **M L**. In this stage the exterior surfaces are complete, and of just such forms as two equal cubes would assume when so placed,—that is, with one angle, **A B**, nearer to you than all the rest. These cubes are here drawn as if they were transparent, and thus you must draw them, in order to prepare yourself for the application of what you have here learned to your future Lessons.

Extend now the line **F H** indefinitely, and then draw a perpendicular from **M**, till it touches this at **O**; then draw **O K**, and the figure will be complete. If it have been truly drawn, **M O** will be the shortest of all the perpendiculars. Now examine line by line, and see that as one is more distant than another you have made, it is less than another, viz.,—that **C L** and **D K** are less than **A C** and **B D**; that **G M** and **H O** are less than **E G** and **F H**; that **G C** and **H D** are less than **E A** and **F B**, and that **M L** and **O K** are less than **G C** and **H D**; that **E F**, **G H**, and **M O**, are less than **A B**, **C D**, and **L K**. If, by this examination, the lines prove to be shorter, according to their distance, and the lines they are related to, then, and not till then, will your drawing be correct. Draw this figure, of different dimensions, several times. You will at once see that everything depends on your drawing the first transparent cube accurately.

LESSON 54.

THE last Lesson is here repeated, with another cube placed on the nearest one. Before this can be done accurately, the lower and nearer one must first be accurately drawn. This being done, extend the perpendiculars **F Q, B O, I** *m*, and *b g*, upwards and indefinitely. Make **A O** as tall as **O B, E Q** as tall as **Q F, H** *m* as tall as *m* **I**, and **G** *g* as tall as *g b* ; the points **E G A H** having thus been found, unite them by lines, and the top of the upper cube will thus be accurately drawn ; and if this figure **E G A H**, which is known to be a square, be now compared with the base **F** *b* **B I**, also a square of equal dimensions in nature, but differently seen, you will immediately see how different in form they *appear*, according as they are more nearly on a level with your eye, or more below it.

These two cubes being done, the further one may be accurately drawn in the following way, as well as by the method described in the last Lesson. Both methods are given, in order to show you that equal correctness may be obtained ; like, as I have before observed, two ways of working a sum, or proving it.

Extend **O** *m* and **H I** towards **P** and **D** ; draw the diagonal form **A** through *m*, till it crosses **B I** at **D**, set up the perpendicular **P D**. Extend now the line **Q** *g* to *c*, determine the length of the line *g c* by comparison with **Q** *g*, and make it shorter because of its distance ; then draw *c* **P**. The object of all this is to obtain accurately the slope of so much of the line *c* **P**, as would be seen to the right of **H** *m*, by a mental perception of so much of it as is unseen to the left of **H** *m*. It may, however, be more simply obtained by judging of the distance between *l* and *m* on the line **H** *m* ; this method, which is according to your earliest Lessons, is not, however, so strictly accurate. Future Lessons will show you the importance of both.

Examine this Lesson in the same manner as the last ; and if it bear the examination, it is true.

LESSON 55.

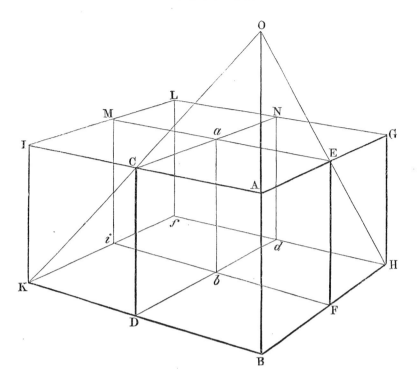

THIS Lesson is a combination of Lesson 53, with a cube placed on the left hand of the near one, and one behind it; thus, four cubes of equal dimensions are represented, as you would see them when in such juxta-position and contact.

First, draw the two near and right-hand cubes, either as they were drawn in Lesson 53, or as in the last Lesson, by making **A O** equal to **A B**, and drawing the diagonal from **O** to the right. Everything depends on these two being truly drawn. Extend the lines **A C** and **B D** to the left indefinitely. The cube to the left is drawn in the same manner by a diagonal from **O** through **C** to **K**, and then setting up on this the perpendicular **I K**. Extend **E** *a* towards **M** indefinitely, and **G N** towards **L**, till **I M L**, and **G N L** cross each other; and having so fixed the point **L** that **L N** shall be shorter than **N G**, and **L M** than **I M**, extend **F** *b* towards *i*, and **H** *d* towards *f*, and **D** *b* towards *d*. Let fall a perpendicular from **L** to touch **H** *d* at *f*; if **L** *f* be shorter than **N** *d*, it is right; draw now **K** *f*; and if where it crosses **F** *b* at *i*, *i* is found to come perpendicularly under **M**, then the whole figure will be true, and exactly true.

Each cube being here drawn as if it were transparent, it is seen entire; and thus its true form, and its diminution, according to its distance, are made apparent.

But you may execute this figure in another way. Draw **A B** of any length, and complete the whole external figure without regarding the inner lines; that is, draw

A B, I A, I K, and K B, then A G, G H, and B H, and lastly I L and L G, observing that, whilst doing this figure, you reason on it in the same way you did when doing Lesson 49, remembering at the same time its proportions, which you obtain by comparing each line as you do it with the line you first made, viz., A B. When the whole figure is thus done, set up O A equal to A B, then draw lines from O to K and from O to H; by so doing you will find the places of C and E, and thence the lines C D and E F. Draw now two lines, lightly (they are not here drawn), from I to G and from L to A, where these cross; you will obtain the point a; then draw a line from E through a to M, and another line from C through a to N. Draw a perpendicular from L for L f, taking care that this line be shorter than I K, then extend lines from f to K and from f to H. You now obtain the remaining lines in the following order, M i, i F, N d, D d, and a b, when the figure will be complete. It must now be examined,—that is, looking to A B as the standard, you must see that every other perpendicular line is shorter than A B, according to its distance.

LESSON 56.

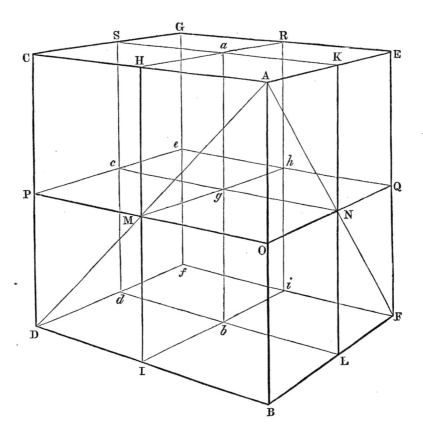

THIS Lesson consists of eight cubes of equal size, the lower four placed, and represented, as in the last Lesson, with four other cubes of equal size placed upon

them; and thus you may consider them either as eight separate cubes, or as one large cube divided into eight smaller ones of equal magnitude; and so considered, you may most easily draw them.

Draw the exterior lines **A B, C A, A E, C D, D B, E F, B F, C G,** and **G E,** in the order here named, and as if they represented one cube, like Lesson 49, only on a larger scale; then draw the diagonal **A F,** and another, not here drawn, from **E** to **B**; through where they cross, draw the perpendicular **K N L**; do the like on the other side to obtain the line **H M I**; and now these two sides are divided, so as to represent to your mind that the divisions are equal, but one being further off than the other, appears to your eye less, and is so represented, and diminished in a degree *exactly* according with its distance. Divide equally **A B, C D,** and **E F,** as in Lesson 42, and from the points thus obtained draw **P O** through **M,** and **O Q** through **N**; draw now diagonals from **C** to **E,** and from **G** to **A** (they are not here drawn); and through where they cross at *a*, draw **H R** and **S K.**

For all practicable purposes applicable to your future " Lessons," no more need be done; and what more is here done is to enable you, by its examination, to trace the different forms of each cube arising from its different position.

You should remember that each plane described by the letters at its angles, as **A B C D,** is in nature a perfect square, and is subdivided into four parts, each of which is also a perfect square. Each square of each plane should now be examined, as **G *f* E F, S *d* K L, C D G *f*, H I R *i*, A B E F, C G A E, P *e* O Q, D *f* B F,** and their subdivisions, when you will see that, although each set of four lines represents what in nature is a square of exactly the same dimensions; yet, from its different position, and, consequently, the different view your eye has of it, so much does the representation of each differ, that no two of these figures will be found actually alike.

This examination is most important to you, because you will find, by constant experience, that it is necessary for you to possess a clear mental perception of what is hid from your sight, in order that you may be able to account for those forms which you do see, by a correct anticipation of those which you do not see.

LESSON 57.

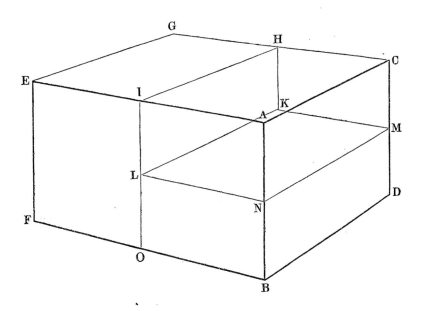

This, and the future Lessons of this Section, show you the application of what has been learned by the previous Lessons, and hence the great importance to you of their being thoroughly and completely acquired.

In this Lesson, consisting of two steps seen in perspective, you have in the framework (by the aid of which you may correctly draw them) precisely the exterior form of Lesson 55, which may also be obtained with equal accuracy in the following manner :—

Draw the exterior lines of this Lesson, and find the place of **I L** by diagonals from **F** to **A**, and from **E** to **B**, as in the last Lesson ; the lines **L N** and **N M** by Lesson 42 ; place **H** so that **H I** shall slope more than **E G** and less than **A C**, or draw diagonals **G A** and **C E**, and then from **I** draw a line through, where they cross, to **H** ; draw **H K** shorter than **I L** or **C M**, and then draw **L K** and **K M**.

You will see that this Lesson is made more complete by shading than any of your previous Lessons. Great attention must be given to the equality of the shade. Give great emphasis to all the darker parts, which must be darker than the general mass of shade, and darkest on the ground at the nearest angle of the stone. Especially observe to give to the shade even and well-defined edges, and a broken and well-defined edge to the shadow on the ground. It is very essential that at all times the limits of the shades and shadows should be well-defined, especially the latter. Care must also be bestowed on the herbage, right and left of the steps, so that it shall come close up to the line of the steps, but no further.

Lesson 57

Lesson 58

Pl. 9

LESSON 58

Is your last Lesson repeated, but reversed. Every observation which has been made to you on that applies equally to this. In that, however, the lines of the steps are regular, as if they were new ; in this they are irregular, as they would become by age. Although the edges are thus broken, yet their general inclination is as perfectly preserved as if they were new, and they are thus truly represented. The sketch or first outline of them must be done with light and straight lines, as in the diagram, which, should they be too dark, you can make paler, by rubbing them with crumbs of bread (not Indian rubber) before the shading is commenced.

Observe, that the upper edges of the stones are marked only by the upper ends of the lines of the shading ; they should not on any account be marked by a continuous outline. The stones here are smaller and more numerous ; and as they are more worn, the greatest attention must be paid to the narrow lines of light on their upper edges, and on their broken corners, and also on the clear, dark, and irregular lines which mark the bottoms of the stones, and which you will see are immediately above the narrow lines of light. These lines are not only irregular in their intensity or brilliancy, but also in their width, and are especially smart and cutting at the angles. The whole character of the Lesson depends on your carrying out these observations.

When doing the perpendicular divisions of the stones, remember what has been said to you in Lesson 42, and you will recognise the application in this Lesson of what you learned from that. The light parts have now to be lightly shaded, and in doing these, you will acknowledge the importance of the different inclinations of the lines, by the reasons which decided on their choice. Do not allow these lines to touch each other at their ends ; the light spaces which consequently occur, should be left. In the shadow thrown by the upper step at *a*, you will see that the remarks made to you on shades and shadows are carried out. The ground, as shown by the line of shadow on it, is more irregular than in the last Lesson, and very distinct. These Lessons you should draw both from the examples and from memory ; and when any Lesson has been completed, it is a good plan for you to examine whether you have carried it into execution, from having really learned what you have been taught ; you thus make sure that what you have done is not due to the eye only, but equally to your intelligence.

LESSON 59.

THE intention of this Lesson is to show you how a hollow cylinder may be drawn truly, when one end of it is nearer to you than the other.

The cube, within which it is constructed, is a repetition of Lesson 51. The circle of the open or near end is placed within the square **A B E F**, and the further end is drawn within the square **C D G H**. Both these squares are seen in perspective, but because the square **A B E F** is seen more foreshortened, it appears to you narrower, and because **C D G H** is seen less foreshortened, it appears to you wider, although more distant; hence, then, the circles which are constructed within these squares appear to be also wide and narrow, the near one narrow, or more of an oval form; the other, wider and more circular. And that this may be completely comprehended, the circle within the square **C D G H**, is given entire, although it will be quite manifest to you that the nearest half only could be seen.

When, in sketching this subject, by the aid of the lines of the cube, you have made sure of the precise curvature of the curved lines, the cube should be rubbed out.

This subject will show you more clearly the observations which have been made on page 54, respecting the shade on cylindrical objects, how gently it increases from the light to the deep part, and how gradually it becomes lighter again towards the edge; and here again the shadows within the cylinder, and on the ground, must have their edges carefully preserved, and be made gradually more intense in those parts where you have been already shown that they are so in nature.

In this subject, also, you will see that the impression of the roundness of the cylinder is greatly aided by the curvature of the lines constituting the shade, and which correspond with the curvature of that end of the cylinder to which they are adjacent.

LESSON 60.

THIS Lesson will teach you how a cylindrical object can be drawn correctly, when looking down on it, and immediately into it. It is constructed on a square, seen like Lesson 52, and its circles are drawn within the squares **A B C D** and **E F G H**, and are perfect circles. When completing this to the form of a basket, care must be taken to make the lines of the materials composing it narrower at the inner end, where they would be farthest off, and to curve them on the near end, so as to show the thickness of the basket.

Take care to break the edge of the shadow on the inside, in conformity with the surface it falls upon; and remember, when doing the shadow on the ground, what has been said in the first and second paragraph of page 57.

Lesson 59

Lesson 60

Lesson 61

Pl. 10

LESSON 61.

THE objects given to you in this Lesson, are intended as further exercise of what you have previously learned, and are designed to prepare you, by their study, to comprehend and to execute more correctly all the following Lessons.

The table is constructed on a cube, such as Lesson 60, but on a larger scale, and is here shown by a harsh ink line, which is thus given for a guide, but which, when your own drawing is completed, must not be allowed to appear. This framework must be first done, which will not only enable you to secure the true form of the top of the table, but the relative dimensions of the other parts, and the position of the legs at the back immediately under the further corners, as well as the relative positions and sizes of the broom, pail, and mug. The last two objects you must draw according to the instructions given to you in Lesson 46; and the shading, by following what you have learned concerning it, in the chapter on shades and shadows.

LESSON 62.

IN this Lesson you have a table constructed on the same framework which has served you for the preceding Lessons 53, 57, and 58; and my intention, in adding this and the sofa of Lesson 66, is to show you, by other examples, the extensive application of what you have already learned. A few only could be here given; it remains for you to test your acquirement by attempting similar subjects from nature.

Draw first a frame-work exactly like Lesson 53.

The table here represented has six legs, and the length of each of these is determined according to their distance, and to the view taken of the table, especially that which is only in part seen at **E**, the remainder to **G** being hid by the top of the table. The leg which is under the corner **M** is hid by the leg at **C D**.

LESSON 63. LESSON 64.

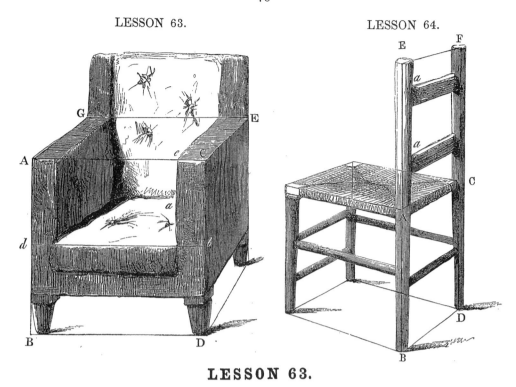

LESSON 63.

First draw a cube in the manner and in the order described in Lesson 25. Divide **A B** and **C D** equally at *d b* for the seat, then *d* **B** and *b* **D** equally for the bottom of the chair, and the upper half of this division, also equally, for the lower part of the cushion. Set up now lines from **G** and **E** for the back of the chair, and then draw a line for the width of the arm *e* **C**, making the other equal to it, and taking care that each at **G** and **E** shall be less where it is more distant. The place of *a* for the back of the seat you will easily determine, as well as the lines for the inside of the left arm of the chair.

When shading this, pay especial attention to the shadow of the arm which falls on to the back and the seat; mark where it is darkest, and preserve its form carefully. On the latter depends in a great degree the appearance of softness. Remember all that has already been said concerning cast-shadows.

LESSON 64.

This Lesson is an application of what you have learned from Lesson 54. Draw the cube as in Lesson 52. Set up **A E** equal to **A B**, and **F C** equal to **C D**; draw **E F**, and the framework of the chair will be complete. It remains for you to add the rails to the back and legs, taking care to observe the difference of their separation at the nearer or farther end, and bearing in mind the reason for that difference. If you have *well observed* this reason everywhere, it will be right.

In this Lesson, all the cast-shadows, such as those from the rails of the back on to the leg **F D**; and of the leg **E B**, on to the upper part of the rails of the back, at *a a*, are smaller than in any of the previous Lessons; nevertheless the observations already made apply here with equal force, and in proportion as they are borne in mind and carried out will your shading of the chair be well and truly done.

Lesson 65

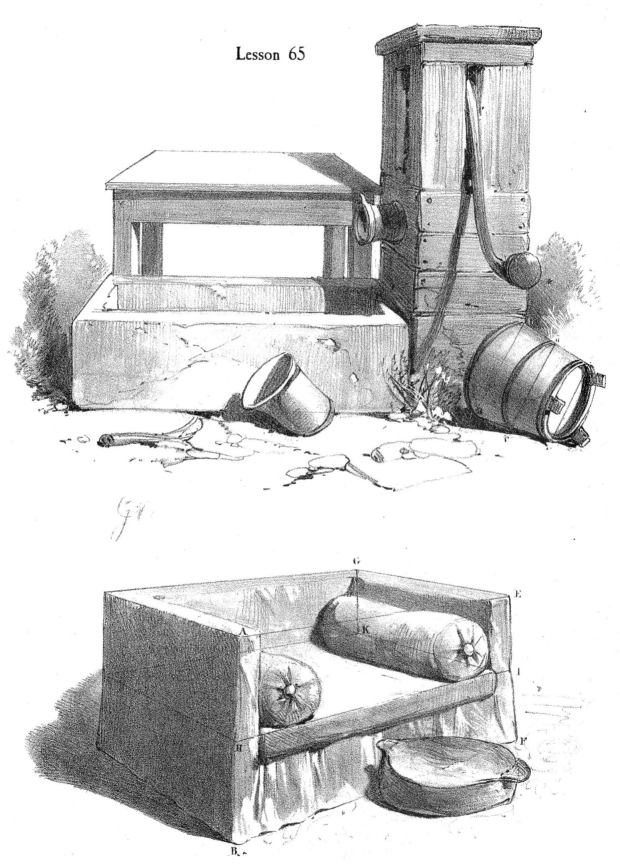

Lesson 66

Pl. 11

LESSON 65.

THE table here is a repetition of Lesson 61, the stone trough of Fig. 1, in Lesson 14, and they are combined like the two steps of Lesson 15. The framework is here again shown by a rigid line. When the forms these represent have been accurately done, and you have also sketched in the form of the pump, the boards on the front of it must be drawn by horizontal and perpendicular lines, observing that they are not all of the same width, and that their edges are somewhat irregular. Whatever may be the width on the near or inner angle, they must be less at the further angle on the left. All this has been accounted for in Lesson 42.

Proceed to draw the pail, by first drawing the lines *a b*, *c d*, and *e f*, parallel to each other, and of their different proportions; these of course are intended, as in Lesson 48, to show the curvature of the curved lines. Apply the same means when drawing the flower-pot which lies by the stone trough. Take great care to emphasize the shadows, and mark especially the form of the shadow of the pump where it falls over the spout, the stone, and the table, and of the handle as it falls over the boards in front; the ground-line also must be noticed, where it is broken or varied by herbage, which in parts hides the ground-line of the objects.

LESSON 66.

THE exterior lines of this sofa must be drawn as if it were one figure; not, as in the Lessons 53 and 54, as if it were composed of two cubes placed side by side. Having drawn this, divide **A B** and **E F** equally, and draw **H I**, then let fall a perpendicular from **G**, and having found **K** draw **K I**, and a line from **K** parallel to **A E** for the back of the seat of the sofa. **K I** serves to show you the precise inclination of the pillow.

When drawing the bottom of the covering of the sofa, you will there take notice how slight are the inflections which mark its curves from the straight line **B F**. In completing this Lesson by the shading, the rigid lines of the diagram on which it is constructed, though left in the original for your information, must be removed from your copy, and more tender lines substituted, which will better express the yielding nature of the sofa and its pillows. Take particular notice of the shade on the pillow, how gently the lighter and darker parts fall into each other, and how the undulating surface is by its means expressed, and mark its rigid and determined shadow.

The foot-stool is little more than a repetition of Lesson 45, and is here given to show you the application of the same principles carried out by lines of a more flexible character, and therefore conveying to you, under the same form, a different impression.

LESSON 67.

THE subject of this Lesson is a barrel, larger in circumference in the middle than at either end : it is represented as lying on the ground with one end presented towards you.

The lines formed by the two cubes, which serve as the foundation of this subject, will guide you in drawing its curves truly. Their truth, consequently, depends on the truth, in the first instance, of the lines which represent the cubes,—these, therefore, must be first accomplished, and when these are done, you will have the chief difficulty surmounted. (See Lesson 53.) The near end, and the far end of the barrel, are within the figures **A B C D** and **G H E F**, but the middle of it, and the hoops which there engirdle it, are outside the square **I K L M**. You must carefully notice that the width of the hoops is most plainly seen in the direction of *a a a*, because they are there nearest to your eye.

Much of the effect of rotundity is lost, because the straight lines on which the barrel is framed are here seen ; but these you need not retain in *your* drawing longer than whilst you secure the curve of the barrel, and then they should be rubbed out.

I extract the following from the " Elementary Art," page 83 :—" Though the shaded parts of objects, in any degree round, do not separate from their light parts abruptly, but gradually, and the rays of light glide over the surface, yet the shadows which such objects cast,—whatever be the surface on which they fall,—except a hairy one, or one analogous to it,—are just as well defined on the edge as those from any angular object, the light and dark parts of which separate abruptly." I mean such objects as constitute Lessons 66 and 70. You have a model which will illustrate this exactly. Place it in the sun or some other bright, but single, light.

LESSON 68.

THIS Lesson is nearly a repetition of a former one, No. 65, and is intended to show the same principal objects of like form and proportion when viewed in perspective, and with the eye above them all.

The table and stone, you see, are framed on a form precisely similar to the steps in Lesson 57, and must be proceeded with exactly as they were ; the outline of the pump being done, what has been said in the last Lesson should be remembered whilst doing the boards, as also the instructions of Lesson 42, which are here more fully applied. More need not be said with regard to the shading and the shadows, except that of the broom ; and here you must remark how true it is, that shadows rarely take the form of the object casting them. The broom handle which casts the shadow here is straight, but the shadow forms an angle, according with that formed by the stone and the ground over which it falls. The dish will serve for another exercise on curved lines. Prepare to draw this by an auxiliary line, as in Lessons 45 and 46. Mark well where the shadow of this and the broom are darkest ; that of the latter, as you see, is most emphatic on the ground where it is immediately close to the broom, and on the stone where it is close to the handle ; the same observations apply to the shadow of the handle of the pump ; notice also the shadow thrown by the edge of the stone trough on to the inside of it, and the shadow thrown on the pail on the left of the trough.

Lesson 67

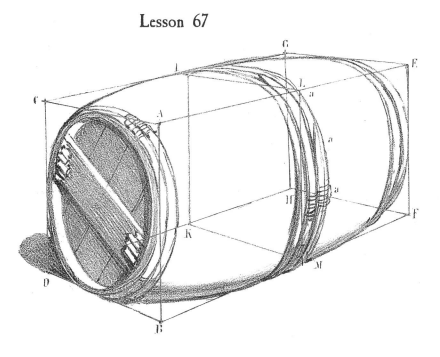

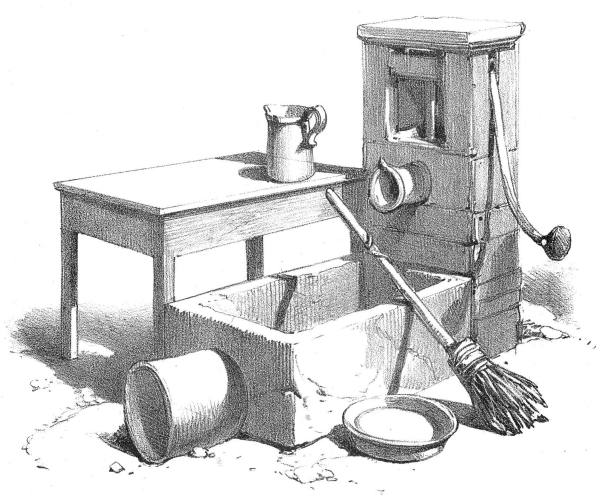

Lesson 68

Pl. 12

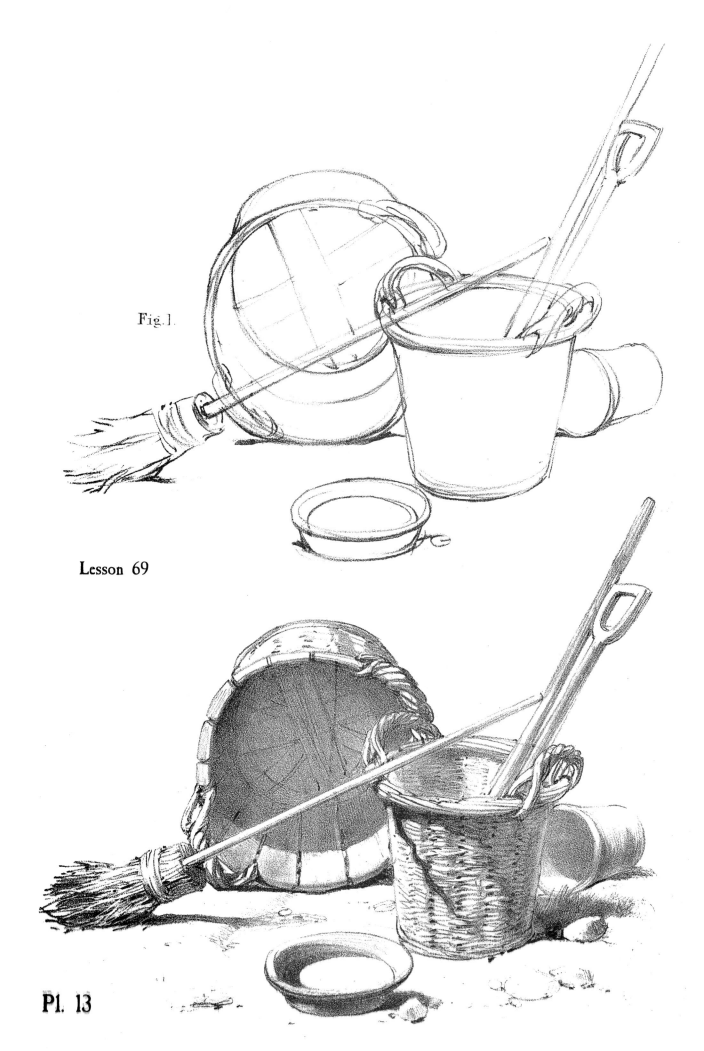

Fig.1.

Lesson 69

Pl. 13

LESSON 69.

In this Lesson you will recognise the basket of Lesson 62. It is again given, but on a larger scale, and is associated with other round objects in different positions, which, at the same time that they exercise you in what you have learned from former Lessons on round objects, place others before you of different kinds and proportions.

When you group objects as in this and other Lessons, you should first draw them correctly by a light line, or lines, as shown in Fig. 1, before you attempt to shade them.

First draw the large distant basket; the other objects you may easily draw in succession, and in proportion to that. If you should find any difficulty in drawing the circle of the outer and nearer rim of this basket, you should first draw a square like Lesson 12. Then obtain the curve of the rim of that basket which contains the spade and stick, by first drawing a horizontal line as in Lesson 45, and the bottom of it in like manner, taking care to find its place on the ground by comparison with the basket first drawn, and proceed in like manner with the flower-pot on the right of it.

The place of the saucer in front must be found by comparison with this foremost basket and the basket above it, and when this has been done, obtain the oval form of its outer rim in the usual way, and take great care that the inner curve of the bottom agrees with it.

When the objects in their separate forms have been correctly drawn, in light lines, and also correctly associated with each other, you may then shade them, and afterwards add the lines characteristic of the materials of which they are composed. The shadow of the broom on the small basket is irregular, like the surface on which it falls, and is darkest when nearest the broom. Both this and the next Lesson are intended to impress upon you, that the shadow which is cast by one object on another, is always darkest at that part where it is in immediate proximity to the object which casts the shadow, and that this shadow, if it passes over objects of irregular surface, always assumes the irregularity of that surface, and exhibits in proportion less truly the form of the object which casts the shadow.

Give attention to the shadow which falls upon the upright basket from its rim. Observe, also, how, as with the broom, its edge is broken by the irregularity of the meshes; the principles belonging to the light and shade of these you have had explained, and your success will depend on your strict observance of them. If you examine the example given, you will see that in every case, small and great, these principles have been rigidly observed, and if your drawing when done appears less satisfactory than your example, you will find, on examination, that it is because these principles have been less rigidly observed.

LESSON 70.

The auxiliary lines on which this Lesson is constructed you will best understand by reference to Fig. 1, which will show you not only the method of drawing the objects it contains correctly, but how they should be drawn previous to their being shaded.

Draw the several parallelograms in the following order, **I K L M, A B C D, E F G H,** and **P Q R S,** and having taken care to observe their connection and proportion, the straight lines forming them serve at once as the means by which you may easily draw the curved lines of all the objects.

When drawing the head, hoops, and base of the Barrel, the ends of the Milk-pail, the openings and bases of the Pitcher and Can, it is only necessary for you to refer to, or to remember, Lessons 45 and 46. When drawing their curved sides, you need regard only the upright auxiliary line, and having decided the curvature of the left-hand side, draw the other in conformity with it, so that both shall curve equally, although in opposite directions.

The shaded sides of these objects illustrate what you have learned in previous Lessons on shades and shadows. The small shadows, such as those of the hoops on the staves of the Barrel, as well as that on the lip of the Pitcher, and the handles of the Can and Milk-pail, must be attended to as carefully as the larger shadows thrown by one object on the one contiguous to it.

The objects composing this Lesson are all smooth objects, and the shading therefore should be done for the most part with a stump; but, with this instrument, though you may easily exhibit the gradual melting of the lights into the shades, and the gradual increase of the latter, yet with it you could not give the necessary—the clean and determined—edge indispensable to the shadows, nor their emphatic depth; these, therefore, must be added with the point of the pencil or chalk.

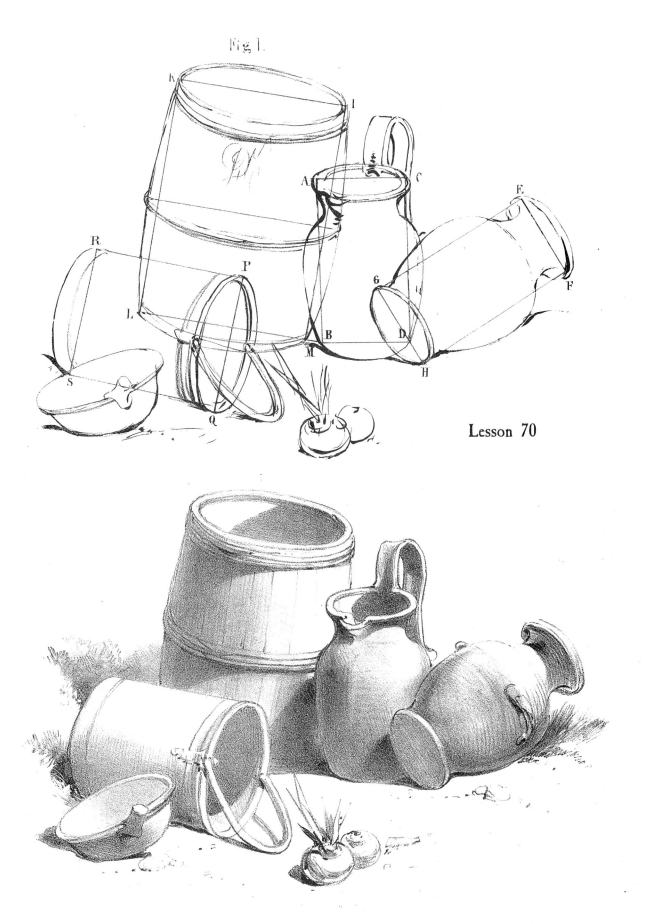

Fig. 1.

Lesson 70

Pl. 14

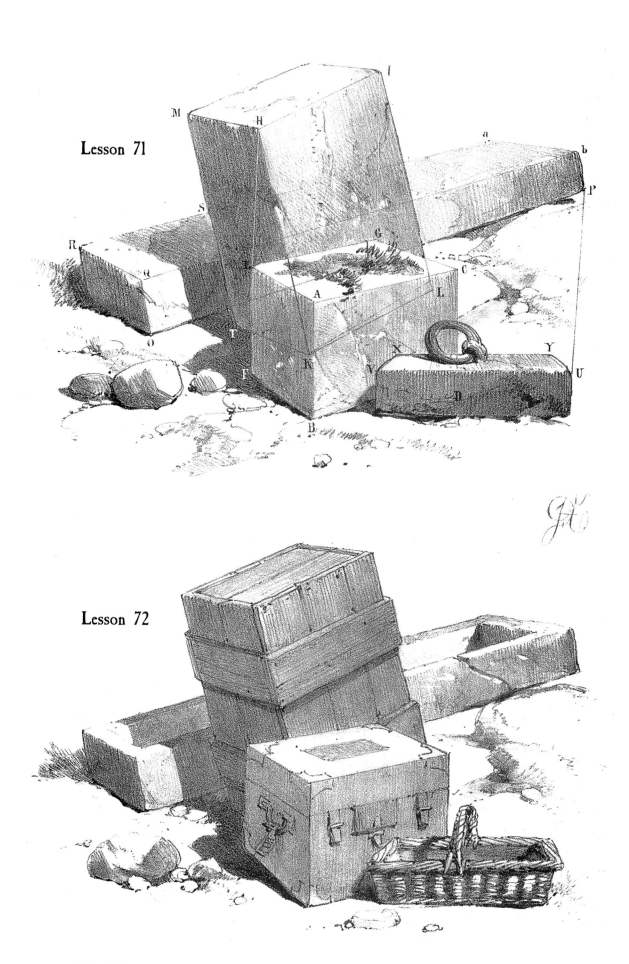

Lesson 71

Lesson 72

Pl. 15

LESSON 71.

This Lesson consists of a number of rectangular stones of different proportions, and quantities, and in irregular combination. Although the outline of all the stones is more or less broken, you must make your first sketch of them with light and straight lines, taking no notice of their required irregularity till you are satisfied that you have first correctly obtained the form and arrangement of every object.

Draw **A B** perpendicular, or nearly so, and of the required height, then all the lines forming this stone. See that this is strictly correct, because all the others are drawn in relation to it. In order the more correctly to judge if it be accurate, draw it as if the stone in front of it were not there; the portion of it which is hidden by that stone is so drawn here. Next draw the perpendicular line **E H**, and having decided on **H**, fix **K** on **A B**, and draw **H K**; now complete this stone, bearing in mind what has been said about the decrease of lines according to their distances. The accuracy of **I L** will be judged of, not only in its relation to **H K**, but also to **G C** where it cuts that line; and so with **M T**, in its relation to **E F**. The unseen portion of this stone is drawn through the one in front of it, in order to show that there is ground enough behind for it to stand upon.

These two stones being done, draw **O P** of the distant stone, and carry this line, as here seen, across both those in front of it, in order to make sure that the right-hand portion at **P**, and the left-hand portion at **O**, have precisely the same directions, otherwise they will not appear to be portions of the same object. From this draw the other lines, and complete this stone, taking care to make **Q O**, and the corresponding angle at **R**, parallel to **M T**. The place of **S** will be found nearly midway between **M** and **T**. Draw **Q** *b*, and then **R S**, through continuously to *a*. These last two lines must be examined in their relation to **O P**, and to each other, taking care that they are not so widely separated at the further, as at the nearer end. Draw the small stone in front, which has a ring on it, and is a repetition of Fig. 1, Lesson 14. The whole Lesson being now done, you must further examine whether **Q** be level with **E**, or nearly, **V** exactly under **G**, **X** level with **K**, and **U** perpendicularly under **P**, or nearly; whether **R Q** slopes like **E A**, and **O P** nearly as **E G**; and lastly, whether the places of **R** *a* and **Y** be correct, by imaginary lines from **M**, **I**, and **C**, such as have been shown you in Lessons 33 and 34.

If, after having thus examined the sketch, it be found to be correct, you may complete it with the shading : following the examples given, and bearing in mind at the same time the instructions contained in Lessons 29 and 30.

LESSON 72.

This Lesson has been given to afford you additional practice of the preceding Lesson, and to show you that what you there learned is of general application; and also, that whilst you learn to draw one object correctly, you are attaining the power to draw many. If, therefore, the previous Lessons have been thoroughly learned, and the instructions derived from them applied to it, not another word will be required to aid you in completing this. You make the light sketch for this Lesson as you did for the last.

LESSON 73.

THE intention of this Lesson is to afford you instruction in drawing circular objects, placed in a manner similar to those of your last two Lessons, and to show you how the different oval forms assumed by the circles, according to their different positions, may be obtained by the different inclination of the line representing their longest diameter.*

The square stone on which is the base of a column must be first drawn correctly, and the circle outside of **X Y** in reference to it—according to previous instructions. Draw the inner circle with reference to the outer one, observing that they touch at the upper and right-hand parts under the letter **G**, and separate gradually and more widely towards the left and lower parts by **E A** and **A C**; **X Y** will decide if these lines have been drawn truly. Draw **H I, H K**, and **I L**, and complete this portion of a column; then draw the perpendicular **O F**, the slanting lines **O U** and **U N**, taking care where **N** touches **E G**, and complete this object by drawing the curve of the top in reference to its diameter **O U**; let **O P** be parallel to **U N**. Draw now **R Q** nearly at right angles to **F O**, and dividing that line equally at **Q**, and from this line complete the object; then draw the circle **I T V**, having first drawn the perpendicular at **T**, and regarded its relation to **I L**; the line **T Z W** will finish the figure.

The shading should now be added, and here it must be remarked that in every instance on the inner edges, as **E A, A C**, and **I T V**, a line is especially to be avoided, or at least if it must be admitted, it should be drawn so lightly as to be unobtrusive; it is always better, however, that the ends of the lines of the shading should be so arranged as to mark the inner edges of the objects, and thus avoid the necessity for a decided outline; for when shade is introduced the illusion of Art is more powerful, and the outline should cease to be an obtrusive outline.

Compare the shadow of the square stone on the column in this Lesson, with the shadow of the like stone on the trunk of the tree in the next Lesson. In the one, because the object—a column—receiving the shadow, has a smooth surface, the edge of the shadow is even and unbroken; but in the other, as it passes over an irregular surface, it has an irregular and broken edge, and thus by the edge of the shadow, in each case, the different surfaces are expressed. These are universal laws, and the examination of all the preceding and future Lessons will show how constantly they have been observed.†

* The line which, passing through the centre of a circle or other figure composed of curved lines, divides it into equal parts.

† The laws of Nature relative to light and shade, have been amply treated on in the " Principles and Practice of Art."

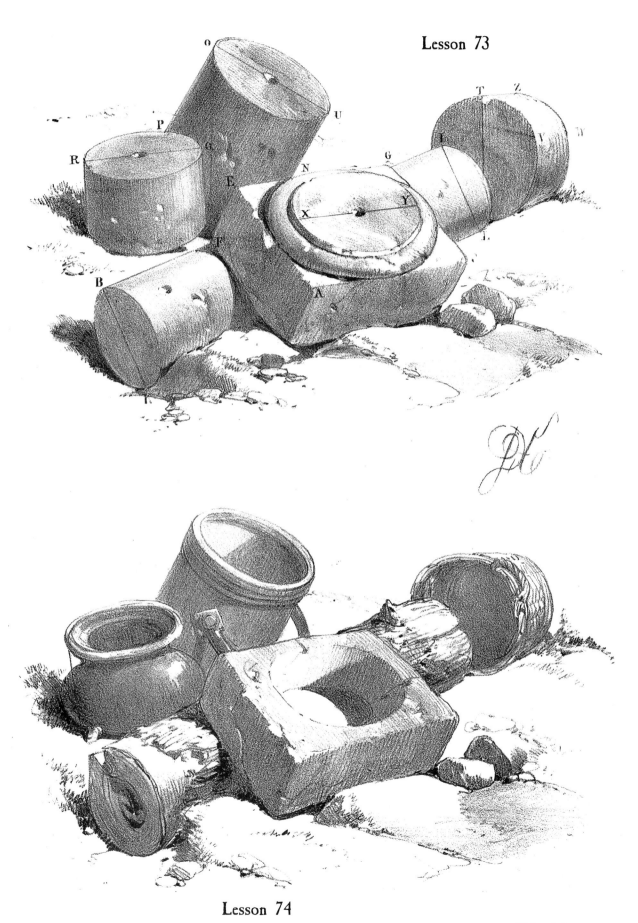

Lesson 73

Lesson 74

Pl. 16

You can hope for no progress unless you commit all these laws to memory. Go into the sun-light, and, placing your pencil upright, allow the shadow from it to fall first on a perfectly flat surface, and then across your fingers. Vary their position, watch the varying form of the cast-shadow, and trace the truth of the observations which have been made to you; not in this instance alone, but in every object around, whether in-doors or out: all will furnish you with additional proofs of their universality. Being able to observe Nature truly is the first step towards a truthful representation.

LESSON 74.

THE intention in giving you this Lesson has been again to show you the general application of what you have learned by the preceding one, and that every observation made applies equally to this, either as regards the outline, or the light and shade. Somewhat more is required in this Lesson to show that one object is generally darker than another, as in the Pitch-kettle, which is darker than the Tub or the other objects. The curvature of the sides of this latter object must be drawn according to the instructions contained in Lesson 70. The auxiliary lines for this object *are* here given.

The shading of this and the previous Lesson you should first lay in lightly with the stump, and then complete with the pencil. All the colour in the Pitch-kettle is obtained by the stump, except the darkest. Whenever, as in this case, any deep colour is obtained by the stump, it should be completed with a soft pencil.

Do not forget to remark how irregular and broken are the outlines of the stone, the trunk of the tree, and the basket, and how much they differ in this respect from the last Lesson.

CONCLUDING OBSERVATIONS.

By the study of this and the preceding Sections, you will have learned those principles on the knowledge of which depends your power to draw objects correctly, and also those universal laws which belong to light and shade.

You will find how true these remarks are, by observing that I have now no more questions to put to you, by way of ascertaining if you possess the knowledge it has been my object to impart—I take this for granted.

This Section has brought to you no new facts and principles; but new evidences of their truth and universality. These have been illustrated by various familiar objects. It is now only necessary for you to look around. Every apartment—that in which you study—all are replete with objects equally illustrative of the principles you have learned, as are those Lessons which I have supplied, and equally confirmatory of their truth. Each is to you an equally good Lesson.

Your attention has hitherto been directed to familiar objects, singly and in groups, in order that your eyes may be opened to see their varying forms, and your hand made skilful to trace them. If, therefore, you have done your duty to yourself, in thoroughly learning what has been put before you, you ought now to be perfectly capable of drawing any circular or rectangular object, and should now exercise your acquired powers in drawing the like from your models or nature—first singly, and afterwards, either in any accidental combination you may see, or in groups of your own or your tutor's arranging. It is only by these means that you can prove whether you have actually acquired the knowledge and power these " Lessons " have so far been intended to impart. If you are still unable to draw similar objects from your models or from nature, it is manifest that your Lessons require to be re-studied. Be sure there is something which you have overlooked, imperfectly comprehended, or mis-applied.

Having the ability to draw what you find in-doors, will be your preparation for the study of what is to be found out-of-doors, and on a larger scale, and to this your attention will be directed in the following three Sections of the " Lessons."

When attempting to draw objects such as tables, sofas, etc., you must not suppose that you are first to draw either a cube or a parallelogram in order to produce the form desired. Having properly studied all your Lessons, you ought now to have acquired sufficient power to do so without such elementary aid.

Most rectangular objects are cubes, or varieties of the parallelopiped ; for this reason I have employed these solids as bases, on which to impart to you a knowledge, not only indispensable to their correct delineation, but which, from being universally applicable, will furnish you with some regular system of study, and enable you to judge of the correctness of your delineation. Just in the same way as a knowledge of the rules of syntax is indispensable to the correct construction of language, so also is a knowledge how to draw these two forms indispensable to the correct drawing of all rectangular objects.

I have endeavoured to teach you, by a simple system, the means by which you may accomplish almost all you could accomplish, were you to follow the science of perspective through all its labyrinths and intricacies, thus greatly facilitating a sure and steady progress. Only such knowledge is presented as you will ordinarily require, and by a method, the results of which are as generally satisfactory as perspective, if not equally rigid, and on which you must continually rely were you profoundly learned in that science. I have sought to avoid burdening your mind with a mass of knowledge seldom required, and certainly not necessary for the early steps of Art. Should you in future desire a further acquaintance with perspective, you will, from having studied by the method here presented to you, be well able to enter on it, and will be prepared not only to understand, but to apply, what you acquire from its study.

SECTION IV.

PREPARATORY OBSERVATIONS.

THE Lessons, contained in the preceding Sections, have been principally confined to familiar and indoor objects, and to those of small dimensions.

In this Section you will enter on the study of objects of greater magnitude, such as you find out-of-doors.

These and all the future Lessons must be sketched in—in the first instance; that is, drawn by light lines, such as are used in all the Lessons of the first Section, regardless of character, and of any small irregularities.

Those general principles which you have already learned, you must constantly bear in mind, as you will find them quite as important in all the subsequent Lessons as you have found them in the preceding.

This should tend to encourage you in the pursuit of Art, seeing that you are at all times learning Lessons of universal applicability, and that the intention of your drawing well whatever has been put before you, is, that you shall be able to draw everything well.

In drawing out-of-door objects, the plan I pursue is, first to teach you how to draw the constituent parts of buildings, such as roofs, windows, doors, etc. The previous Lessons will have furnished you with the power to draw their forms; your attention will now be directed to the methods of characterizing their nature or properties; and then to the study of entire buildings, first singly, and afterwards in combination with others, and other objects.

It is at this point that you enter on the study of what is more properly called Art. There is something beyond the mere description, by lines, of the forms which objects assume: we have not merely to impress the eye, but the mind, with their characteristic qualities, and to raise on it those sensations we experience when looking at them in nature. Thus, after having drawn the form correctly, you evince your talent by adopting any method which shall explain the nature of what composes that form, whether new or old, ponderous, rigid, or rotund, and whether it be proximate or distant. None of these qualities exist in the materials of Art. It is evident, then, that on your ingenuity, talent, and knowledge must depend the degree in which you successfully depict them.

The subjects of which this Section is composed are drawn, with the exception of Lessons 94 and 95, of such dimensions as you may follow. As a general rule, after having sketched each subject by light lines, you must proceed to depict the form and character, in every part by the outline, broad or narrow, dark or light, in every varied degree, such as you see indicated in each example, without regard to the shades and shadows, which may then be added; but not until you have first done the outline as I have described, and that as completely as if it had been your intention to make a drawing in outline only—such as you see in Lessons 94 and 95.

Take the greatest care to draw every line clearly, and at once; and, to prevent mistakes, observe the intention of every line before drawing it, and notice attentively their varieties of colour, from the faintest to the most intense.

LESSON 75.

THIS Lesson consists of a roof composed of the ordinary English flat tiles. You might naturally imagine that it would be desirable to represent *all* these, but not so ; it is quite sufficient if as many be represented, as will give the idea that the whole roof is covered with them, and in such a manner as will convey the impression of its age or newness. Every line might be accurately copied, and no such impression be given.

Take care that you make such an outline as I have described in the preparatory observations ; and, as a general rule, observe, that every line, of every kind and character, should have distinct and well-defined edges. Everything depends on this, for if they be indefinite and woolly, they will fail to represent that the objects they portray are of a hard nature, and therefore they will be bad.

Such lines as characterize the tiles must be placed on the edges **A B**, **C D**, and **A G**. On **A D** and **C D**, the tiles are more plainly exhibited in every respect than on **B A** and **C B**, because they are nearer, and therefore would be more plainly seen, but most plainly at **D**, because there they are nearest. Moss is commonly found on old roofs, and, as here represented, is generally darker than the tiles. In drawing this, care should be taken to preserve its peculiar form, which is constituted of curved lines, contrasting so well with the straighter lines of the roof and tiles. It is this contrast of colour and form which makes it agreeable to us.

Below the line **C D**, the ends of the rafters are usually seen, just as they are drawn in this and in the following Lessons. Between them and immediately under the line of the roof, the shadow is always very dark, and should always be made darkest at the nearest angle **D**; this helps the eye to appreciate the proximity of **D**, and the remoteness of **C**. On the line **A G** the edges of the tiles only are seen, and at **A** you will notice that a curved tile is represented; such are always placed over the ridge of the roof to prevent the rain coming in. In the construction of the roof there are other timbers lying in the direction of **B A** and **C D**; the ends, however, are only seen along the gable at *a a a*. Take care always to make the angles **C**, **D**, and **G** project well over the walls. Compare the copy now made of this Lesson with that which you were recommended to make before you had studied the Lessons in Sections II. and III. The difference should be very striking, and sufficient to convince you that you require the use of your understanding as well as of your eyes in learning Art.

LESSON 76.

THIS Lesson consists of a lean-to roof, very common in Scotland and the northern counties ; it is covered with stones or slates, of irregular form and thickness. All the observations made to you in the last Lesson apply equally to this. On this roof you

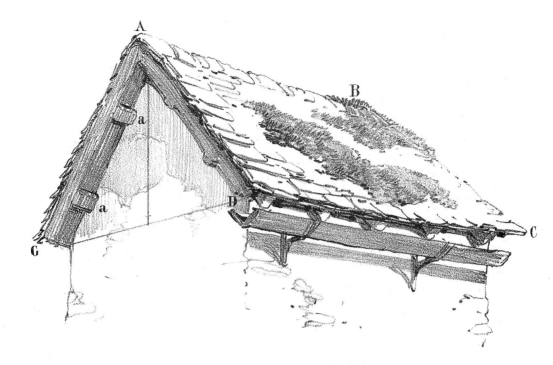

Lesson 75

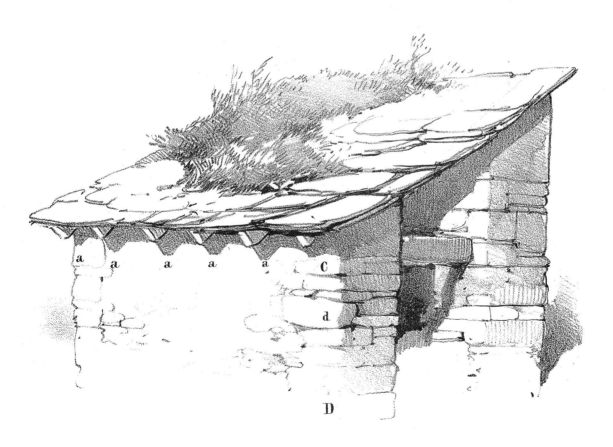

Lesson 76

Pl. 17

have herbage, which, like the tiles and stones, is most characterized on its nearest edge, and most emphasized at the nearest part. Let the lines everywhere be touched with great variety in depth and in form, so as to mark the varied length, the scantiness or the abundance, the compactness or the looseness, of the herbage.

In this Lesson, I may be able to make you feel more completely what I mean by your outline being firm and decided, and everywhere possessing a clear and distinct edge. If you examine the lines you see here, you will find that every one is so drawn.

To give you a still further proof of the extent of nature's guidance, I must refer you to the slates, which, if you attentively observe, you will find that their thickness is first shown by a broad line, or by two narrow ones having shade between them, and that the lower line is made broad or narrow, and very intense, in order, either to show the shadow on another slate, or to represent the dark space seen between them. But for further illustration I must refer you to the lines representing the stones, which you must less regard as lines of varied depth and thickness exhibiting their form, than as the spaces, broad or narrow, which separate the stones from each other, from between which the cement has fallen or been washed away; thus not a line, but a hole, a recess, or a space, has been represented, and the wall is thus made to appear old; some of the stones, such as *d*, seeming to be so loose as to convey the idea of their being easily removed.

Again, you observe the appearance of going-in more emphatically portrayed in the recess or inner part of this shed. If you regard it attentively, you will see that it appears as if you could enter, as if it were more distant from you than the walls. Now this is just what is required: there, it is not actually more distant, but it must have the appearance of being so. To effect this receding of the interior, you must now devote your efforts. To make the slates and stones look loose and hard, and the herbage flexible, is just what constitutes Art, properly so called, and to the attainment of these results the shadow must be made perfectly even, whatever its intensity, and the lines characteristic of the slates and stones around be firm and more intense.

Pay great attention to the shadow of the rafters at *a a*, where they fall on the wall, and to the character of the stones of the building at the angles, especially at the inner angle **C D**. There is no line here; but you are perfectly sensible that **C D** is a perpendicular angle. Mark well the variety in form and size of the stones at each outer angle, and where the lines are tenderly or emphatically touched. Here again, as with the tiles of the roof in the last Lesson, although no more stones are represented than those on the edges or angles, you are perfectly conscious that the whole building is composed of such as are there represented.

LESSON 77.

NEITHER the last two Lessons nor this require any especial instructions for drawing the forms. I shall, however, have to say a word to you about it, because the roof is here composed of a different material, viz., thatch, the characteristics of which are, that it always appears thick and weighty, and, when old, loose, and of an uneven surface, arising from the loss of the straw in part, the growth of moss on it, and the yielding of the rafters, which have bent under its weight. Knowing these facts, you have to inquire whether they are portrayed, not only in this, but in every case; and when your drawing is done, and you compare it, as you ought, with the original, you have to inquire, not whether your drawing has the like lines exactly, but the like kind of lines, in every part as forcibly expressive of the like facts.

Observe, that as in your last Lesson the character of the thatch must be given along the extremities or edges **A B** and **B C**, and that at the nearer angle **B**, and also on the post under it, the lines and shades must be darker and more emphatic. Whilst the lines and shade on the angle **D B** are greatly broken, they generally tend in the direction indicated by those letters, and it is here that you more effectively express the nature of the roof, and more especially in the irregularity of its surface.

Little need be said on this Lesson, as the general instructions necessary to enable you to execute it, have been already given in the two previous Lessons. The chief variety consists in the greater thickness of a thatched roof, and in the difference of character necessary to express it. The straws composing the roof are bound together by twigs of green osier, such as baskets are made of, and are placed crossways as they are here seen.

The angle **A B C** is given, so that you may judge correctly of the slope of **C A**.

Lesson 77

Lesson 78

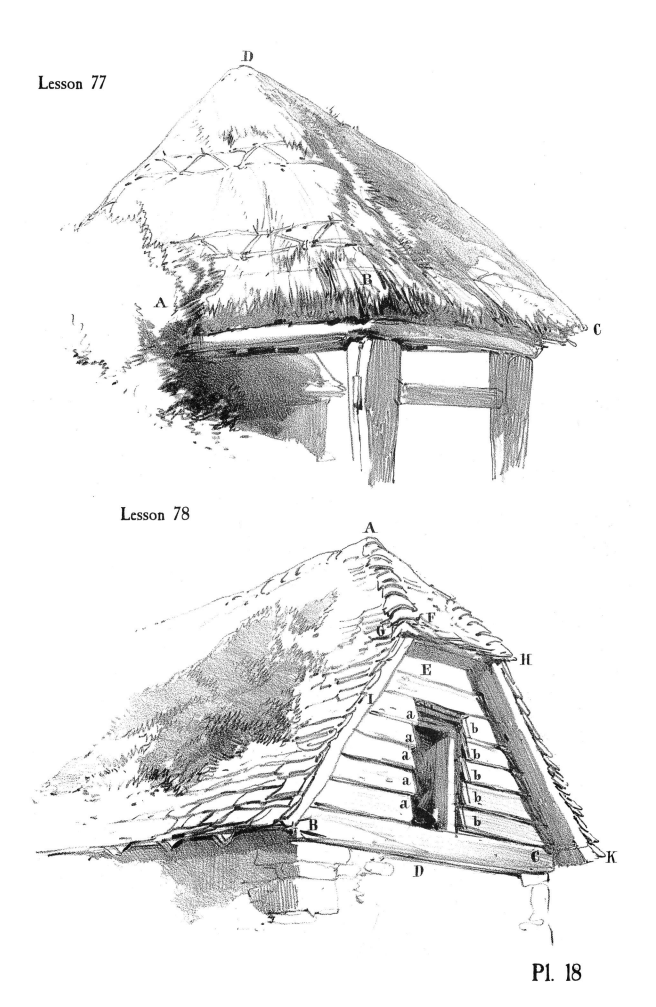

Pl. 18

LESSON 78.

THE subject of this Lesson shows to you a very ordinary mode of forming the roofs of farm-buildings and cottages in England.

Little need be added to what has been said in Lessons 75 and 76. In the tiles here you have an opportunity of practising what you learned in the former Lesson, and in the window what you have learned in the latter.

Divide **B C** at **D,** and set up the perpendicular **E D**; draw the base of the roof at **G H,** and find the apex **A** by the line **A I.** There is nothing more to be observed in the drawing of this roof, than has been noticed in Lesson 77. The peculiarity here consists in the drawing of the curved ends of the tiles on the inner angle of the roof from **A** downwards, and in the boards on each side of the window. They are what are called feather-edged boards, and overlap each other; this is shown at *a a,* and also at *b b,* but at *b b* their thickness is seen together with the framework of the window, and both must be carefully noticed. Take care to observe the edge of the shadow which is thrown on these boards by the projection of the roof at **H K**; let it be very clear, well defined, and broken, so as to express the overlapping of the boards and the consequent unevenness of the surface on which it falls.

LESSON 79.

THE window which forms the subject of this Lesson, differs in no very great degree from Fig. 1, Lesson 14.

Draw the parallelogram **A B C D**, and divide it into six equal parts for the upright divisions of the window, which are technically called mullions, first placing **E F** in the middle, between **A C** and **B D**, as the easiest mode of making all the divisions equal. Do this with single lines, and then place the roof at its required distance, taking care that it projects at *l* and **F** over the sides **A B** and **G H** : then draw the corresponding projection at *m* **I**.

Draw now the double lines of the mullions, showing their thickness in front; and then on each side of these, others, showing that their thickness increases on the retiring sides, and then draw the small sloping lines each way, top and bottom. You will see that in 1 and 2, the glazing is done by reticulated* lines, leaving the spaces white; but in 3 the spaces are shaded, and the reticulations white; 4, 5, and 6 are left blank, in order to show more completely how the shadows of the mullions are thrown. They fall in the same way on the glass. The form of the shadow at **L** and **M** must be carefully given, as it exhibits the angle of the roof at *l*, and the projection at **N I**.

LESSON 80.

THE sketch of this window is very simple : it consists merely of a parallelogram, **A B C D**, divided into four equal parts at **E F**, **G H**, and **I K**. More need not be said on this Lesson, as the last will have sufficiently prepared you, except that the glass is differently shaded. It will be observed that some parts are shaded, and some are quite light. When glazing of this kind is old, some portions bulge out and others retire, thus catching the exterior light, or showing the obscurity of the apartment inside; and it is to represent these two circumstances that it has been shaded as you here see it.

Such a window as this is very common to the humbler class of cottages.

Take care that the shade you put on to represent the interior apartment has a defined edge, and appears to retire. Look to the form of the shadow falling from the mullion of the window on to the curtain.

LESSON 81.

THE sketch of this Lesson is as simple as the last ; the only difference is, that the parallelogram, **A B C D**, is divided into three equal parts. The whole of this is to be proceeded with precisely as the two previous Lessons ; the only difference consists in the greater width, and different proportion of the divisions, which should first be drawn square, and afterwards curved at the upper corners. Take particular care to draw the lines of the retiring sides of the stones at the angle **A B** correctly.

* Crossed in the form of net-work.

Lesson 79

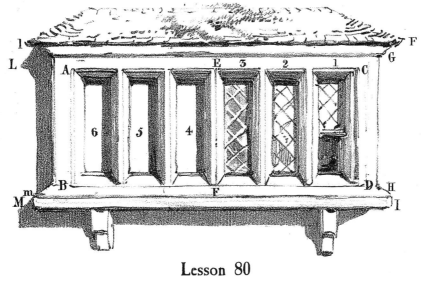

Lesson 80

Lesson 81

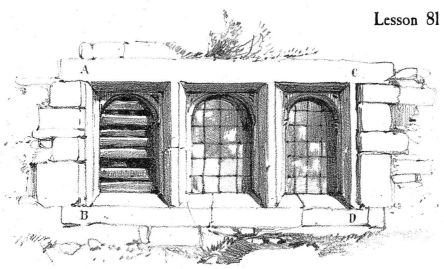

Pl. 19

LESSON 82.

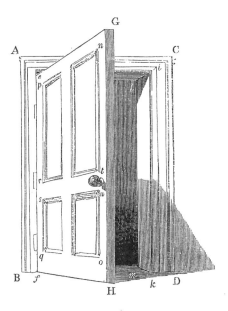

THIS Lesson consists of an ordinary room-door, and is composed of a parallelogram **A B C D,** as seen in front, where you see the opening of the door, and of another parallelogram of the same size, seen in perspective, for the door itself.

The lines *e f,* **G H,** and *i k* are of course of the same height in nature ; *e f* and *i k* being equally distant, are presented here as equal, but **G H** being nearer, must be made taller, because it is nearer, and therefore appears taller. The square divisions on the door are called panels, the spaces between them styles.

When you have drawn the outer line of the door, which is a form you must now be thoroughly familiar with, draw another figure within it, *p q n o,* as if it were only one panel taking the form of the entire door, and then divide it by the style *r s t u,* and also by the middle and vertical one, not here lettered ; always strictly observing what has been said of objects, and their parts, appearing less and less as they are more distant, and employing those means with which you have been made acquainted in various of your previous Lessons. Take great care of the form of the shadow, and particularly at that part where the door closes in. When you have practised this Lesson, draw a room-door from nature.

LESSON 83.

This is an ordinary cottage doorway with a wicket. With its general form, and that of the step, you must be already familiar. It is only necessary to direct your attention to the framing of the door at *a b c d*, so that you may show the sloping lines at the angles which exhibit the inside, or what is called the return of it. You will find that on a smaller scale this is similar to Lesson 33.

Take care also to make the upper and lower edge of the wicket irregular, especially at the lower edge, to show that the boards have been worn by violence or by the influence of the weather; observe also that these boards are neither straight nor of equal width, and that there are lines on them to show the grain of the wood.

The interior is drawn so as to give the idea of an irregular apartment, and is shaded, so as to convey the impression of the darkest part being the most distant. Keep all the edges firm and well defined. The herbage on the left must be attentively drawn. Notice the gradual increase of the leaves from the upper to the lower part, and also of the shade under them, which is darkest just at the corner of the step; and notice also the shadow on *a b* from the edge of the stones at *g h*; mark its depth, and see where it is broken by the light admitted between the broken angles of the stones.

It may seem to you unimportant to notice what will doubtless to you appear trifles; but it is on the power to observe them that the power to draw hinges. I wish you to understand that what has been rightly done must have been rightly observed, and that a satisfactory and pleasing result is not the fruit of genius but of attentive observation.

Lesson 84

Lesson 85

Lesson 86

Pl. 20

LESSON 84.

THIS is a window of more architectural pretensions than those already studied, and is shown as if much above the eye, and in perspective; it is thus that it would be generally seen.

It is only necessary for you to draw the line **C D** of any length, fix on the inclination of **A C**, and proceed by what you have learned from former Lessons.

It must be here observed that the retiring side of the mullion **E F** is now very unequally seen, scarcely at all to the left, and entirely on the right. The division at **G H** is technically called the transum, and is formed just like the mullion. The sill, **B D**, on which the mullion rests, is made to slope, and so is the transum, that all may throw off the rain and moisture.

The label **L I K M** must be carefully drawn, so as to show the moulding of it.

LESSON 85.

THIS Lesson consists of the window of Lesson 81, seen in perspective. You should already know how to sketch it, and how to form its divisions, from the instructions you have received in Lesson 41. A little within the outline **A B C D** is another line all round, leaving a space nearly equal to the thickness of the front of the mullions. Only one of their retiring sides is now seen, the varied moulding of which you must very carefully mark by lines at each end, but more particularly by the light and shade. The marks across each mullion, showing the divisions of the stones forming it, assist materially to show how it is moulded.

LESSON 86.

THE window in this Lesson is a repetition of Lesson 79, with this difference, that it is here seen altogether in perspective, and divided into four parts only. The instructions conveyed to you in that Lesson, and the subsequent ones, are sufficient to guide you in accomplishing this, and must be borne in mind: such as first drawing the general form, then finding the places of the mullions, so that they and the window may be made shorter and narrower in proportion to their distance—the projections of the mouldings, and of the roof at the angles—the form of the shadow and its evenness —and where the character of the roof is to be placed and emphasized, etc.

LESSON 87.

But little more need be added to the instructions already given, to enable you to execute this and the following two Lessons. What has been said on the drawing and construction of roofs, their shadows, and those of the ends of the rafters, where the tiling is to be characterized, and when most emphatically, is equally applicable to these Lessons, which are composed of two dormal or roof windows, represented as if above the eye, which is the view you generally have of them.

This Lesson must be sketched out by first drawing the line of the roof **A B**, and then **C D E F**; afterwards place the window *i k l m* within it, so that the space between *i k* and **C D** may be less than between *l m* and **E F**. The framing of the window is only seen on the further side, and at the top. In this Lesson the foreshortened tiles on the ridge of the roof at **G H** are more plainly shown than in any previous Lesson. In this view, as in Lesson 78, you see their curvature, but not their real length.

LESSON 88.

After having drawn the general form of this Lesson, which is like Lesson 19, but reversed, divide the front of the window into three parts; and when completing this subject, take care of the form of the shadow thrown over the divisions at *a a* by the board above them, which shows that one is square and the other round, and that this shadow becomes broader as it falls farther back on the glass. Thus we see that the irregular surface formed by the glass and the divisions is mainly, if not entirely, expressed by the form of the cast-shadow; and so is the irregular surface of the roof by the cast-shadow from the window. In the drawing of the boards at the left-hand side of the window, you will see that their outlines are always darker and sharper than the lines of the general shade, and that these latter are allowed to be seen sufficiently to express at the same time the grain of the wood. Take care that the ends of the boards next the window are light, and that they are separated by well-defined touches of very dark shade.

You have here again, as in Lesson 76, the shadow of the end of each rafter on the wall at *b b b*.

Lesson 87

Lesson 88

Pl. 21

Lesson 89

Lesson 90

Pl. 22

LESSON 89.

THE subject of this Lesson will remind you of forms you have already been made acquainted with in Lessons 39 and 48 ; but, as it is here drawn to a larger scale, the parts are more clearly shown, and require somewhat more explanation. You have one arch within another ; the outer one must be first drawn, and for this you prepare a skeleton form precisely similar to Fig. 2, Lesson 21 ; taking, as in that, F E for the springings of the arch, of which *a* is the centre or key-stone, and from this the lines lean each way, exactly toward a point placed in the centre between F and E. After having drawn this outer line, you draw one within it to represent the thickness of the wall, or rather, how much the inner arch recedes.

To draw the inner arch proceed with that as with the outer one, and take the upper line of the beam which crosses it, as its springings. Finish the beam, and form the upper lines of the doors in reference to that, and the lower lines by observing that they slope in an exactly contrary direction.

Whilst doing these doors, refer to the second paragraph of Lesson 83. Every observation therein made on the wicket gate applies equally here to the doors.

Although this Lesson is more complete than any you have had, it contains no alarming difficulties. Like as in Lesson 76, you have every variety of thickness, and depth of line, marking the divisions of the stones ; and although the perpendicular angles of the wall are preserved, yet mark how those angles are broken and indented. The essential import of this Lesson is to convey the idea that you can enter the apartment,—a wagon-house. Now, this idea is due to the evenness of the shade, the entire absence of any lines, or irregularities in its colour, and equally, if not more than all, to the sharpness and clearness of the lines which form its limits everywhere ; whether of the arch, the doors, or the cross-beam, to which the shade comes close up. Observe that all these things are equally attended to in your drawing ; and take care to preserve the form of the shadow of the stick on the wall, and of the right-hand half of the door on the ground. If you remember, as you ought, what you have learned from the observations on shades and shadows in Section II., you will find that they have been in this example most rigidly observed. I must also direct your attention to the shadow cast by the angle E F of the outer arch on to the inner one : not only does this shadow become irregular from the irregularity of the surface it falls on, but additionally so from the broken angle which casts it.

Whatever observations are at any time made to you, and whenever you are directed to regard the example to which they are annexed, it is by no means intended that you should regard that only as evidence of their truth; but, remembering what you have read, you should look for parallel circumstances in past or following examples for corroboration of their truth and value. Take, as an instance, the lithographic example of Lesson 107 as a further illustration of what you have learned here.

LESSON 90.

THE intention in this Lesson on Plate 23, is to afford you practice in producing shade and shadows of varied intensity, and to explain more fully what is meant by shade and shadow.

The opening of the doorway and the step are nearly a repetition of Lesson 36, with the exception that the opening is wider, and to it is appended a door whose outline is exactly like the one in Lesson 93. Therefore what you have learned from these two Lessons will be sufficient to enable you to make the sketch.

The view of the doorway is from within the apartment to which it conducts, and this is in shade; but the upper part of the door, and the door post, are under shadow from the upper part of the door; and the steps are *under shadow*, in part from the wall on the left, which is itself in *shade*. Its outline completely represents how the corners of the stones of an old wall are broken away. On looking at both these *shadows*, it will be seen that they are darkest just where the light is brightest, as on the door-post, and the door-sill. *The proximity of the darkest part of a shadow, and the brightest light of the object on which it falls, is an invariable law of nature.*

This law of all cast-shadows, may be most plainly observed on all white or light objects. More information is not required to aid in executing this Lesson than you have obtained from your previous Lessons.

Lesson 93

Pl. 23

LESSON 91.

THE chimneys constituting this Lesson have been given to show you the method of drawing such as are ordinarily built in England; and, with the other Lessons on this page, are intended to illustrate further the necessity, when drawing Architecture, of always marking with great care the projection of the mouldings beyond the general outline.

One of these chimneys is of brick, and is placed on the side of the roof; the other is of stone, and is placed across the roof. Both are alike in their several divisions of bases, shafts, and caps, and are composed of such figures as your early Lessons will have rendered you familiar with. These divisions are separated by mouldings at **I K G H L**, and **M**; the sloping lines of which, and also the courses of the bricks and stones, must increase in their slope the more they are above the roof on which the chimneys are placed. The perpendicular lines of the shafts in each chimney serve to show you how much the mouldings and base of each project beyond it. Here the instructions contained in Lessons 40 and 42 should be again read over, before you attempt to complete the chimneys.

I would have you compare these chimneys with each other, to become sensible of the different expression of age conveyed by each. In consequence of the narrowness and sharpness of the lines showing the divisions of the stones in one, and the broader lines used in the other, to show the divisions of the bricks; the neatness and precision of the angles in one, and their broken condition in the other, you thus depict clearly that one is comparatively new, the other old. Refer, if necessary, to what has been said in Lesson 75.

LESSON 92

Is a chimney usually constructed on the gable of stone cottages, and is common to Wales, the North of England, and Scotland. Although much simpler than those of the preceding Lesson, in its projections at **A C** and **F**, in its top at **H** and **I**, the stones composing it are of more irregular forms. This example, as well as the others, is here given on a large scale, in order that you may completely understand the details of form, construction, and light and shade, so that when these chimneys are found attached to buildings on a smaller scale, the touches, then consequently small, may be perfectly understood, and their meaning appreciated: not looked upon as trifling touches, straight or crooked, placed at random, and without purpose of any kind.

It is the great business of these Lessons to show, that for every line of every kind a satisfactory reason can be given, and thus to prove, that the power to depict an object by Art, comes from a previous knowledge of Nature; that everything seen in the original is not only not the result of chance, but can be clearly demonstrated, and so should it be in your copy. Your eye cannot be trusted until your mind has taught it to search for the immutable truths of Nature, and then you see them, but not before.

In this Lesson you will hardly be able to trace any of the lines of the shading. After the shades have been done as usual by lines, they should be lightly passed over with the stump. Great care is necessary in using this instrument, not to damage at any time the precision of the edges; unless these be perfectly kept, your drawing will be more injured than improved by the shading.

I make no further remark to you on this Lesson: you ought, by this time, to know all else concerning it.

LESSON 93

Is an ordinary Italian chimney, and differs in its general form but little from Lesson 40.

The roof of course is composed of Italian tiles, of which you will find more said in Lesson 122, but as the space for exhibiting these is here small, it is the more imperative that every line or touch should be effective. You should examine the lines which represent the tiles on the left-hand side; these not only show the course they take, but at the same time afford the idea of that side of the roof being in shade. You should then look at the inner angle of the roof, and such lines and touches as you see at its base on both sides: however small they may be, they have their intentional significance.

The shaded side of the shaft of the chimney, is done almost entirely with the stump.

Whenever you use the stump, it should be immediately after the outline or sketch is done, for if you were first to put in the lines for the character, the stump would smear them in passing over.

Should there be any irregularity in the shading, it should be filled in afterwards with the point of the pencil.

Pl. 24

Lesson 95

LESSON 94.

THE intention of this and the following Lesson is to show you how the simplest exterior form may be rendered pleasing by varied and interesting features, and according to the degree in which the details of those features are represented. It is also my intention to give you some notion of how much may be expressed by a few lines, if the hand which executes them be guided by knowledge; and precisely because they are few in number, is it the more important that they should be true in purpose.

The form, although reversed, differs but little from Lesson 13. The minor features you already know. On examination, you will find that round the gateway and the windows, and along the angles of the building, the stones are carefully marked in every variety of form and expression. Some few independent markings also occur on the surface, in order to convey the idea of the solidity of the whole fabric. The form of the rock, also, must be carefully drawn, as well as the lines of the road approaching the gateway, which is Lesson 89 in miniature, as these contrast with the lines of the building, and add to the interest of the whole because they increase its variety.

LESSON 95.

THIS Lesson is intended to exercise you in drawing round towers, and to show you, by comparison with the previous Lesson, how much more pleasing an object is whose general form is varied, even when it has but little interest in its minor features, than one whose general form and features are like that of the previous Lesson.

This subject depends almost wholly on its form, and the lines of the ground are so associated with those of the building, as to increase the variety of the whole. To this end the towers are neither of them of the same height, nor of the same diameter, neither are they divided alike by the stone courses, nor have they windows of equal size or in like relative positions.

As this subject is expressed almost wholly by the outline, great care must be taken to give it varied emphasis,—sometimes making it light and tender, and at others dark and firm.

LESSON 96.

THE cottages in this Lesson are a repetition of Lesson 36, but reversed, and are intended to show you that if, as here represented, they are more interesting, they are so in consequence of their evidence of your greater knowledge of the subject, and from the greater number of ideas suggested to the mind. Short of colour, the mind is in possession of nearly all it can require.

In the roofs you will find all which you have, or ought to have, acquired by the study of Lessons 75, 76, 77, whether, as regards the method of their construction, the mode of characterizing the materials of which they are composed, or how, where, and why, they are to be emphasized. The window on the front of the thatched cottage is a repetition of Lesson 80, or nearly so; and, although it bears no comparison with that in point of size, it still exhibits as much truth.

In looking over these cottages, you will see that neither in the roofs, nor on the walls, nor in the shades or shadows, either as to their intensity or the mode of producing them, has one thing of all which has been previously placed on your mind and before your eyes been forgotten or omitted. If, therefore, this drawing be more satisfactory than Lesson 36, it is not because it is more finished, as you might erroneously say, but because it carries home to the mind a greater number of truths. It is more complete—not more finished.

If the lines, here expressive of the different materials of which the cottages are composed, whether stones, thatch, or tile, be examined, not a line in them will be found actually like the Lessons referred to, but the kind of character adopted in each, and the truths exhibited, are identical. Hence, then, I cannot too often repeat, nor can you too sufficiently understand, that the advantage to be derived from each drawing presented for your study, does not consist in your making an exact and fac-simile imitation of it, such as might be procured by an exercise of patience and a correct eye; but in your carrying out in your copy with equal force those truths which your instructions should have prepared you to recognise in the original. It is not the likeness of your copy to the original, mark for mark, dot for dot, or shade for shade, which in any case constitutes its merit or proves your attention, skill, or progress, but in your never failing to exhibit the same facts, great or small, and in conveying impressions of the same truths with the same force. All these you may perfectly accomplish in your copy, without one line of it being identically like the original. Consequently the merit of your copy does not depend on its exact likeness to the original, such as may be made by one entirely ignorant of the intention of any

Lesson 96

Lesson 97

Pl. 25

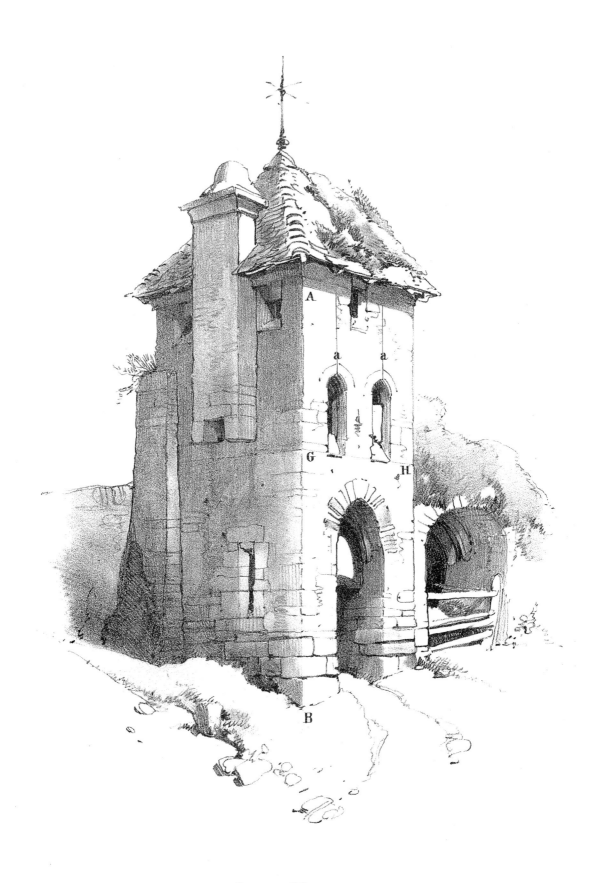

Lesson 98

Pl. 26

line of it, but in so far as it proves your perfect comprehension of the objects sought, and their achievement by independent means, rather than by slavish imitation. The merit of your copy is therefore to be judged of, not by its servile likeness to the original, but rather by its producing the like impression on the mind, and with equal power.

LESSON 97.

THE subject of this Lesson is a repetition, or nearly, of Lesson 37. In that, the only object was to obtain the general form; in this, the intention is to add the various features and character, and to give to it additional interest by increasing the number and variety of the minor forms, with variety and intensity in the shades and shadows, so as to render the whole brilliant and emphatic.

In this Lesson you will see, as much as in any other you have had, that the shades retire,—that is, they appear to go in, and to be more distant than the light parts, whatever may be their depth; and this effect is dependent, as I have already told you, on the sharpness and purity of the outline which encompasses it. Were this not observed, every shade here between the boards, and elsewhere, would appear nearer than the boards themselves, and every intensely dark shade, a blot.

Look well to the cast-shadows from the roof, etc., on to the boards, and also over the trunk of the tree, and its shadow on the ground, and see how their irregularity of surface is explained, and bear in mind the observations made to you in the last Lesson.

LESSON 98.

IF it were not for the study and the knowledge you have already had and acquired, this Lesson might at first sight appear too difficult; on examination, however, you will find that it is only a combination of what you have already passed through. In its general form it is, with the exception of the buttress on the left, a repetition of Lesson 40; the chimney is that of Lesson 92, or nearly, and the door and archway are but modifications of Lessons 89 and 90. Here then you have a simple form, which, as you found it in Lesson 40, hardly engaged your attention; now made interesting, because it has attached to it many attractive features. The merit of the whole must depend on the merit of the separate parts; these you have already studied in former Lessons,—you have but to repeat them here, in the broken character of the roof, and the form of the moss on it;—the character of the stones in the broken lines at the outer edges,—and the yet more effective expression of age on the inner angle **A B**;— the varied form and size of the stones, the variety of the lines which express the spaces between them;—the way in which the courses of the stones slope as they are above or below the eye;—the general form of the arched doorway, and the different inclination of the lines which exhibit the stones around it, etc., etc.

Draw first the general form, then the buttress, and the two angles of the chimney which touch the roof of the tower, whose true places you find in reference to that; next the two small windows at *a a*, must be so placed that they may appear as if they really were in nature on a level with each other; but as the one is further off than the other, it appears to the eye to be lower down, and the degree in which it appears to be so, is decided by the line **G H**, which shows what would be the inclination of a course of stones at that height, and therefore what would be the apparent inclination of a really level line, or of two objects which, like the windows, are really level with each other. Besides their apparent height, their apparent places must be determined. Each is at exactly the same distance from the angle at **G** and **H**; but as the distant space would appear the least, so the further window must be placed nearer to **H** than the one on the left is to **G**: the perpendicular line from each of these windows decides for you their places.

Having made your slight sketch, complete the whole in outline like the Lessons 94 and 95, and lay in the shaded side of the tower first with the stump, which may afterwards be made darker and more even with lines from the point of the pencil; this method prevents the lines from appearing too evident, which is always to be avoided. Take care to give the oblique line of the shadow from the outer and inner arch of the gateway, and to mark the stones of the left angle which tell against it.

I might say more to you on the subject of this Lesson, but it would only be to repeat what you ought already to know, and if you do not, this is not the Lesson you should have in hand.

CONCLUDING OBSERVATIONS.

IF you have possessed yourself of the instructions contained in this Section, you will be well prepared for the more enlarged study which your future Lessons will open out.

In the course of the study of what is herein presented, you will have become acquainted with the details of various parts, each separately studied, and although, in the course of their execution, what you have been called upon to notice may appear trifling or unimportant, yet it is on the power to make these observations, that the power to draw hinges. It must be manifest to you, as I have already said, that what has been rightly done must have been rightly observed, and that a satisfactory and effective result is not the fruit of genius, but of attentive and correct observation.

In order to test your progress, you should attempt to draw from nature such objects as constitute the Lessons in this Section, which you will be able to accomplish with facility, and with the same ability you displayed in the copies, if you have really learned the reasons and the principles these Lessons have been intended to place before you, and provided also you have tested the acquisition of each Lesson, by drawing it from memory. It is no proof that you have learned a Lesson because you have copied it exactly, any more than your progress in language is proved by your ability to copy correctly a correct sentence. If, on the contrary, you can express the same sense by the same or similar words, spelt and arranged with equal regard to the orthography and syntax, then you have understood the language, and you can express ideas beyond those contained in your exercise; but not till then. Such it is with drawing.

Indefatigable and earnest pupils will be content to work out the truth patiently, whether on a large or a small scale; the superficial and the impatient, disliking the labour necessary to acquire knowledge, are happy if they can possess themselves of an easy and specious substitute, and are, therefore, anxious to have what they call bold examples, which demand but little labour, and less knowledge to imitate.

Bold examples are either the efforts of ignorance to wear the garb of knowledge, and, if possible, to be mistaken for it; or, if they display real power, they would be as much beyond the imitative faculty of a student of drawing, as the production of passages of poetic expression, equal to great writers, would be to the students of language, before he had even learned the connexion between the verb and its nominative case.

The difference in the meaning of a word depends on its place in the sentence, on a syllable or a letter; if these be not too trifling for the proper acquisition of language, why should similar and parallel observations on Art be so considered? Those who look on Art in any other light than as another language, equally difficult of attainment as a language of words, or attainable on any other than similar terms, view it falsely, and for that reason will never attain it.

SECTION V.

PREPARATORY OBSERVATIONS.

In this Section, you will be taught the application on a larger scale of what you have already learned. The instructions hitherto given to you, have been chiefly confined to, and founded on, the method of drawing a cube correctly, and in any position when seen below your eye, and also when other cubes have been associated with it in various ways.

Here, the intention is to show the cube again to you, but with additions, and on so large a scale, that all, or the greater portion of it, may be above your eye. It is subdivided into equal parts, so as to show them of a magnitude in exact relation to the whole cube,—to their distance from the eye,—and to the degree in which they may be seen foreshortened. These are the difficulties with which the science of perspective contends, and my desire is to enable you to master them, and be competent to draw all objects satisfactorily, such as may in a general way come before you, without having occasion previously, or simultaneously, to contend with the difficulties and complexities annexed to that science.

The most elaborate and ample knowledge of perspective will not enable you to draw an object with perfect exactness, unless you have previously obtained correct measurements of it, drawn to scale, and other pre-requisites : but, as these are all completely unattainable, under ordinary circumstances, you can only approximate so near the truth, that an educated eye, being unable to discover any error, may receive what has been done as true. We are, for the most part, left to the exercise of the eye and the reason ; I therefore take you up where that science would leave you, and endeavour to educate you to see what is correct, by conveying a like knowledge on a

simple system, and leaving you by its practice, to acquire a sufficient degree of accuracy. This, it is true, will fall short of that extreme accuracy which is only attainable on such difficult conditions, and is hardly ever necessary to any but architects, or architectural draughtsmen, or to such persons as desire to draw buildings of numerous parts and elaborate detail, and to whom the study of perspective as a science is really indispensable.

It must not be understood from this that I propose to supersede the study of perspective; my object is to prepare your mind to demand, and to receive, so much of it as may be useful, not to burthen it with knowledge, the utility of which cannot at once be seen, and never may be necessary. I intend, therefore, in a future division of this work, to present such a knowledge of the subject as may enable you by its application, to make sure in any case that your eye has not been deceived; to use a knowledge of perspective as a test whether truth has been obtained, rather than as a primary condition of obtaining it.

In this Section, you will find entire buildings of various kinds, combining the parts already separately studied in Section 4, thus affording opportunities for exercising your acquired knowledge whilst endeavouring to extend it. When first sketching these larger objects, you will find frequent occasion for what your earliest Lessons have taught you, and you should be at great pains to acquire the power of drawing lines as much as possible through their entire length.

Every Lesson supplied in this Section should be drawn by you on a larger scale, and always in outline completely, previous to the shades and shadows being added, except when and where you have occasion to use the stump. If you at once refer to the examples of Lesson 113, you will there see the aspect your drawings are always, in the first instance, to present.

The power to express your intentions in outline only is a very important acquisition. In the first place, it is a kind of brief translation, and, in the next, you learn an expeditious and terse method of drawing forms, and of expressing certain ideas. You will find yourself often able thus to gather from nature, in a kind of short hand, what you could not have time to complete more fully with the shades and shadows.

LESSON 99.

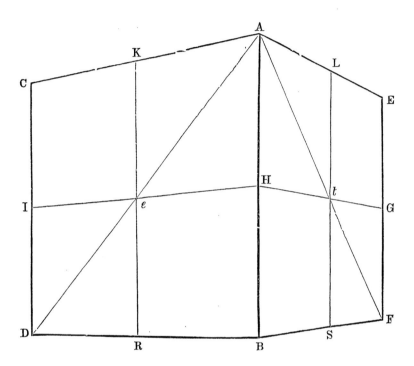

THIS, and the following diagram in Lesson 100, are given with the intention of instructing you in those principles by which objects on a large scale may be drawn accurately, when they are seen in perspective; that is, to show you how the apparent slope of the horizontal lines of the retiring sides of objects may be truly represented, so as to accord with the degree in which the side or surface is seen foreshortened, and with the distance of their upper, lower, and intervening lines either above or below the eye. Every side, surface, or face of an object, when seen, so that one angle or limit of it is nearer the eye than the other, is said to be seen foreshortened.

Here, as in the former Lessons, the instructions are founded on the cube, which is represented on so large a scale, that the upper lines of it are considerably above the eye: because it is intended to be applied to buildings, the greater portion of which is much above the eye, when they are viewed from near the level of their bases.

Reference has frequently been made to Lesson 42, and if it be well remembered, the Lesson here given to you will be found perfectly analogous to it; precisely the same principles are here carried out, only on a larger scale, which will not on that account present any additional difficulties.

The diagrams, either as here given, or when applied to your future Lessons, must be drawn with rigid accuracy, and should therefore be executed with the ruler and compasses.

Draw the line **A B** of any height, then **C A**, which being foreshortened, does not appear of its real length, and therefore should not be so long as **A B**, and being much above the eye it appears to slope down; then draw the line **C D** and compare it with **A B**, and lastly **D B**. If **C A** has been drawn of its required length, and **C D** of its required height, **D B** will be right, both in length and inclination; but not otherwise. Divide **A B** equally at **H**, and **C D** equally at **I**, then draw **I H**, and the diagonal **A D**. Where it crosses **I H** at *e*, set up **K R**. Then draw **A E**, which, you must observe, slopes more than **C A**, and being more foreshortened than that line, must appear shorter. When fixing on the point **E**, previous to drawing **A E**, take notice that it is below the level of **C**; then draw **E F**, which must be shorter than **C D**, because it is farther off; and lastly **B F**. Divide this face, by the upright and diagonal, as **A B C D** has been divided.

You will see that the whole cube has been divided into eight smaller ones, and may be regarded as one figure, or as constituted of eight parts, having their forms drawn exactly as they would be seen in their different positions.

LESSON 100.

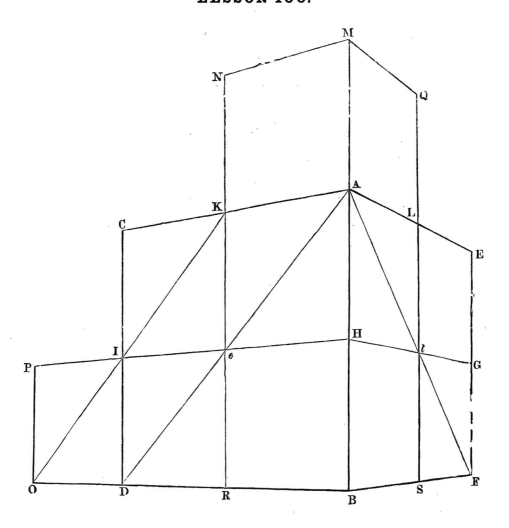

THIS diagram is a modification or extension of the preceding one; and to accomplish it with ease and truth, a figure precisely like that of the last Lesson must be first drawn. This being done, make **A M** equal to **A H, K N** equal to **K e**, and **L Q** equal to **L t**; then draw **N M** and **M Q**. These two lines are thus found to slope more than **K A** or **A L**, because they are still more above the eye, and this top cube, having been so drawn, has *precisely* the shape it would assume, according to its relation with the others.

Extend now the line **I H** towards **P**, and **D B** towards **O**; then draw the diagonal **K I** to **O**, and on **O** set up **O P**. Thus will another cube be added of its true form and size, according to its distance.

If the perpendiculars were divided into any equal number of parts, as in Lesson 42, and lines were drawn to unite these divisions, each line would be found to have a different inclination, in exact accordance with its difference of position. Do this for the sake of practice.

LESSON 101.

Your success in drawing the barn, which is the subject of this Lesson on Plate 27, will depend on your being capable of drawing correctly the diagram given in Lesson 99.

Assuming this to be done correctly, with the ruler and compasses, as recommended, you will find, that by this framework, you have obtained the lower line of the roof at **I H**, the position of the gable at **L**, and the ground-lines **D B** and **B E**.

When the thickness of the gable has been drawn, which brings its lower corners projecting beyond **H** and **I**, and its apex higher than the line **A E**, the upper line of the roof should be made to slope like **C A**, which will serve you as a guide; its length must of course be determined by **I H**, but it must be less because of its distance. The slope and height of the log which leans against the roof may be readily determined by comparison with the perpendicular line **A B**; and in like manner the position and form of the door, the door-opening, the palings, and also of the style, may be ascertained with accuracy in the same way.

The various slopes of the lines of the boards at the gable end must be decided by the lines of the diagram **A E, H G, B E**, according as they are found proximate to either, like the courses of the stones in Lesson 42; but they must be determined by your eye, which ought now to be practised enough to judge accurately. The chimney will be found to slope in front exactly as **A C**, but on the retiring side to the right it slopes like **A E**. The upper and lower lines of the door, with the cross pieces to which the planks and hinges are fixed, slope like **I H** and **D B**, and you must now understand, *that the lines of all surfaces which retire in a like direction, or face the same way*, will have like inclinations; thus it is with the door, and the side of the barn **I D H B**.

The form of the barn being now obtained, you may add the light and shade and character, but first rub out the lines of the framework.

For the roof, you will refer to the instructions given in Lesson 77; for the shading, and for the shadow of the log, to what, in Lesson 70, has been said on the shadow of the broom, and on cast-shadows generally.

Take care to preserve the general forms made by the grass on the ground, and to express the grass itself by lines of varied intensity and varied inclination.*

* On the subject of grass and herbage, see " Elementary Art," pages 74 and 75.

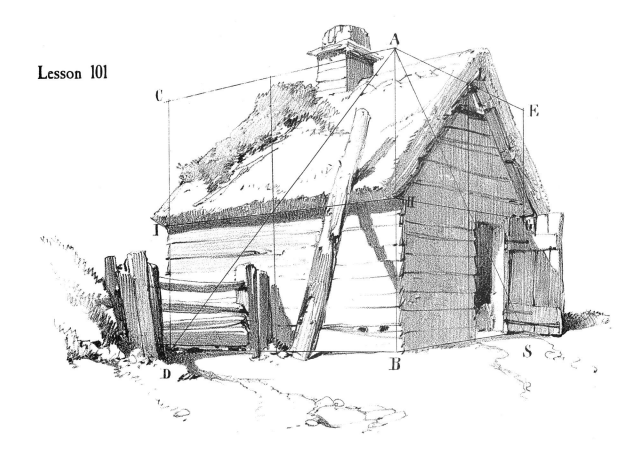

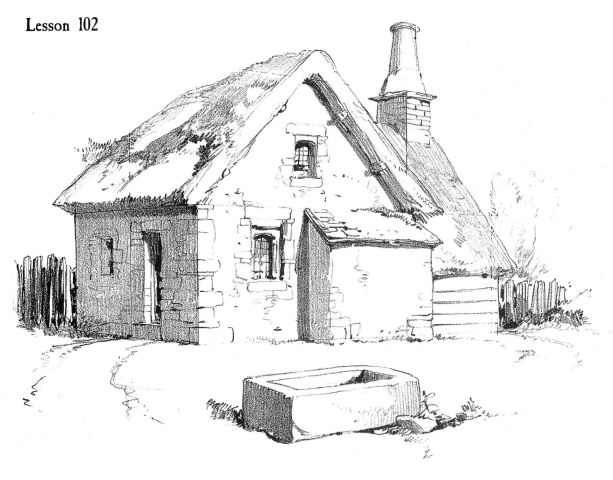

Pl. 27

LESSON 102.

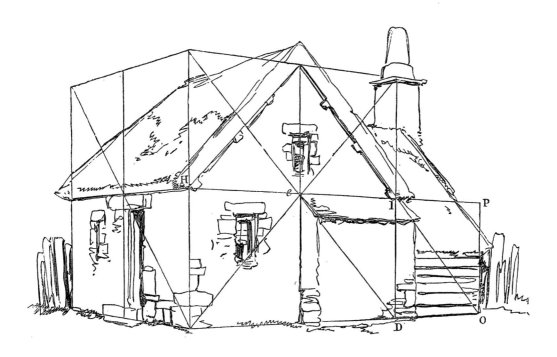

By reference to the wood-cut you will see that this Lesson is constructed on a cube or diagram, one side of which is more foreshortened than the other. This subject must be drawn exactly as the preceding Lesson, with an additional square **D I O P**, obtained like that in Lesson 100.

The lines of the diagram alone are a sufficient indication of the lines of the cottage, to all which the remarks made in your last Lesson apply. When drawing the chimney, you must remember what has been there said with reference to the inclination of the lines of objects whose retiring surfaces have like directions. The stone trough in front is a repetition of that in Lesson 68.

These subjects you should draw of different proportions, generally larger, and add the shade and character. It would be desirable also to draw them a second time from memory, and without the least assistance from the original, relying entirely on your previously-acquired knowledge, in order that by this practice you may be the better prepared for the more complicated forms of the future Lessons, and also to prove incontestibly, that every step which you make in advance, is due to the progress of your mental knowledge, simultaneously with your increased accuracy of vision.

Such exercise as this will strengthen your memory, and make you more capable of depending on yourself. The comparison of your copy thus made with the lithograph example, shows at once what you have completely acquired, or what still needs more of your attentive study.

LESSON 103.

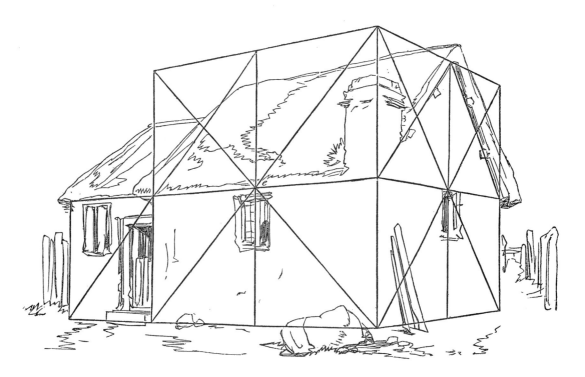

In order not to encumber and disfigure the original drawing by the diagram, I have here, as in the last Lesson, added a wood-cut, which, besides relieving the drawing of lines injurious to its effect, serves better to show you how the whole subject should be sketched in the first instance.

The diagram in this Lesson is like that in Lesson 102. It is not here lettered, nor are any directions given as to the order in which the lines are to be drawn, as I presume the previous Lessons will have made you familiar with the mode of drawing the diagram, and as the subject is composed of features and materials to which the attention has already been directed, no further observation need be made on them. Although the form of the subject differs from the Lesson referred to, it is yet so simple, that the diagram, together with the instructions of the previous Lessons, will be sufficient to ensure your drawing it correctly.

LESSON 104.

THE cottage which forms the subject of this Lesson isprecisely the same as that of the last, only differently viewed. In the former Lesson you found it drawn as it would appear to a person seated nearly on the ground; in this it is represented as if seen from a higher building, or from higher ground: every line, therefore, tends upwards.

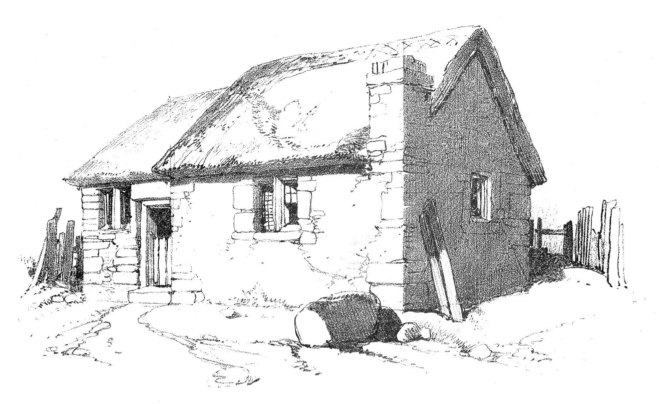

Lesson 103

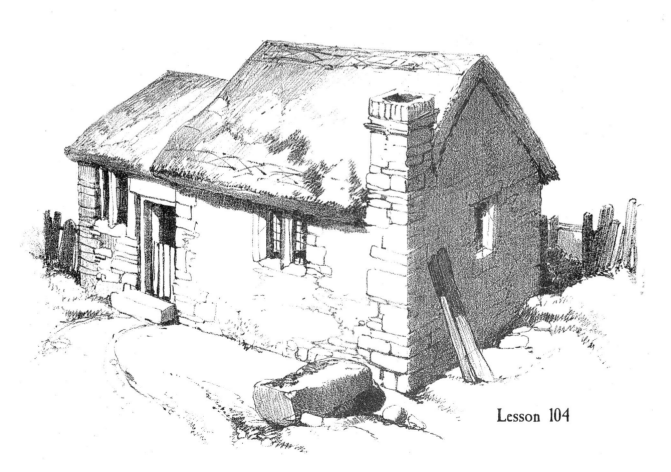

Lesson 104

Pl. 28

The cottage, as here seen, is constructed on a diagram exactly like that of Lesson 56, which you should first draw as there described. The addition, which forms that portion of the cottage containing the door, should be made as shown in the last Lesson, with the exception, that in this view, the base of the building and the lower and upper lines of the roof here slope upwards, and the top of the chimney is seen.

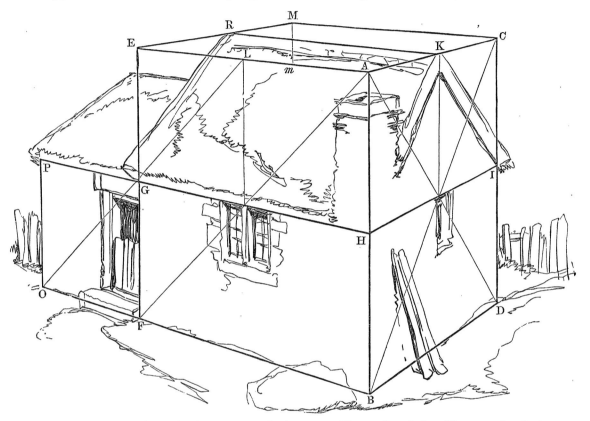

If you examine this Lesson attentively, you will see that it is still more detailed than the one above. Besides the character given everywhere on the extremities, more is added on the surfaces, so as to produce variety and to express solidity. If you examine the stones, you will not find any two of them alike, either in form, size, or expression. The observations contained in former Lessons, on the mode of marking the inner angle **A B** without a line, and on the necessity for leaving small pieces of light on the upper corners of the stones at this angle, have been here strictly attended to. Observations on any general law of nature, which have been made for your guidance in any particular Lesson, have never once been overlooked by me, but have been repeated in every subsequent Lesson I have given you, whenever and wherever they were required, in order to show that a principle founded on truth is universal in its application. Thus, in learning one Lesson, you have learned many; the difficulties of any one overcome are the difficulties of many overcome; and although your mind may appear to have been fixed and confined to any one Lesson for a time, it has been submitting to a preparation for drawing all things of a like kind to be found in nature.

LESSON 105.

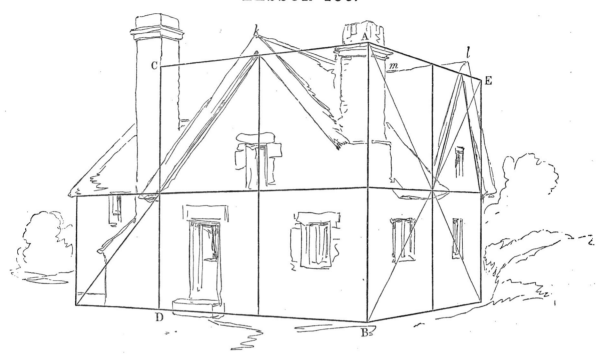

This Lesson is founded on a diagram exactly like that of Lesson 103, but the subject is of a higher and more complex character, and, with the following Lesson, is intended further to illustrate what has been said in the fourth paragraph of that Lesson.

After you have correctly drawn the diagram, draw the chimney at the angle **A B**, and observe that its cap and the lines of the bricks on each side of it slope like **A C** and **A E**, and also the lines of the other chimney at the angle **C D**, but in each gradually less, according as they represent courses of the bricks lower down. Draw now the front gable, and then the retiring ridge of the roof *k l*, which, because it retires in the same direction with the shaded side of the cottage, must incline as the lines of that side incline, according to its height above the eye; the ridge *m l*, of the roof of the further gable must slope like **C A**, for similar reasons.

The places of the door and windows will be easily found; the door is like that of Lesson 83, but is here seen in perspective.

LESSON 106.

This subject is a repetition of your last Lesson, supposed to be viewed from an eminence, and I give it by way of elucidating still further the application of those principles which were exhibited in Lesson 104, and also to prove to you that they are equally adapted to the one, as to the other subject.

I take it for granted, that you can construct the diagram in Lesson 56, with an addition, such as shown in Lesson 104, perfectly, and that you can follow the lines of the buildings in connection with it, as they are here seen. I, therefore, deem it necessary to leave you to execute all this for yourself, whilst I explain to you what is the object intended by these diagrams, which, though employed with various modifications in all the succeeding Lessons, are not so obvious to your eye, as in those which have hitherto been given. In many of the Lessons in the last Section they will be altogether omitted.

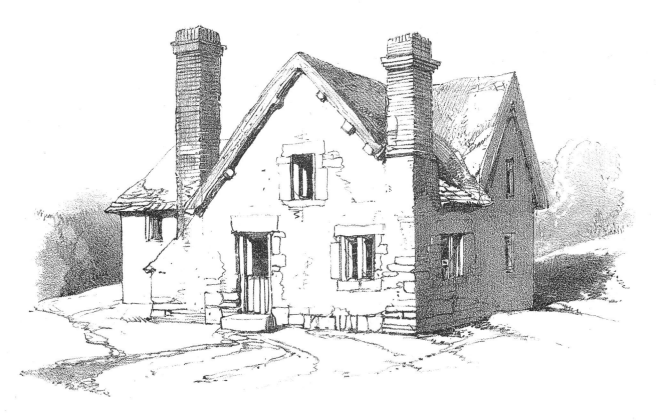

Lesson 105

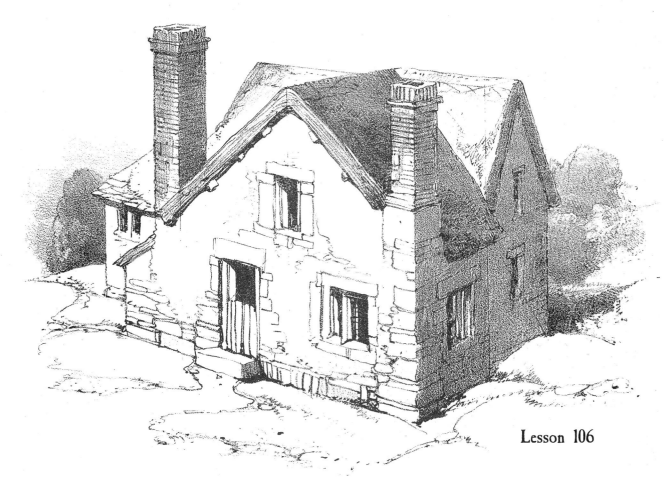

Lesson 106

Pl. 29

I do not for a moment imagine that you can resolve every object you see into one or other of the diagrams furnished to you; this would be as difficult as it is unnecessary. My intention has been chiefly, by means of these diagrams, to make you first understand the operation of the law of vision enunciated in the last paragraph of Lesson 13, and then to teach you how to carry it out with accuracy, under various modifications and aspects, as applied to a perfect figure,—the cube. Thus you first learn to know the truth, then to recognise it, and hence you become impatient of error, and finally attain a method of comparing and proving, mentally, what you have first arrived at mechanically.

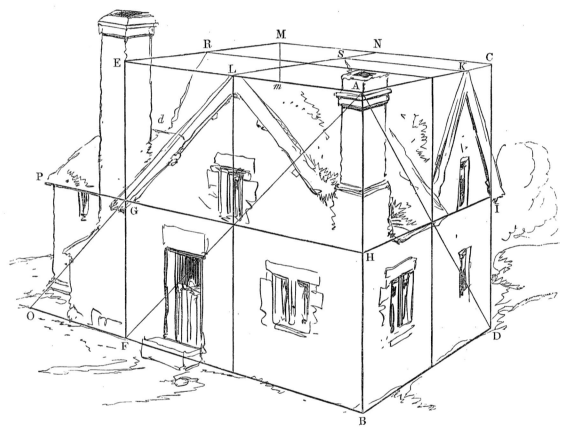

Ascertain by a line mentally drawn, as **A E**, how much taller the farther chimney is than the nearer one, and that the apex of the gable **K** would touch a line from **A** to **C**. Conceive a line from **I** to **H**: this will show how much the base of the near chimney is above it. The roof of the out-building at **P** follows exactly the direction of the line **H G**. Another, in like manner, conceived from **E** to **F**, would discover the left angle of the door-step, and also that the line of the ground must slope more than the imagined lines at **A E** and **H G**, because it is more below the eye. The slope of the ridge of the roof from **L** by comparison with an imaginary line **L N**. The ground-line **B D** must slope in the same direction, more, because it is still more below the eye. The point **I** would be found by an imaginary line from **H**, passing along the lower line of the roof behind the chimney. The line of the roof **K S** would be ascertained, by comparison with the imaginary line **E A**, and **R** *d* by comparison with the nearer end of the gable to which it belongs.

The upper and lower lines of the windows and door, as well as their places, may be accurately determined by the same process of mental comparison.

LESSON 107.

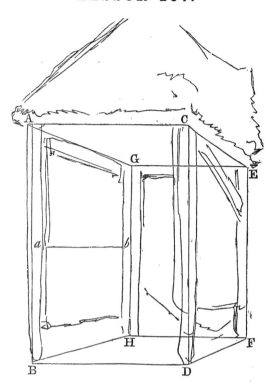

This Lesson, consisting of the entrance to a barn, is constructed on an oblong, viewed transparently. The letters will be sufficient to guide you, although the upper lines **A C** and **C E** are involved in the lines of the thatch, and the others more or less in the wood-work.

Draw **A B C D** rectangular, decide on the place of **E**, and draw **E F**, and **F D**, then level with **E** place **G**, but more distant from **A B** than **E** is from **C D**. Let **G H** equal **E F**, and draw **H F** and **B H**; this being now done, **G H E F** should present a smaller figure than **A B C D**, but of exactly the same proportions.

Draw now the lines of the door on the side **A B G H**, taking care that they gradually converge from **A B** to **G H**. At *a b* they are perfectly horizontal, and as they get nearer, either to **B H** or **A G** they gradually slope up or down. In this door you have an excellent illustration of what has been said in Lesson 101, because as **A B G H** is a face or plane in the same direction as **C D E F**, therefore its lines take a like direction. The shadow which falls from the roof shows, by its general inclination, the altitude of the sun, and in passing over the door, shows the nature of the surface over which it passes; great care should therefore be taken to mark this line of the shadow as it passes over the door, and thus to exhibit those parts of it which project and those which retire. The perpendicular lines of the door should be drawn the last.

Whatever further information you may need touching shading of the interior of the barn, you will find by reference to Lessons 76 and 89. It must appear as if you could walk in. This is the result you are to seek.

Lesson 107

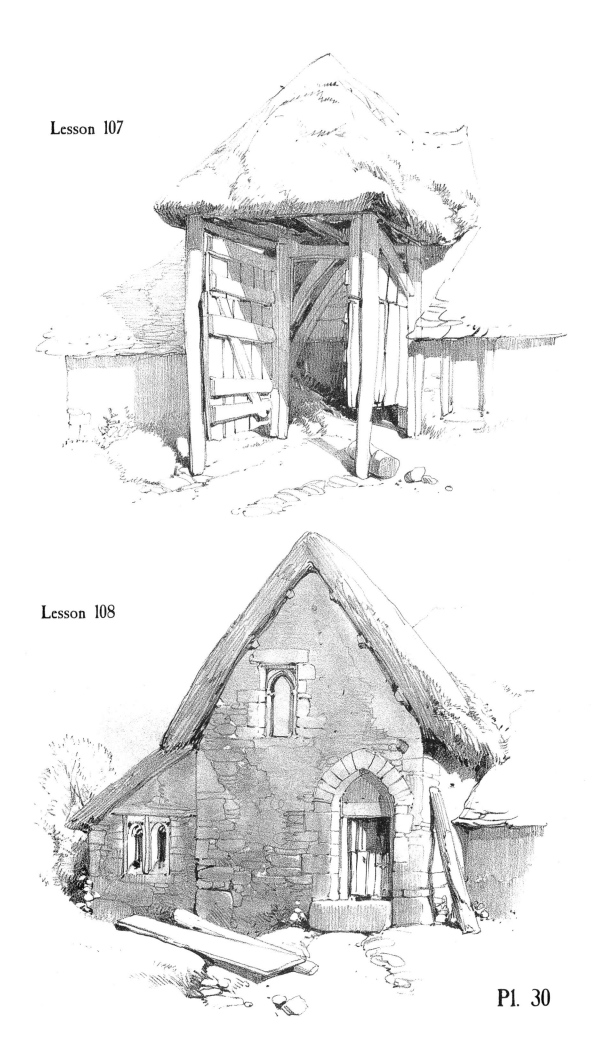

Lesson 108

Pl. 30

LESSON 108.

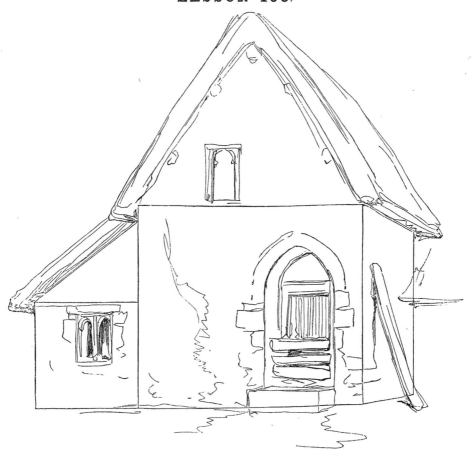

THE subject of this Lesson is a portion of St. Radegund's Abbey, near Dover, in Kent, and my wish is, that you should execute it without any instruction whatever, except such as you may obtain from the wood-cut, or such as you have derived from every previous Lesson, in so far as the outline, character, and expression are concerned· From its simplicity you should be able to do it from memory; and, under the examination of your master, if you have one, prove whether you have learned the principles you have been taught—whether the memory be that of the eye rather than that of the mind—and if you fail, whether the failure be attributable to ignorance or to idleness.

The broad shadow seen here over the entrance-front is done with the stump, and must be put in before any of the character: the difficulties to be overcome in doing it are to make it even, and to leave the small lights on the step, on the side of the door, and on the windows, and to make all the edges clear, and neat.

You must always remember, that you have done nothing effectively, unless with a distinct and justifiable intention—you should admit nothing to be pleasing or properly executed, until you can prove it to be true. The power to investigate what has been done, and to test it by a knowledge of the truth, assures you, if you admire, that your admiration is just; it ensures your progress, because it guards you against retrogression; it makes your feelings satisfied with what your judgment approves, and encourages you to persevere, because your feelings become, by this process, more refined, and your mind and hand prompted to fresh exertion.

LESSON 109.

AN ITALIAN CHAPEL OR ORATORY, NEAR ROVEREDO.

THE lines of the diagram on which this Lesson is constructed, are in part shown on the drawing; but should you not find them sufficiently distinct, you must turn to the wood-cut below, which I shall refer to, as the necessary preparation for this Lesson, instead of injuring and disfiguring the lithographic example by letters. Having drawn the diagram, divide **A H** and **E G** equally, and draw a line *d c*, which will determine

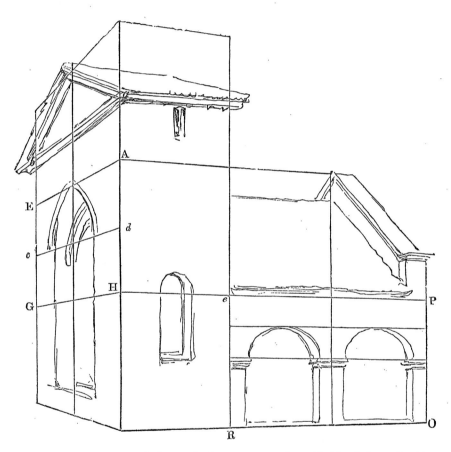

the place of the springings of the arched entrance; then divide **P O** and *e* **R** equally, and draw a line which will decide the bases of the two blank arches.

The wood-cut added to this Lesson reverses the subject, by the aid of which you can sketch the subject in this view, and by reference to the drawing, complete it with the shadow and outline. This exercise is intended to induce you to apply what you have learned, and to wean you from a direct and continual reliance on the original, line for line, and touch for touch; to substitute, in the place of direct copying, something which shall be a first step towards originality and self-dependence. I want you to gain the habit of independent thought and judgment,—to walk alone—not always to require to be taken by the hand.

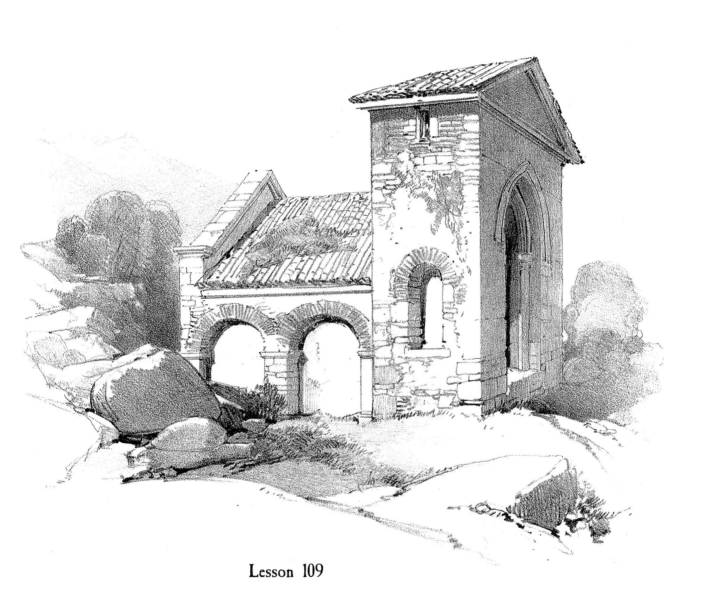

Lesson 109

Pl. 31

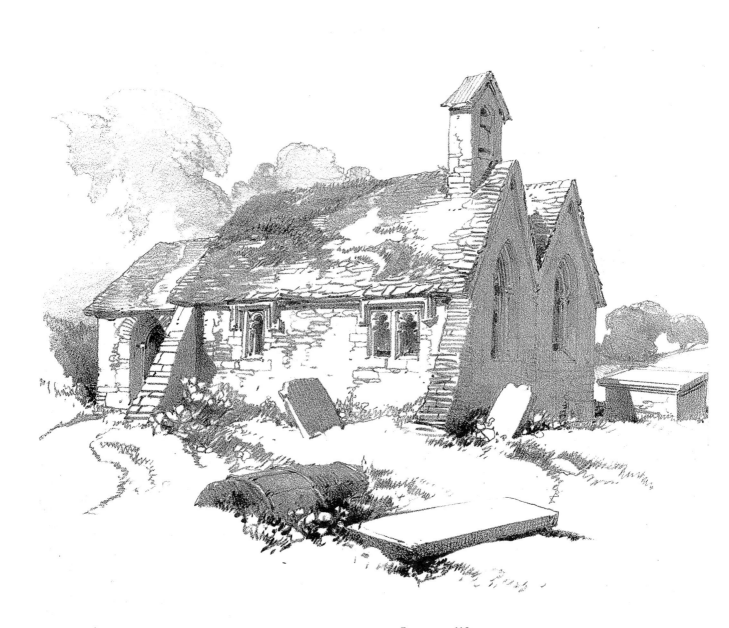

Lesson 110

Pl. 32

LESSON 110.

VILLAGE CHURCH AT MUKIR, YORKSHIRE.

THIS Lesson is constructed on a diagram, like Lesson 99, which may be thus drawn :—Draw the cube **A B C D E** and **F**, find **U O** by the diagonal from **K** through **I**, and **Q T** by the diagonal from **C** through **P**, then divide **P O, H B**, and **G F** equally, and draw the lines *c b* and *b a*; these two lines decide the bases of the windows. Now divide **A H** and **E G** equally, and draw the line *d f*, which will decide the height of each of the large windows under the gables. The line **U A** will assist in determining the slope of the roof of the church from each gable, and also the slope of the little bell-tower on the nearest roof. The buttresses at **P** and **H** can be easily added; it is only necessary for you to remember how the lines of their bases are to slope. In order to give you still further exercise in obtaining the different inclination of lines, the tombstones have been added.

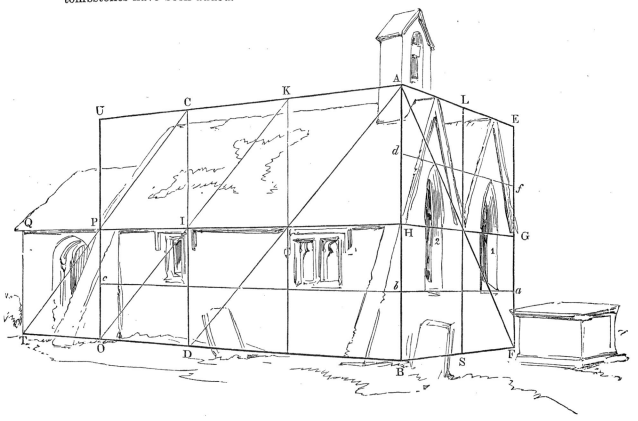

When this subject has been completed by the aid of the diagram, as shown in the wood-cut, you should attempt it without that assistance. All the information and illustration given in the former Lessons, as to objects of equal size and equal parts appearing to be less, as they are more distant, must be employed and depended on. To gain this truly, and also the true inclinations of the lines, both above and below the eye, has been the object of these mechanical methods.

LESSON 111.

AT BEILSTEIN, ON THE MOSELLE.

My intention in this Lesson is to show you how the instruction you have obtained from previous Lessons applies to objects of greater magnitude, and also in this and the following Lesson, to impress upon you the necessity for great precision in the execution.

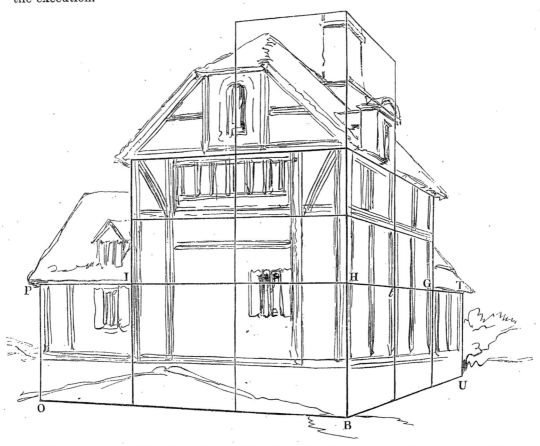

The wood-cut will sufficiently exhibit what the diagram is, and how the subject is framed on it, with all its details of timbers and windows, which latter are those of Lessons 79 and 88. The only lines of the diagram which are shown in the drawing are **P H** and **H T**; and as these are nearly horizontal, it proves that the eye of the spectator was but a little below them. By these lines you will decide most accurately the slope of the roofs **P I** and **G T**. The base lines **O B** and **B U** were required in the sketch, to obtain the line of the lower timbers accurately, but they are afterwards hidden by the irregular surface of the ground.

Great evenness must be observed in the shades and shadows everywhere. The shades must never be allowed to pass beyond the outline which, in every instance, should always be rather darker than the shades, so as to preserve the requisite clearness.

In the front of the large building you will find the window of Lesson 79, and in the small building to the left you have the window of Lesson 88.

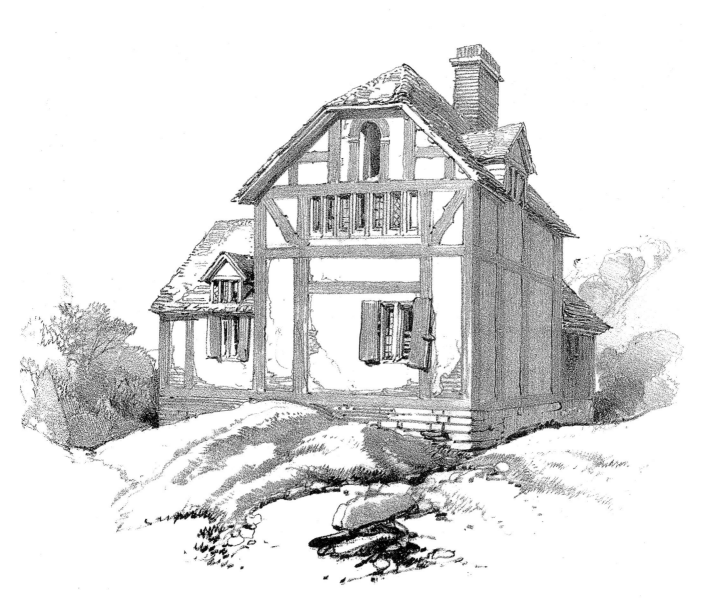

Lesson 111

Pl. 33

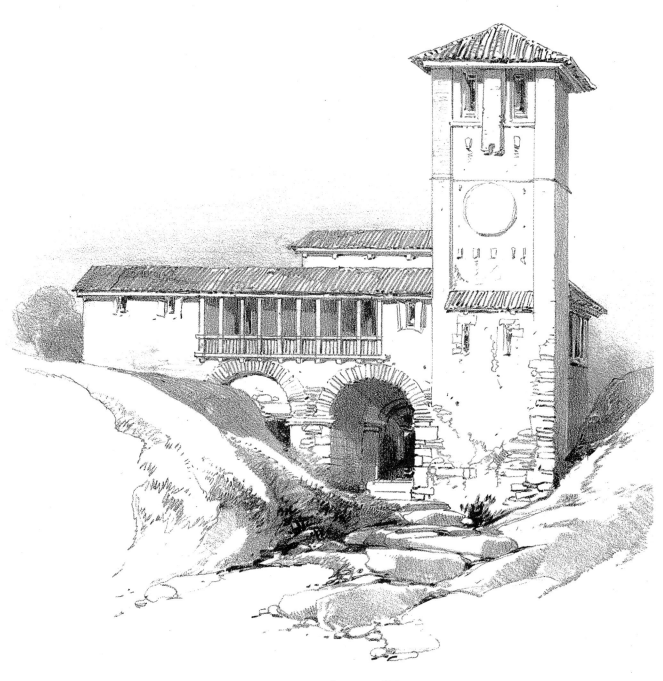

Lesson 112

Pl. 34

LESSON 112.

ITALIAN BUILDINGS AT BERGAMO.

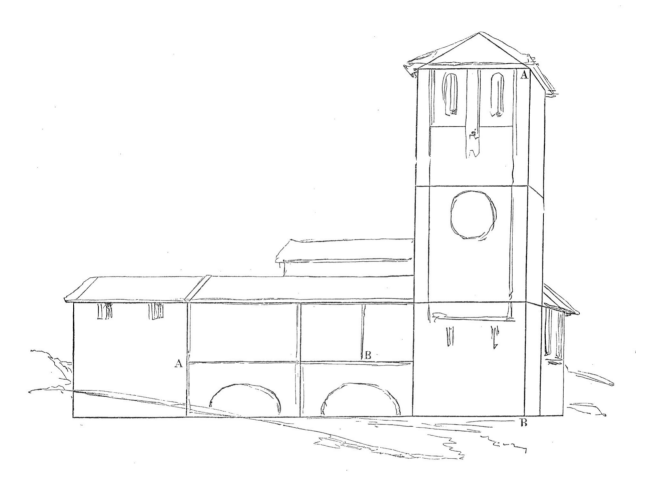

THIS Lesson is intended as a further exercise for you in neatness of execution, because, as the subject of it is larger, but drawn to a smaller scale than the preceding Lesson, that neatness is imperative.

A greater quantity is represented within a smaller space. Take, for instance, the gallery **A B,** which in nature is thirty feet long and ten feet high; here, then, we have a feature presenting a front of no less than three hundred superficial feet, here represented on a superfice of two square inches. According to this scale, every line which represents the upright posts and the railing occupies a space three inches wide or more; the slightest deviation, therefore, in a line anywhere, would represent a considerable irregularity, and if the lines of any one of these posts were only separated

from each other by the breadth of a line, that post would appear as if it were three inches, or more, thicker than the others. If, with a feature of the subject so large as the gallery, a slight deviation is so great an error, in the smaller objects, such as the tiles and windows, similar deviations would be productive of intolerable errors. From this you will see, that neatness of execution is not merely a recommendation, but is an imperative necessity on which more than half the merit of your drawing depends.

When, as in this case, objects of magnitude are represented on a small space, the outline should invariably be done everywhere before the shading, and should as invariably be rather darker.

The whole of the shading on the building must be done with the pencil or chalk, as the stump would not leave the edges sufficiently clear, but on the ground the latter may be used with advantage, first laying in the general shade with it, and afterwards adding those lines which are characteristic of the grass, stones, etc., taking care to keep their strength subordinate to the building, which, by reason of its superiority as a feature, should always be made more striking. Not a touch on the ground should be as dark as the recesses of the windows and the shadow of the roof, seen between the upright posts of the gallery, or on the wall beyond them. You must take care to preserve this shadow always of the same breadth and depth of colour.

The roofs being made dark by the lines which represent the tiles, together with the shade on the ground, convey the impression that the building is of a light colour, and in bright sunshine.

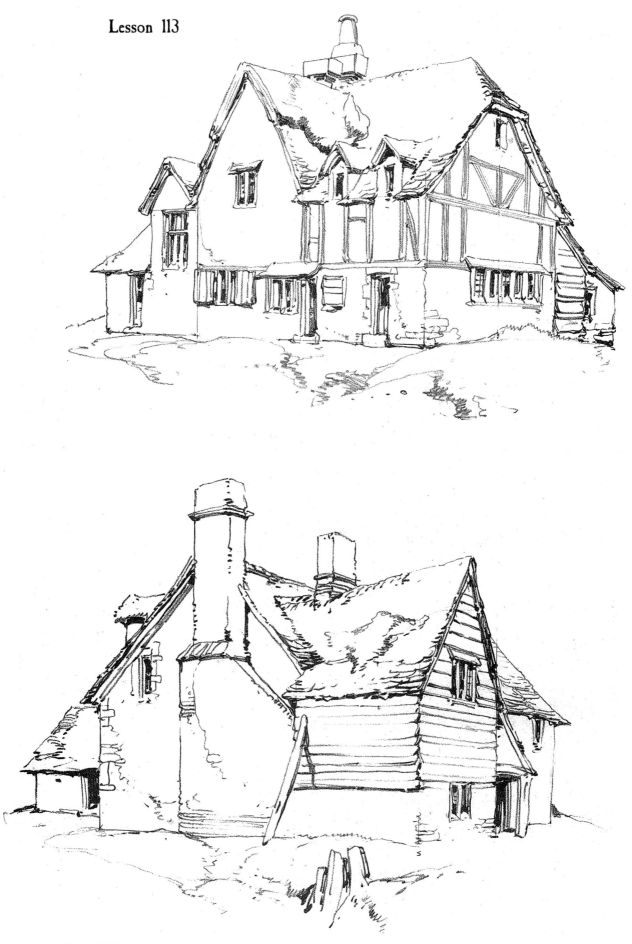

Pl. 35

LESSON 113.

It is not by putting questions and receiving verbal answers, however correct, that your progress can at this stage be tested. You may remember what was stated in your first Lesson as the principle on which this work has been framed for your instruction, viz.: That you should possess a clear mental perception of what is to be done previous to any operation of your hand.

All the explanations hitherto afforded in the earlier Sections have been intended to convey to your mind a complete knowledge of the object or objects constituting the Lessons; and, the catechetical examinations, to elicit the proof of your possession of that knowledge. The examples in this, and in the last Section, afford you demonstrable evidence of its value, by placing before your eyes various examples in proof of its application, its importance, and its power. Every subject, if you have properly studied it, will have convinced you, that in no instance have the instructions presented to you been forgotten or unheeded. Assuming that you have viewed each as a mental appeal through the medium of the eye,—that you have studied, not mimicked it,— that you have always sought the ends required, and not a slavish versimilitude, line for line, and dot for dot,—I have set before you these two examples, in outline only, and without the diagram. If you are really as instructed and as skilful, as by this time you ought to be, you will be perfectly able to complete these subjects by the addition of the requisite shades and shadows, so as to put them into a condition similar to, and as effective as, anything you have done from previous and completed examples of a like kind.

No diagram has been given. I intend that you should prove that you understand the true inclination of foreshortened lines, either by their position in relation to the position of the eye viewing them, or by their relation to each other.

You must sketch, in each subject by light and continuous lines, beginning always at the nearest angle of the building, and drawing each line in succession, according as it is related to, or is dependent on, another; its association or relation you must account for before you attempt to draw it. Having thus done all the exterior lines, you now proceed to determine on the position of the doors and windows, comparing them with each other, so as to determine their several places and sizes; and the height of the chimneys by reference to the gables to which they are contiguous. This being

correctly done, you have merely to subdue your sketch with bread, and then to give character to the entire outline, whether of brick, wood, or stone, so as to explain the material of which each is composed. Make your lines continuous or broken, tender or emphatic, in obedience to your acquired knowledge, until, finally, *your* drawings wear the aspect of these, although in yours no one line is an absolute fac-simile of the examples. All must be clear, decided, and emphatic.

When your drawings are so far satisfactory, you must add the shades and shadows to them, and, as I have already told you, to give them the appearance of being substantial.

As the subjects are here drawn, the sun is indicated as on the left, therefore you must place your shades and shadows accordingly, making them deeper or more delicate, according to the surfaces they cover.

It should be perfectly unnecessary to add another word of instruction: I should only repeat what you already know, or ought to know. If you have learned and practised your Lessons in the order in which they have been presented, you will be able to complete these subjects with little or no difficulty, nay, with as much ease as you may have copied any of your previous examples, wherein you will find parts corresponding exactly with such as you have here. To these you should refer, either to refresh your eye or your memory.

You must not imagine that I have imposed on you a task of any extraordinary difficulty. I have seen the same kind of thing done in a multitude of instances, and unless you also are now equally capable, you are in no condition to take your attainments to nature—you have not enough to take; but if, in your drawings, every line and shade has been, and can be, supported by your knowledge of the truth, you can go to nature, and be sure of success.

When your drawings are done, may I ask every question already asked, whether touching the form, the character, the shades and shadows, and be sure of receiving a satisfactory reply? May I ask if each part of each drawing is true, and whether you can prove it, and be sure of an affirmative answer? If not, you will have to retrace your steps: to go on would only be to increase your embarrassments, and take you further from the acquirement of Art.

CONCLUDING OBSERVATIONS.

ALL the Sections of this work have been so arranged that one shall be the necessary prelude to the other: consequently I expect, that from the study of what this contains, you will have acquired the power to draw objects correctly; the constant use of the diagram on which each subject has been formed, should have enabled you to make the various and distant parts and features less, in proportion to their distance, or their foreshortened aspect. My intention in employing the diagram has been to enable you by its use to arrive at that diminution accurately, so that having accuracy to contemplate, your eye should be educated to see, and your mind to judge, accurately; until at length you are able to rely on yourself confidently, and can relinquish the artificial support derived from the method here exhibited, and so variously applied.

In every Lesson, I pre-suppose that you have learned all former ones, because of occasion being perpetually given for their further practice. Your attention has been called, not only to the forms of objects, but to their character and expression; so that your mind may not only recognise the shape of an object, but the materials of which it is composed; all having their proper character depicted, in proportion to the magnitude of the object itself; and all the shades and shadows made darker or lighter as they would be found in nature, in all their relations and gradations.

SECTION VI.

PREPARATORY OBSERVATIONS.

Presuming that you have fairly applied yourself to the acquisition of what has been placed before you in the previous Lessons; that you know well what the forms of the objects should be, having been put into possession of methods by which they may be accurately drawn, and having been shown how the various materials composing them may be characterized,—your attention in this Section will be chiefly directed to expression, to objects in combination, to local colour, and to the more extended application of the means of Art, so as to procure results of a higher character than belong to that more individual imitation, to which your attention has hitherto been unavoidably limited. But few diagrams are here given, and those only which show the whole object above the eye, or which may instruct you in the drawing of Gothic arches, or objects widely separated from each other.

It will be found a good plan to draw each of these subjects, which are more complicated than any previously given, on a larger scale, or in outline only, before the shading is attempted, in order to acquire the power of expressing them by the simplest means. The intention of these Lessons being, to enable you to draw the like from nature, and that by the practice they present, you may learn to depict truly and rapidly, whatever object may have attracted your attention or won your admiration, when, for want of time, you may not be able to study it with its light and shade complete. With the ability to draw an accurate outline, and possessed of the knowledge of those laws of light and shade and character, which have been imparted to you, you may be afterwards able to exercise and increase your powers from Nature; and whilst thus procuring for yourself treasures of intense interest, you will at the same time enrich your imagination, quicken your feelings, and keep yourself alive to those beauties which you have learned to appreciate through the medium of Art.

LESSON 114.

A CATTLE-SHED.

THIS subject, though very simple in itself, I have given to afford you practice in combining with it various accessories,—that is, other subordinate objects which add to its interest.

If you require the aid of a diagram you must look to the *wood-cut*. The subject, excepting the roof of it, is constructed like Lesson 41. The upright lines, seen on each post, sufficiently indicate the way in which the whole front must be divided into three parts by light lines, before any attempt is made to draw the posts themselves, or the curved timbers which rest on them, and which appear to give, to each space, the form of an arch.

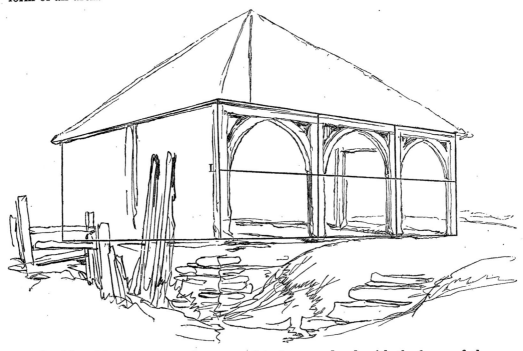

In this subject, your eye is supposed to be on a level with the bases of the upright posts, consequently these, and all other objects of exactly that height, whether retiring to the right or left, appear perfectly horizontal; such as the middle round of the ladder and the top rail of the stile. All lines above this level will slope down according to their height above it, and the direction in which they retire; such as the rounds of the ladder, the boards, the window and roof on the shaded side, the manger and hay-rack under the shed, and the lower line of the roof on the light side. Below this horizontal line all lines slope upwards; such as the bars of the stile, the lower rounds of the ladder, and the stone steps.

The lighter parts of the shade over the hay-rack and manger are done entirely with the stump, because it produces an even shadow without lines, and when these are afterwards put in to define the character of the objects under shadow, they appear as they ought, distinct; the darkest parts are entirely done with the point of the pencil or chalk, without showing any lines. If these instructions be strictly attended to, and the edges everywhere kept clear, the shades will appear to retire.

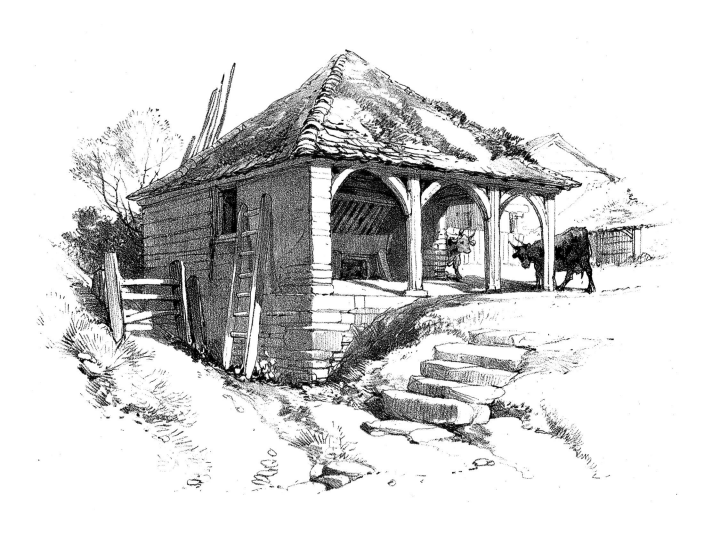

Lesson 114

Pl. 36

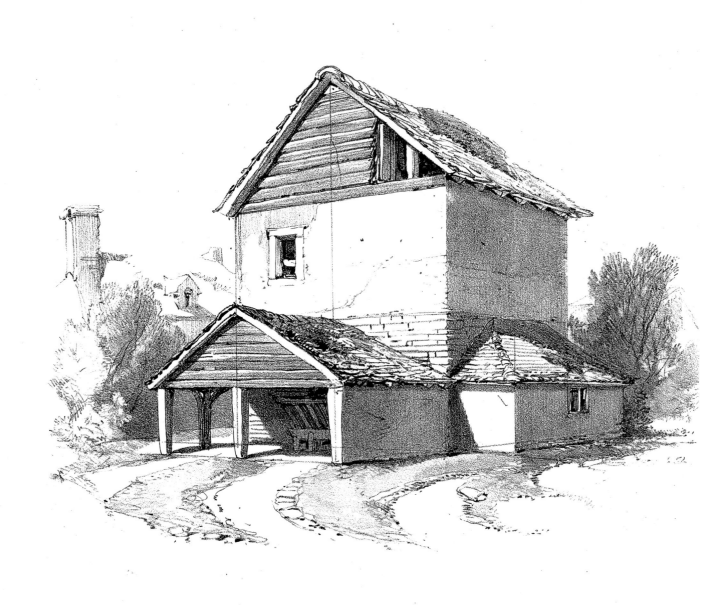

Lesson 115

Pl. 37

Pay great attention to the shadow of the roof over the posts, and also to their shadow on the ground, which should describe its irregularity; notice also the shadow of the shed as it falls over the ladder and the stile. Great attention must be given to mark the leaves and herbage at the left-hand corner of the shed, the variety of curves formed by the herbage on the ground, and the difference of the steps in form and size, as well as to the varied expression and emphasis given to the lines which describe their form or depict their character.

LESSON 115.

FARM BUILDINGS AT PENSHURST.

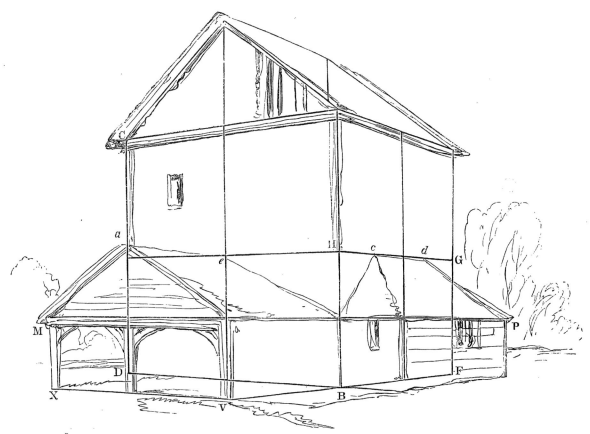

My intention in this Lesson is to show you how to draw correctly the projecting sheds attached to the principal building.

First form the cube on which the principal building is constructed, and decide on the line **M P**, which, being perfectly horizontal throughout, shows the height of the eye of the spectator; then project **F B** to **V**, till it touches the centre line descending from the gable, then draw **V X**, sloping it upwards rather more than **D B**. Let the line **C D** form the centre post and the gable of this shed, and place the post at **M X**; then draw the line of the roof *a e*, which, being as much above the eye as **H G**, will slope like it, and in the same direction. The shed on the right must be drawn in the same manner as the first, but this I leave you to do for yourself without any definite directions—you ought not to require any.

LESSON 116.

AN ITALIAN STABLE AT ANGERA.

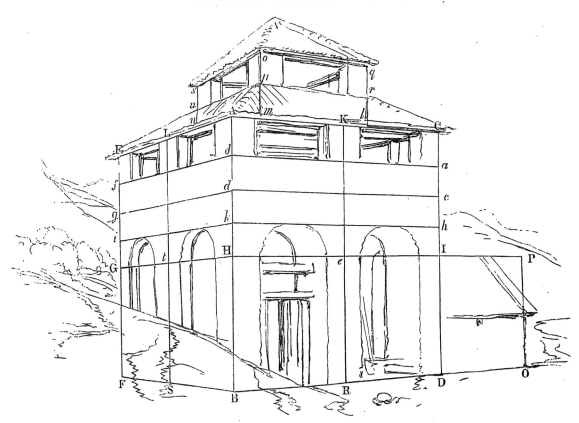

DRAW the cube, and the extension **D I P O**; divide **A H**, **E G**, and **C I**, each into four equal parts, and draw the lines *f d* and *d a*, *g d*, and *d c*, *i k*, and *k h*. These lines determine the exact slope of the base of the openings under the roof, of the string course below them, and of the tops of the arches. The upright lines **L S** and **K R** will decide the space between the arches, and the spaces between them and the angles of the building, which are called the piers, and also the like relative places of the openings immediately under the roof; find now the points *u p r* of the roof by the lines *u n*, *p m*, and *r l*. When the roof of the stable is done, set up on it the lines *s u*, *o p*, and *q r*, of the Loggia, taking great care to make the necessary observations respecting their height; then find the apex **V**, and complete the roof. The sloping line of the ground is easily determined by the lines of the diagram.

The shading, both on the building and on the ground, should be laid in with the stump. Do not forget that the character of the upper and lower lines of the roof should be put in before the lines which exhibit the rows of tiles. The shading on the grass should not be done until the building is complete, lest the hand whilst drawing the building should smear it. Pay the greatest attention to the varied forms of the masses of the grass, and endeavour, as much as possible, to give varied strength and inclination to the lines which give it character. On these masses of grass being carefully drawn and characterised, depends the surface of the ground appearing more distant at the building than at the lower and really nearer part.

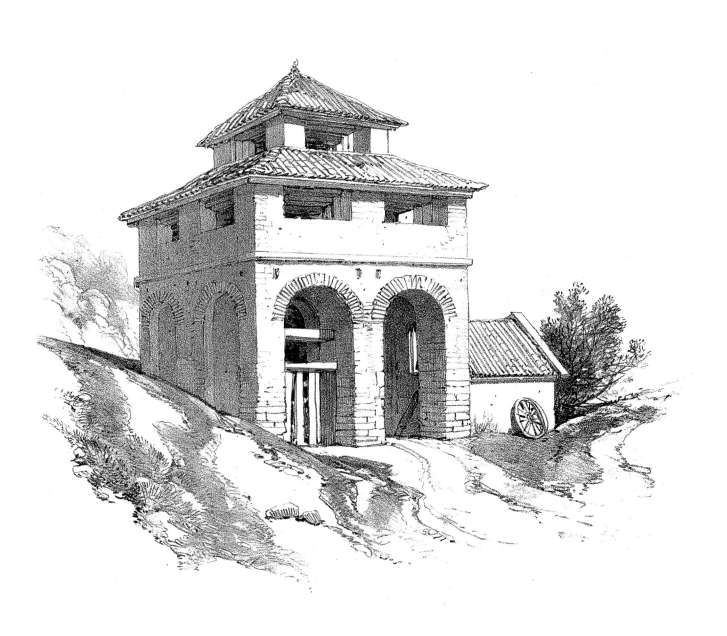

Lesson 116

Pl. 38

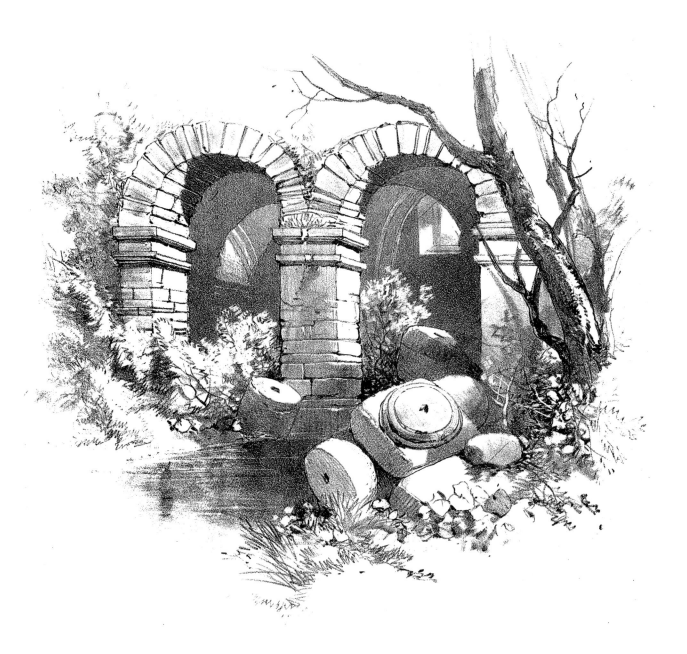

Lesson 117

Pl. 39

LESSON 117.

A PORTION OF THE CRYPT OF THE CASTLE OF EHRENBERG, ON THE MOSELLE.

THE wood-cut will at once explain to you the simple nature of the diagram on which this subject is constructed; and in making the first study of this Lesson, you may draw the parts as they are here drawn; but to accomplish the intention of the Lesson, you should be capable of making a like comparison of the parts by the like lines mentally perceived.

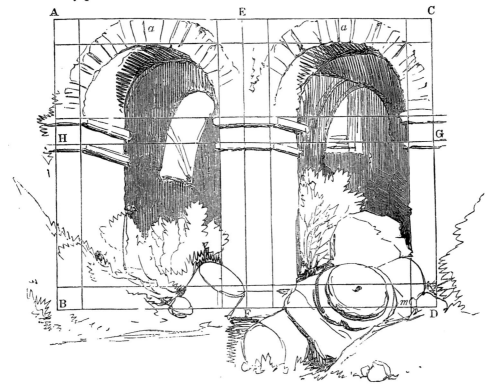

Draw **A B C D**, and divide the figure equally at **E F**; then place **H G**, and having these lines, the rest may be easily found. In this subject, where arches are drawn on a larger scale than in any of the preceding Lessons, their construction may be better seen and understood.

At *a a* there is always a stone, the centre of which is the centre of the arch, consequently a line which would show the joint of a stone is never to be found in the centre of an arch; this stone is called the key-stone.

In the stones composing the foreground of this subject, you will recognise Lesson 73. The water, and the shading of the crypt seen within the arches, should be first done with the stump, and then completed with the pencil; but for the shadows under the arches, and the herbage, the pencil or chalk only should be used, as these parts must be made dark and firm; and the distant, or inner parts, be thus made to appear more remote.

If you compare this and the last Lesson, you will find that the lines expressive of the various objects composing them are broader or finer, so as to accord with the scale on which the objects in each Lesson are represented. Were the features of this Lesson characterised by lines as narrow and delicate as in the last Lesson, they would look insignificant and niggling; and were lines as broad as in this Lesson to be employed in the last, the whole would look coarse and clumsy.

LESSON 118.

BUILDINGS AT PUZZANO, LAGO MAGGIORE.

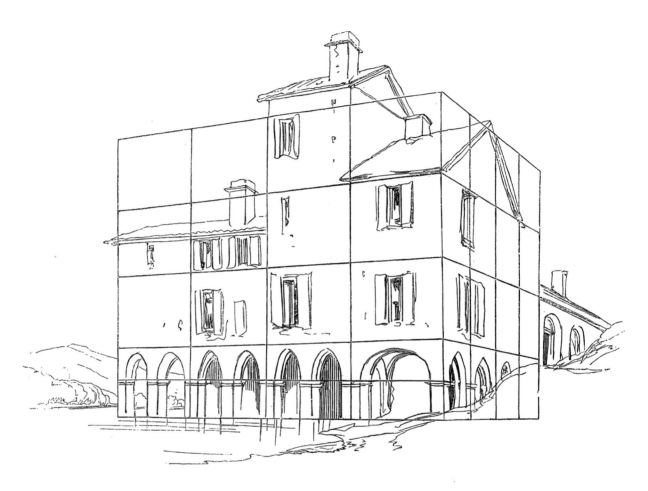

REFERENCE to the wood-cut will show that your eye is supposed to be level with the tops of the piers on which the arches rest. The lines of the diagram will be sufficient to guide you to the required accuracy of the upper and lower lines of the windows, etc., but the shutters rarely follow these, as they are perpetually shifting or becoming loose by the loss of their hinges. The vertical lines will serve to show such objects as are perpendicularly over others.

As I have directed you in all the foregoing Lessons, the whole subject must be sketched before the details of windows, arches, and chimneys are put in; and the places, forms, and sizes, of all these must be decided, before any attempt be made to give character of any kind; for if the general outline be wrong, and all the details of windows be placed in relation to it, they too will be wrong, and the whole will require to be removed. It is, therefore, to avoid this consequent, and unnecessary, waste of time, that I have instructed you to proceed, not only with this, but with every drawing, in the manner I have explained.

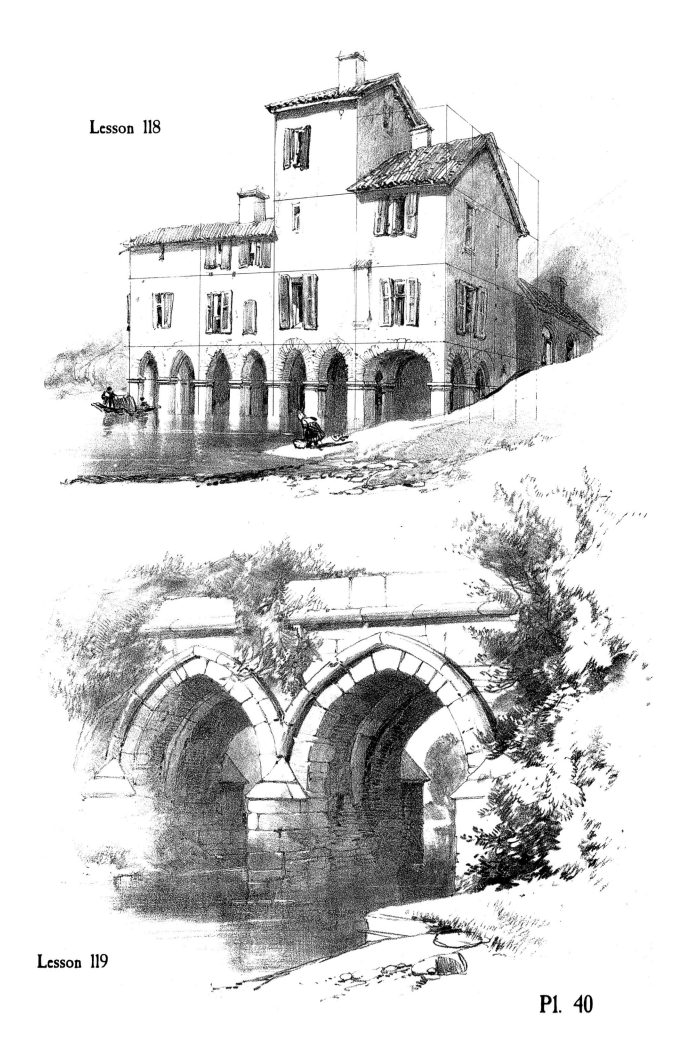

Lesson 118

Lesson 119

Pl. 40

LESSON 119.

AN OLD BRIDGE AT LAUNCESTON, CORNWALL.

THIS subject being one of architectural character, and consisting of gothic arches, requires the aid of a diagram to ensure accuracy in the drawing of the arches.

The knowledge you will have already acquired from all former Lessons, makes it unnecessary for me to say much in this. The lines enclosing the entire subject **D F E B** should be first drawn; the horizon or the height of the eye is at *g h*. The methods of dividing this space must be already well known to you, and the lines of the diagram will show you how to construct the whole subject with complete accuracy. Every line indicative of the stones of the arches, should tend to the centre of each arch,—that is, to the point in the diagram where the diagonals **D O** and **O B**, separately cross the lines **L M** and **I K**. This subject being on a larger scale, requires that the more minute circumstances of detail should be noticed, such as the opening of the joints of the stones, the fractures of their outer angles, and the lights which steal in upon them. The lines showing the divisions of the stones which form the moulding round each arch must be most carefully drawn; each has a different curve because each is differently seen, and the ends of each, like the stones forming the arch, point to the centre. The expression of the curvature of this moulding depends entirely on these lines.

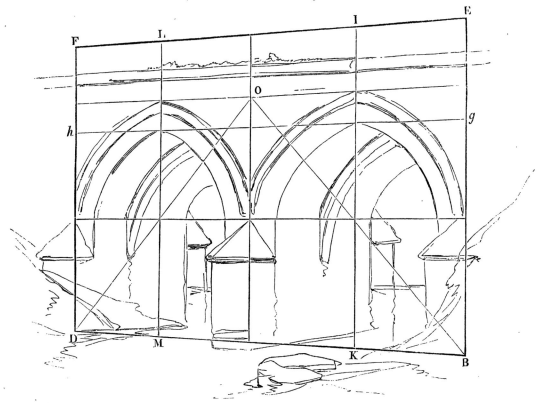

The whole of the shading, even the ivy and foliage, is first laid in with the stump, but is afterwards completed to its required depth by the pencil. When drawing the foilage on the right, take care to place its character always on the limits of the shade, to which it must assimilate in depth or lightness of colour, and when drawing the branches, never allow their outer extremities to be seen.

LESSON 120.

THIS Lesson, in the castle, with its round and square towers, and in the shed in the foreground, present to you several features which are intended to exercise you in greater intricacy of outline, and in preserving the true inclination of the sides of objects having the same direction, when at a distance from each other, as are the two square towers, and in giving the different degrees of intensity in the shades and shadows, as well as in the separation of the lines composing them, so as to show the different distances of the objects.

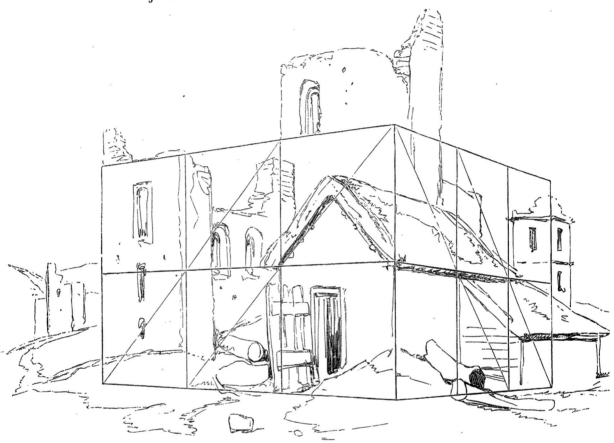

To secure the places and relative proportions of all the objects, the shed in the foreground must be first drawn, accurately. The nearest angle of this should be first drawn, then the gable, the lines of the roof, and afterwards the boards and door, remembering all the while, not the diagrams on which similar objects have been constructed, but what the diagrams were intended to secure, viz.—the right degree of the diminution of an object in proportion to its distance, and the right inclination of lines, above or below the eye. Whilst doing this, you must call to mind the knowledge you have derived from your early Lessons, without which you will never be able to determine for yourself whether your production is true. You will for ever be the humble copying slave of your original.

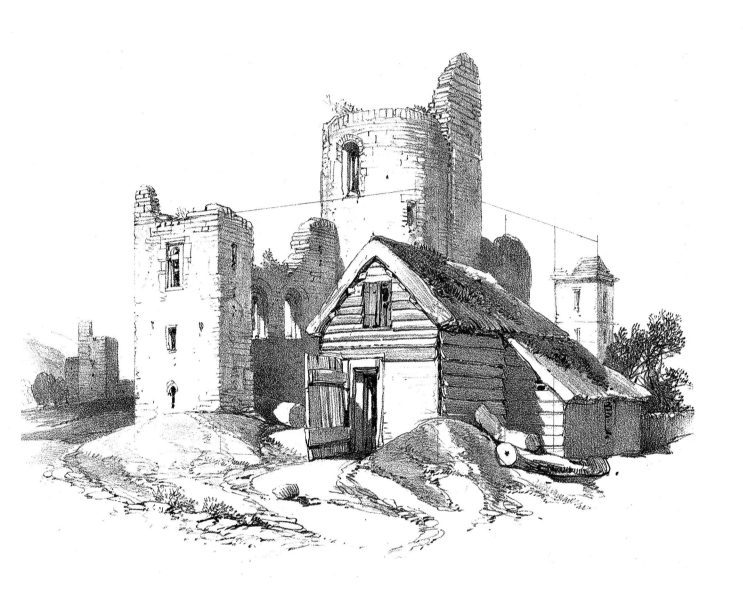

Lesson 120

Pl. 41

When this is done, the round tower may next be drawn, deciding first on its height, by comparison with the shed, and observing where its upright lines touch the roof of the shed; then draw the broken wall, which has the two windows in it, and the square tower connected with it. By the shed, also, the height of this tower is ascertained, and also its ground-line; the courses of the stones in front have exactly the same slope as the boards; those on the sides, and the lines of the distant tower, are like the roof of the shed, and may be compared with it. When these are done, draw the distant tower, and the hills on the left, and the varied curves of the lines on the ground, which are as essential to the interest of the subject as are any other lines it contains, because they add to the variety, which is always so pleasing, and which you should always seek to obtain.

When the whole subject has been lightly sketched-in, I would have you complete it in outline only, like Lesson 113, leaving out the shading entirely. This outline should exhibit all that here marks the characters of the object, on their surfaces as well as their forms. To give emphasis to this outline, the shaded sides should be marked more strongly, and especially the dark moss on the roof of the shed, the dark inner lines of the gable, the lower lines of the roof, the insides of the doorway, the windows and the characteristic outlines on the ground, observing generally to keep the different gradations of strength in every object, according to its distance, marking those most forcibly which are nearest, as the shed, and the pieces of timber lying on the ground.

My intention in giving this one subject, is to afford you the opportunity of making an outline from it, as above described, which is just the way in which you should proceed when drawing it from nature, and also when making a second drawing from it, adding the shades and shadows as in the original.

You should practise the parts also, separately, and on a larger scale.

The wood-cut, showing the diagram, has been given, to assist you in judging whether what you have done, according to your instructions, be right. It is not intended for you to copy.

LESSON 121.

INTERIOR OF AN APARTMENT IN TUNBRIDGE PRIORY, NOW DESTROYED.

THIS Lesson is a combination of several preceding Lessons, which you will have already studied and practised during your progress, and they are brought together here with the intention of showing you, that while studying them separately, you have been acquiring the power to draw them in combination, and thus to make them more influential in pleasing, than they ever could be when separate. In short, to show you that a whole is made up of parts, and that to ensure a whole picture being well done, its parts must be well done.

This subject combines the following Lessons :—34, in the form of an apartment; 25, in the corn binn; 90, in the doorway on the left; the pitcher, can, etc., are from Lesson 70; and the baskets on the right, from Lesson 69. Consequently the instruction conveyed in these Lessons need not be repeated here; the same observations necessary to drawing these objects separately, are required here, with these additions, —that they must be in proportion to each other, and to the whole picture; their size, their position, and their depth of shade, must be in relation to the rest.

First draw the lines of the apartment **A B C D**, and **E F G H**; these will assist you in ascertaining exactly the places of all the objects in it, as well as their form, because you can constantly compare them with these straight lines; and, as in the previous Lesson, it will be desirable first to draw the subject entirely in outline, which

Lesson 121

Pl. 42

will be little more than the wood-cut. Of course, when completing the subject, the straight lines you first draw for the form of the apartment must be rubbed out, as by passing through them, as they do here, they entirely destroy the impression we ought to have of the various surfaces of the objects.

When, in your second drawing of this subject, you attempt to put in the shades and shadows, it will be sufficient for you to ascertain the form and arrangement of the objects; because if the outline be previously completed, as in the wood-cut, it will be entirely destroyed by the shading; the shading, therefore, must be first done, and the outline be afterwards added.

As no objects, except those near the door, could be in bright sunshine, so all, except those, must have a light tone of colour placed all over them. This should be done by charging a piece of cloth, flannel, or leather with chalk,—the latter is the best—in the manner described in Lesson 25, and so folded as to obtain a broad flat surface. Pass this fearlessly all over; the small lights can afterwards be removed, and should any large portions require to be lighter, but not absolutely white, such as the half light on the underneath part of the arch, and the beams of the ceiling, and the light on the wall beyond, they can be so made by bread. The stump will give a great portion of the depth required, but the entire depth must be obtained by a soft pencil or chalk, and also the character which is given by lines on the walls, the timbers of the roof, and on the ground, where they convey the idea of an irregular and broken surface. The outline must be in every case as pure as possible.

When, as in this drawing, the local colour of the objects is attempted, so much of the paper is covered that the lights become doubly precious; hence, then, the small lights in the midst of these masses should be scrupulously preserved: most of these, such as those on the upper surfaces of the steps seen through the doorway, may be obtained in the following manner:—After the general mass of colour has been fearlessly put in with the stump, cut a small opening in a piece of clean thin writing paper, and lay it gently on the drawing, showing through the hole that portion which is to be removed: this may be now rubbed out fearlessly with Indian rubber, as the surrounding paper, if it be held firmly, will protect that portion of the drawing which is underneath it.

In observing where the outline and character of objects must in all cases be placed, and most emphatically expressed;—how all the shades should appear to retire;—the laws appertaining to the edges of cast-shadows;—where they are darkest and where the darkest part of the whole picture must be;—you must have ready in your mind all that you have learned from previous Lessons, and be able not only to show your tutor that you can imitate what has been put before you for practice, but that you are able to account satisfactorily for all you have done;—that your mind has been engaged as well as your hand.

LESSON 122.

PART OF BEESTON PRIORY, NORFOLK.

THIS Lesson is presented to exercise you in drawing gothic arches, when seen considerably above the eye. It is to show you how the diagram, which has enabled you to draw your previous Lessons correctly, will aid you in like manner with this, and that you may either actually construct the diagram, or, by a mental perception of the lines forming it, make the comparisons and observations necessary to procure and place its several parts with the requisite accuracy.

The practice which you have already had in drawing the diagrams of the previous Lessons, should render it unnecessary to give you any directions regarding this, which you will use or not according to your ability to draw the subject correctly without its assistance.

Lesson 122

Pl. 43

I have intended also to show you the necessity for making the shading and character broader and bolder, when applied to a subject all the parts of which are on a larger scale.

When the sketch is completed, the shading should be laid in with the stump, which may be more fearlessly applied to the broad shadow on the left, and to the foliage, than to the architecture, lest by any chance the purity and sharpness of the edges should be injured. Shade, even the lightest, passing over an object, prevents us from seeing it clearly, and as it becomes darker, it obscures our view more and more, until it finally becomes so deep as to obliterate it altogether.

The reverse, however, is the case with the light which reveals objects more and more according to its brightness. Hence, then, it will be seen in looking at this subject, that these laws of nature have been attended to, for in all the sun-lit parts, the building, its features, and the stones composing them, are all clearly defined: the ivy, the foliage, and the posts also; but on the shaded sides of the arches, the stones are barely exhibited, and whatever else the broad mass of shadow on the left falls over, whether foliage, herbage, or stones. You will also see that this shadow is made darkest where it is nearest to the object which casts it, and gradually lighter as it recedes from it; thus showing, on a larger scale, the operation of a law of nature which has also been illustrated in all the Lessons, except those which have consisted of diagrams only. On the shaded sides of the arches, the shade should be perfectly even, and may be produced by broader strokes of the pencil, and you will find everywhere, in the shades and on the outline and character, that the lines employed, whether light or dark, are for the most part broader than such as have been applied to depict objects on a smaller scale. The remarks made in Lesson 117 should here be remembered.

When placing the various shades on the ivy, it will be sufficient to imitate their depth, and their places; it would be positively impossible, and certainly unnecessary, to imitate their precise form. When the masses of shade are laid in, so as to approximate in form as near as may be to the original, it will be sufficient; the objects of real importance are, to confine the expression of the character of the ivy to the edges, where it separates from the sky or the building, and to where the lighter and the darker shades of it separate from each other; in both these places pourtray it most carefully, and always with a line varying in depth of colour, according to the depth of the shade, but always a little darker, so as clearly to exhibit the character and to impart brilliancy and precision. If the character be given by a line too dark, and therefore out of harmony with the shade, not only will the ivy lose all appearance of flexibility, but the stones of the building will, by comparison, lose their character of hardness.

Art is not only required to represent the entire forms of objects and their separate parts, but to convey to the mind an impression of their separate qualities or peculiarities. In conveying these impressions, consist the chief difficulties of Art.

When, therefore, the power to draw forms has been acquired, it should be your great aim to contend with these difficulties; and, when you have completed your drawing, ask your own feelings whether the objects represented be as completely expressed in kind as in form.

The characteristics of hard, soft, flexible, opaque or transparent, space or distance, etc., etc., have no real existence in Art; consequently these impressions are conveyed to the mind in a great degree, or almost entirely, by comparison, as for instance in this subject, if the shadow on the left, and the shade over the ivy on the right, were as dark or darker than the shades and shadows of the building, they would look equally or more solid, and the building, by comparison, flimsy—thus imbuing the mind with impressions contrary to the truth, and to what we know and experience; we must therefore pronounce it to be bad. It is not Art.

Lesson 123

Pl. 44

LESSON 123.

ITALIAN BUILDINGS AT SAN PIETRO, NEAR VERONA.

IT is not because the subject of this Lesson presents any greater complexities or difficulties in regard to its form, than those you have already passed, that it is put before you ; but being on a larger scale, and its parts more removed from each other, there is therefore more difficulty in ascertaining precisely the slope of each, according as it is more or less above or below the eye. This, however, is easily ascertained by forming a diagram, such as the face **A B C D** of Lesson 99, which there consists of four squares ; but here of sixteen.

Draw, in this case, the exterior lines **A B C D**, and divide the space they enclose, as your previous Lessons will have taught you, until you have the required number of divisions. The inclination of such lines and features of the subject as fall on these lines will be at once determined ; but such as lie between the lines of the diagram, must be determined according to their proximity to the line to which they are proximate.

This is an Italian building, and in a former Lesson I promised to point out to you some of the peculiarities of an Italian roof, which is composed of tiles, half cylindrical in their form, like the half of a hollow tube cut longways. These roofs project considerably over the walls, on which they cast a broad shadow ; this you will see on reference to your example. The lines exhibiting the tiles are drawn in a sloping direction, according with the inclination of the roof; these lines must be broad and narrow, near to, and separate from each other, having transverse lines between them, so as to show the ends of the tiles.

You will immediately see that the chimney at **D** is a repetition of Lesson 93. The other chimneys are but modifications of this one.

The principal part of the shading must be done with a stump, because of the necessity for avoiding, as much as possible, the appearance of lines in the shades and shadows ; except just so much as may show that the walls are perpendicular. Keep all the edges distinct and sharp, and the outline clear, varied in colour, and everywhere darker than the shade or shadow to which it may be contiguous. This rule you must invariably observe.

LESSON 124.

PART OF TUNBRIDGE CASTLE, KENT.

Accustomed as you have been to draw forms accurately, by aid of the diagrams, and to know when they are accurately drawn, no diagram is here given. You may proceed with the subject in a different way, and obtain the required accuracy.

First, sketch the nearest tower, which is greater at the lower than at the upper part, by straight lines, and as if there were no ivy on it: this must be afterwards added, by a line drawn beyond those you have drawn for the tower, so as to account for its thickness. This being done accurately, proceed with the tower to the right, and the ivy on it, and with the leading lines of the ground; and judge of their height, curvature, or length, by comparison with, and by their relation to, each other.

This subject being simple, your attention is particularly required to the method of shading, and of showing the difference between the local colour of the various features,—that is, the difference in their depth of colour, irrespective of shade; as, for instance, the ivy, which is darker in its local colour than the stones of which the castle is built; the small tower of the castle, which is generally darker than the masonry of the rest of the building. This local colour must be put in with the stump. The sharp clear lines along the stone courses of the tower must be done before attempting any shading. Cut a blunt and short point to a quill, with this draw lines on the paper where these lights are to be, thus indenting the paper; when the stump afterwards passes over them, as it cannot deposit the black-lead in these grooves, they will appear light.

After the sketch of the subject has been made, a light tint must be placed all over the ivy and the large tower; the shaded side of this, and of the light tower, may also be put in afterwards, and with the stump, nearly to the depth of colour required, which, towards the ground, becomes gradually darker.

The only danger in using the stump is, that the clearness of the outlines is in jeopardy; and if destroyed, the brilliancy and precision of the drawing would be effectually ruined. Great care must be taken, therefore, not to proceed too far with the stump in the attempt to obtain depth, and never to encroach on the outline. In order to avoid this, it is safer, when the local colour and the shades have been put in as directed, to complete them to their required depth with the point of the pencil or chalk, taking care only to allow the lines from the pencil to be very sparingly seen, so that

Lesson 124

P1. 45

they may harmoniously assimilate with the stump. The lines which represent the stones, the character of the grass, and of the ivy, should be seen with as much distinctness, or nearly so, as on the white paper. The clearness of these lines should be kept with the most jealous care.

In placing the courses of the stones on the towers of this drawing, you must not fail to remember what has been said in Lessons 47 and 48, which need not be here repeated, to aid you in completing this subject; but it will be necessary to call your attention to another law of nature belonging to cylindrical objects, which has not yet been explained.

When cylindrical objects, such as these towers, and the stems of trees, possess any marked character or irregularity of surface, that character, or irregularity, is most plainly seen in that part where the light is gradually falling into the shade.

This is fully exhibited here in the large tower on which the stones are marked most plainly in that part; where also you will see that their separations are not only shown by a darker line, but that, on the upper edge of most of them, there is a bright and narrow line of light. This fact you will also see illustrated in the upright basket of Lesson 69.

In buildings which, like this, have been for ages exposed to the rain, wind, and sun, and the damp from the ground, the courses of the stones or bricks, immediately on and near the ground, become more evident; the cement falls away from between them, and the stones more or less disintegrate, according as they are of a soft nature, or to the length of time they may have been exposed to these influences. Attend carefully to the cast-shadows from the ivy as they fall on the large tower.

LESSON 125.

In an early Lesson I told you that the best means for measuring the precise curvature of curved lines was by comparing them with right lines. Amongst such objects as are composed of curves, there are few more difficult to draw than boats, especially when they are seen foreshortened, as in this example. This difficulty arises from the appearance of these lines being so dissimilar to their reality. You will comprehend what is meant if you refer to the lithograph or the woodcut. When you regard the further side of the boat, you see it is nearly a straight line, whilst the corresponding, and nearer side, is a curved line, differing in its degree of curvature in every part. Now these two very dissimilar lines, require to be so drawn that their dissimilarity in the drawing shall impress the mind with the idea, that in nature they are precisely alike in their curvature. This is the difficulty, and can only be met by instituting horizontal and perpendicular lines, such as you see in the woodcut: they are here drawn, and so you must draw them, until you can mentally contrive and set up a similar kind of framework, wherewith you may be able to judge of the curves of every variety to be found in boats. No two of them are alike. I have added a buoy, and some portions of a chain attached to it. The place of this, and of the distant house and rocks, must be obtained by reference to the boat, which should be the object first drawn.

Lesson 125

Pl. 46

Beyond correctness in the forms of the objects, and their associations, there are other circumstances which equally demand your attention, and equally require to be achieved. I mean the expression of the space lying between the objects, and also their individual characteristics, particularly those of the foreground, of which, by reason of their nearness, you are more cognizant.

In the first place you have to express the rotundity of the boat by the shades and shadows; and if you look attentively at the latter, you will see all those principles observed which I have all along endeavoured to make you acquainted with, and that they as effectively operate to make this boat look rotund as the tub in Lesson 46. You must not only express the bulging sides of the boat, but the hollow well within it, which must look as if you could drop a stone into it.

Everywhere you will see, that whatever may be the delicacy or the intensity of the shades and shadows, the outline attached to them in every part, is always rather darker. There is also an attempt to express local colour,—for you will see that the outside, or tarred part, has a tint all over it, whilst the inside, forming the seats, etc., is left white. So far the boat would look round, but not sufficiently solid, until you place on the planks lines which shall represent the grain of the wood; these being done, your boat should not only look round but substantial. The buoy has no other lines than such as express its form; hence its surface gives the idea of its being smoother than that of the boat. In the distance, you see little appearance of lines, except such as mark the form of the rocks and the buildings, and these of very delicate and uniform colour. Now, the result of all this is, or ought to be, the expression of space; it should seem, as if the objects were so separate from each other, that we could pass round them; that from the buoy to the boat is but a step, whilst to reach the buildings would require many.

Look now at all the surfaces, the perpendicular and flat walls of the buildings,— the nearly upright, but irregular, surfaces of the rocks,—the various undulations of the ground, now smooth, now rough and stony: then to the liquid pool, which reflects a portion of the stem of the boat. Although some of these are but slightly touched, in subordination to the principal objects, the boat and buoy, these characteristics are recognised and felt, and materially aid the impression of truthfulness we derive from the whole.

LESSON 126.

REMAINS OF A GREEK TEMPLE.

In this Lesson you will have to exercise the higher and more difficult qualities of Art. Should you require a diagram in order to obtain the indispensable neatness and accuracy of the building, which is more than probable, it will be sufficient to refer to Lesson 100; indeed it will be better for you to construct this diagram in the first instance, as the accuracy in the building is its chief difficulty, and the principal requisite.

To accomplish the foreground, and to gain those characteristics, great attention must be first paid to all the leading lines, which should everywhere be carefully preserved, and variously emphasized; the shades over it in the distant parts must be scrupulously even, showing no lines, except on approaching the near parts, where they should appear more and more evident. Attend particularly to their slope, so that the inclination of the surface they cover may be clearly depicted, but above all preserve the form, the size, the brightness, and the edges of the lights, with the most scrupulous care. The nearest stones and leaves must be the most clearly defined, so that by thus conveying the impression that these are near, the rest may appear more distant. Make all the darkest parts very firm; not a line should be visible in the shade over the mountains; they should be particularly tender and delicate, and should be done before the temple.

The shades on the building, unlike those of the foreground, differ but little from each other in their depth of colour, and it will be seen that, if we have any impression of the columns being round, it is due to the cast-shadows thrown on them from the caps and cornice.

Before we go farther it will be necessary to observe, that a great portion of the pleasure this classical subject affords is due to the varied lines of the mountains in the distance, and to the broken and undulating lines of the foreground and the objects composing it, which, contrasting with the regular and perpendicular lines of the building, altogether afford that variety which is such an indispensable element of Art.

But it is not alone from the variety of form that we derive pleasure, we are equally indebted to the different sizes of the columns of the temple, their different height, their different light and shade, no two of them being alike:* the different

* See " Principles and Practice of Art," Chapter on Composition.

Lesson 126

Pl. 47

magnitude of the objects in the foreground, ranging from large to minute ; the contrast of the smooth and chiselled surfaces of the temple with the loose, broken, and irregular characters of the ground and fragments, the hand of man and the hand of Nature, the civilized and the wild, the distant and the near, the dark and the light, all contrast each other, and by that contrast, aid each other in conveying those impressions to the mind which contribute so essentially to the pleasures we derive from the contemplation of Art.

Neatness and care would alone be sufficient to accomplish the building, every line, every light and shade, of which is distinctly seen, but something more is required in the foreground ; no patience, however enduring, no vigilance, however untiring, no sacrifice of time or labour, would serve to imitate the ground, as the building may be imitated, either here or in nature ; nor is it required. We recognise the forms of the building and know when they are true, and its fragments which are scattered on the ground, but we do not recognize the fragments in the foreground in like manner, because their forms are less definite. We there notice the fractured remains, the irregular and broken ground, the moss, the grass, the stones, the leaves, all lying in disorder, wild and waste, and judge whether they be truly depicted, by the force with which these impressions are brought home to the mind; and if, joined to these, we can awaken contemplations akin to those which gave occasion to the following beautiful lines from Byron, we shall have achieved the highest effects of Art :—

> " There is a temple in ruin stands,
> Fashioned by long-forgotten hands ;
> Two or three columns and many a stone,
> Marble and granite, with grass o'ergrown!
> Out upon Time ! it will leave no more
> Of the things to come than the things before !
> Out upon Time ! who for ever will leave
> But enough of the past for the future to grieve
> O'er that which hath been, and o'er that which must be.
> What we have seen our sons shall see :
> Remnants of things that have passed away,
> Fragments of stone reared by creatures of clay ! "

LESSON 127.

AFTER all the Lessons you have studied, containing so many varied subjects, those of this Lesson have no visible attractions; nothing to win your admiration or attention; whatever they want, you must supply. I have given you only skeleton outlines, with such features, in windows and doors, as you will no doubt remember formed the subjects of your early Lessons. Beyond these scanty indications, everything is left to the exercise of your own knowledge and judgment. When drawing each part in its turn, you must refer to the features of any past Lesson, wherein you may find such as will be adapted to your present wants. Taking these, in conjunction with your acquired knowledge, in every respect, you ought to be able perfectly to complete these subjects, until under your hand they wear the aspect of a like kind with those with which you have been abundantly supplied; and now you have arrived at the true test of your ability.

You are not called upon to apply your knowledge in imitation of what another has done; but by its application to work out for yourself every effect of character and circumstance appertaining to each subject, whether of impression, detail, or construction. You must express satisfactorily the old or the new, the near and the remote, the square or the round, the illuminated or the obscured, the shades and the shadows, the recesses and the surfaces,—and all these with reference not only to the object singly, but to those with which it is associated, so that your intentions may in every instance be fully and unmistakeably explained. Herein will you evince the sum of your acquirements, and you must prove yourself capable of drawing from nature, as surely and as distinctly, as you can read what is here written—as much a master of the pencil as you are of the pen. You commenced, perhaps, with some persuasions that to draw a genius was necessary; I hope you conclude with the conviction that no more is required than the genius of comprehension and industry.

Lesson 127

Pl. 48

CONCLUDING OBSERVATIONS.

I ENCOURAGE you now to look back on all you have acquired, and compare if you can the condition in which your last Lesson leaves you with that in which your first Lesson found you. Look around on nature, on objects in-doors and out-of-doors, and ask yourself whether you view them with the indifference you formerly did, or whether you have found out through the medium of Art new sources of pleasure, which were before unknown, and which, for aught you then felt, might as well have had no existence. Are you sensible of no new enjoyments? Do you still look with the same blank indifference on Nature as formerly? Then have you copied, not studied, your Lessons; but if you can look around, and derive from your survey of objects, new pleasures and new sensations, then have you studied your Lessons, not merely and mechanically copied them—then have you spent your time well, not trifled with it, and have obtained your reward. Instead of looking at your Lessons, you have laboured over them; instead of seeing in them so many objects which you have been called upon to imitate, you have found in them transcripts of things whose contemplation has given you pleasure; instead of concluding that art is an appeal to your eye only, you have learned that it is addressed to your mind; instead of the belief that it depended on the materials, you have found that it emanates from acquired knowledge, correct observation, and sound judgment; instead of being solely attributable to genius, you have found those faculties of the mind exercised in this, which have been exercised in other pursuits, but in a different way, and with corresponding success.

I trust these Lessons will have served to dissipate the idea that to acquire Art to a useful and gratifying extent, a genius is needed; that they have proved a knowledge of it to be the result of education, and that Art may be possessed by all in a valuable degree, if it can only be attained by few in a remarkable degree; but, above all, I hope I shall have proved how vain is the general attempt to colour, how forlorn the hope, unless with knowledge, which I have here endeavoured to impart. All which has been here taught of the laws of nature respecting the form, the light and

the shade, and the character of objects, is as indispensable to the use of the brush, as to that of the pencil. Can you, when reviewing the many steps taken, sometimes difficult ones,—the many truths of nature you have learned, think my assertion untrue—that without such knowledge an attempt to colour is absolutely hopeless? The contrary would be to suppose the highest efforts the most easy, or that Art lay rather in the implements than in the mind using them,—that, in short, the means are the end, the box of colours the only enviable acquisition, or how to mix them, the most precious knowledge.

But it must be unnecessary to say another word. If you have studied in earnest what I have endeavoured in these Lessons to put before you, you are already persuaded, that you have not learned in vain. For if the end of Art be to depict nature truly, by whatever means, then will you have seen that such truths as you have learned must be as important to colour as they have been to the pencil: You have already acquired a great amount of learning, which at once advances you far on the road towards a skilful use of the brush; you have not to learn truths and their development, but merely the mechanical application, or employment of such different instruments and means, as are more powerful, because by their use, a greater number of truths can be grasped, and the mind be, therefore, more powerfully affected.

Should you find no time to prosecute Art beyond these Lessons, their exercise will have expanded the faculties they have employed, and left the mind richer, the feelings more acute and embellished, and the hand ready, with the means it has acquired of transcribing from nature, whatever passages may have afforded pleasure either in the power to render its images palpable, or to minister to the every-day necessities and realities of life.

On the advantages to be derived from the study of Art, or the impediments which have hitherto obstructed its progress, I need do no more in conclusion, than transcribe a few passages from the introduction to Graham's Practical Exercises on English Synonymes; which, though written in a just advocacy of the study of the English language, bear so equally on Art, in principle and in argument, as to need only the change of such words as are given in italics, to show the force with which they apply as well to Art as to Language.

" It should be remembered before any study be commenced, that we have two objects in view: one, and this of the greater importance, is the effect the study will produce as to the general improvement of the mind; and the other, its practical utility as regards human comforts, or human intercourse. Now, the latter of these objects is that to which most men direct their attention, whilst the former holds but a second place in the opinions of many, and with the majority is considered wholly un-

155

important. The strength of mind to be acquired by a cultivation of the reasoning faculties is not so perceptible to the generality of mankind as that accomplishment which affords frequent opportunities of exhibition."

"The scanty information given to young students on the genius and character of art, would, of itself, be sufficient to warrant any one in endeavouring to promote a knowledge of its nature and philosophy. It is a singular fact, that notwithstanding this unaccountable neglect of what ought to be considered an important branch of a *liberal* education, there are few who are not ready to admit the necessity of a closer acquaintance with *Art*, and confess that a more accurate knowledge of it, acquired in early youth, would have better prepared them for many duties *even* of common life, *which* they now feel utterly incompetent to fulfil."

"It *must not be forgotten* that in cultivating an innocent taste, we are purifying the mind from low and grovelling propensities, instilling a love of the true and beautiful, and establishing a most delightful resource in after-life, and one of the best modes of securing an avoidance of vicious and degrading pursuits."

"But the importance of *art*, both as a subject of *general* or of *particular* study, is now becoming more extensively acknowledged. It is high time, then, that something more should be proposed for the younger student than the *exercise of his capacity for imitation.* Some mode of study is required which shall exert his powers of discrimination in the use of *art*, and bring him into closer acquaintance with its beauties, so that he may thereby acquire a relish for its characteristic power and genius. The attempt in the present work to supply that want, is published with a confident hope that whatever be its defects, it may assist in giving an impulse to the study, and promote a knowledge of *art*, which it should be every educated Englishman's boast to understand and to appreciate."

Hence then the cultivation of art, its promotion, and its encouragement, depend on the general spread of that sound knowledge which alone can rightly estimate it, and which being infused into the minds of the young, establishes in them a genuine love of Art. Thus is the stimulus to its future progress created, its stability secured, and with it a large amount of honour and wealth to the nation.

THE END.